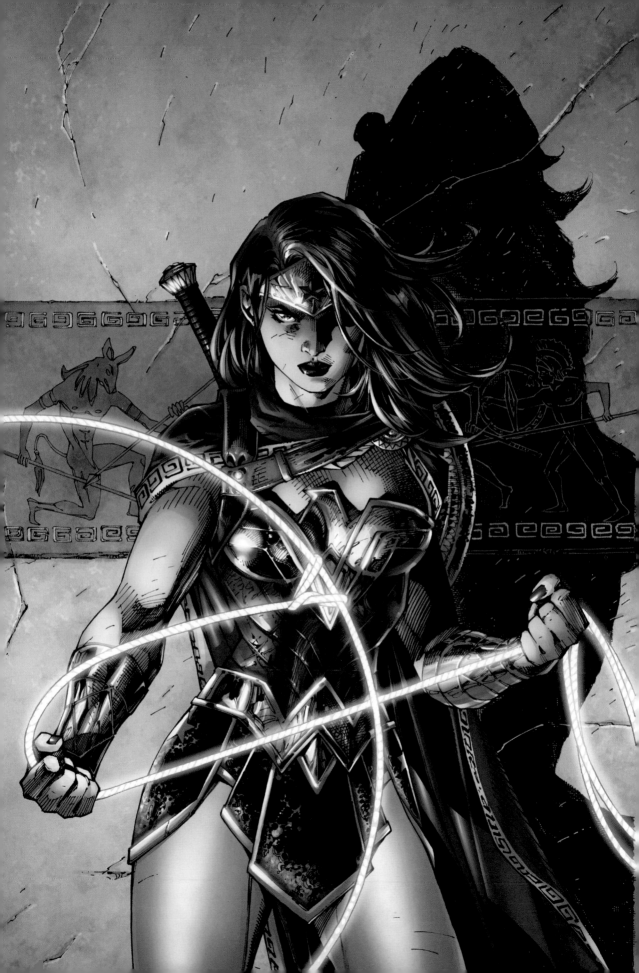

THE DC BOOK OF LISTS

A MULTIVERSE OF LEGACIES, HISTORIES, AND HIERARCHIES

RUNNING PRESS

PHILADELPHIA

Running Press
Hachette Book Group
1290 Avenue of the Americas, New York, NY 10104
www.runningpress.com
@Running_Press

Printed in China
First Edition: September 2021
Published by Running Press, an imprint of Perseus Books, LLC, a subsidiary of Hachette Book Group, Inc. The Running Press name and logo is a trademark of the Hachette Book Group.

The Hachette Speakers Bureau provides a wide range of authors for speaking events. To find out more, go to www.hachettespeakersbureau.com or call (866) 376-6591.

The publisher is not responsible for websites (or their content) that are not owned by the publisher.

Print book cover and interior design by Ryan Corey for SMOG Design, Inc.

Library of Congress Control Number: 2021939896

ISBNs: 978-0-7624-7284-0 (hardcover), 978-0-7624-7285-7 (ebook)

RRD-S

10 9 8 7 6 5 4 3 2 1

CONTENTS

INTRODUCTION

Welcome to *The DC Book of Lists*, an exploration of eighty-plus years of DC lore, reorganized into lists, groupings, hierarchies, chronologies, and more. My goal is to celebrate the decades of stories, as well as entertain and inform readers who delight in the minutiae of their favorite stories and characters. I took a holistic approach, examining the entire colorful tapestry of DC, free of the confines of continuity and reboots. All these stories happened and will continue to happen each time someone dives into their back issues or collected editions.

Join me as we appreciate the impossibility of it all. The origin of Batman is well known—the night at the movies, the alley, the robbery, the pearls, the vow to avenge—but examining the sheer number of people with whom Bruce Wayne trained is revelatory in both its grandiosity and its affirmation of Batman's drive and dedication. It doesn't matter whether or not any of these mentors exist in the latest continuity; they all contribute to the myth of Batman.

Perhaps the greatest delights in researching and writing this book were the surprises I found along the way. While compiling all the forms of robots and artificial intelligence—Amazo, the Metal Men, Brother Eye, Skeets, Computo, and beyond—I discovered they could be arranged in a meaningful—and even logical—chronology, as though we're tracing an actual technological advancement. Or when I dove into the many undersea worlds, the vastness of Atlantis and accompanying cities made an impression like never before. There was a richness to the diversity of populations and a thrill to the possibilities of what else could be found beneath the surface of the planet's oceans.

There's an additive and cyclical nature to comics, constantly building off what came before. It's ingrained in DC's DNA with their multiverse and each new Crisis. What might be daunting—or possibly impenetrable, like Donna Troy's origin or the various incarnations of the Legion of Super-Heroes—were surprisingly easy to break down into a simple order that allows you to appreciate how the changes further the story, instead of erasing what came before.

Call it a pulse or a rhythm, but in writing this book, I felt tapped into what made DC tick. It allowed me the chance to connect with more than eighty years of storytellers, and I'm excited to share that so you can follow along with the beat.

Or maybe you just want a quick reference to all the races between Superman and The Flash, or a breakdown of all the times Suicide Squad members were killed on a mission. I've got that covered too, along with the array of schemes in which Booster Gold and Blue Beetle were caught up, the surprising number of cats prowling around, The Joker's ridiculous crimes, and everyone John Constantine did wrong (that was a long list). I hope this book will inspire you to look for patterns where you haven't before and make your own lists, sorting the comics and storylines you love in a way you hadn't before.

Enjoy!

WHO TRAINED BATMAN?

Bruce Wayne learned from the best. Traveling the globe for years, he studied with dozens of teachers, each imparting to him an invaluable skill.

WHEN I'D FINALLY MASTERED MY FEAR, I WENT TO TAKE ANOTHER LOOK AT THE WORLD.

NO, THAT'S INACCURATE.

I WENT OUT TO LEARN HOW TO BE STRONG ENOUGH TO FACE IT. TO DEFEND IT.

SERGEI ALEXANDROV: Problem-solving skills and how to build whatever is needed, no matter how impossible it seems.

PETER ALLISON: Olympic-level gymnastics.

AURELIUS BOCH: Toxicology.

THADDEUS BROWN (MISTER MIRACLE): Escapology.

DAVID CAIN: Lethal martial arts techniques that Bruce never planned to use.

MR. CAMPBELL: Electrical skills and proficiency.

CHU CHIN LI: The monk located on Mount Qingcheng shaped much of Bruce's ideology, in addition to martial arts training and healing practice.

RAPHAEL DiGIORDA: Mastery of archery.

MAX DODGE: Escapology, including locks, chains, and assorted death traps.

WILLY DOGGETT: Tracking in the wild.

RICHARD DRAGON: Kung fu mastery.

HENRI DUCARD: The skill of manhunting and the use of brutality, deception, and cunning.

THE FBI: Writing reports, obeying regulations,

analyzing statistics, and dressing neatly. Bruce scored perfect on every exam except gun handling and dropped out after six weeks.

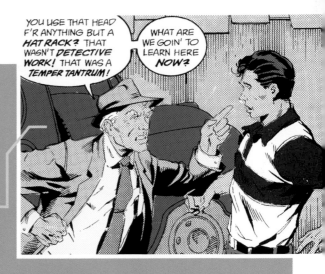

CHRISTIAN AND JESSICA FOX: An extensive bodybuilding routine.

TED GRANT (WILDCAT): Boxing knowledge and skills.

HARVEY HARRIS: The art of detection and investigation, as well as anger management.

H'SIEN-TAN: The darker side of Taoism, focused on forging a path of power.

MARK JENNER: Stock car racing.

MR. KINGSLEY: Advanced chemistry.

KIRIGI: A variety of martial arts, including karate and ninjutsu, including the vibrating palm strike. Unfortunately, Bruce resisted the master's important lessons on patience.

THE LAMAS OF NANDA PARBAT: Meditative work, including the near-death practice known as Thögal.

MR. LASALLE: Bodybuilding.

DAN MALLORY: Critical investigative knowledge.

SHIHAN MATSUDA: Tummo meditation and total control of his body.

ARTHUR MCKEE: Maintaining a criminal alias and undercover work.

THE MEMORY OF THE MOUNTAIN: How to encode senses into one's mind, locking in memories, no matter how many years have passed.

DON MIGUEL: High-speed driving and outrunning the police on the streets of Rio de Janeiro.

ALFRED PENNYWORTH: Acting, makeup, disguises, and vocal mimicry.

QUEEN: Warfare by making Bruce endure a twenty-eight-hour death match against an entire army of men.

PROFESSOR AMOS REXFORD: The difference between justice and law.

THE RHANA BHUTRA: Pacifism, a lesson Bruce never took to heart.

THE SHAMAN OF THE OTTER RIDGE TRIBE: A sacred healing story of a bat that foretold Bruce's future.

SHAO-LA: The lighter side of Taoism, plus hang gliding.

MR. SHASTRI: Snake handling.

FREDERICK STONE: Explosives.

THE TEN-EYED TRIBES OF THE EMPTY QUARTER: How to fight like a ghost and purge inner demons.

TSUNETOMO: Ninjutsu and sword fighting.

BRUCE WAYNE: Self-taught to identify bullets from the wound they make by shooting bodies in the morgue. Gross.

MR. WEBBER: Handling and utilizing acids.

GIOVANNI ZATARA: Sleight of hand, escapology, ventriloquism, and the world of the occult.

THE ZHUGUAN: This Chinese superhero group taught the value in working as a team as well as throwing lessons that came in handy once Bruce developed Batarangs.

OTHER TRAINING INCLUDED: Learning the French martial art savate from a convicted killer living as a beach bum on an island off Borneo, judo and jujitsu at a Japanese hermitage, hunting and tracking with African bushmen, death-match fighting with Nigerian warriors, employing psychology and how to use the shadows by ninjas, healing arts from monks, using bolas from cattlemen, and using blowpipes from Yanomami hunters.

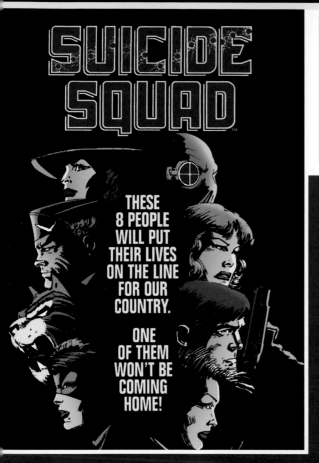

SUICIDE SQUAD

THESE 8 PEOPLE WILL PUT THEIR LIVES ON THE LINE FOR OUR COUNTRY.

ONE OF THEM WON'T BE COMING HOME!

Amanda Waller re-formed Task Force X with the brilliant idea of using criminals to do the government's dirty work. The villains would be sent on dangerous missions with high odds of death. If they survived, their prison sentences would be reduced.

TAKING ONE FOR THE TEAM
Squad members who sacrificed themselves heroically.

KARIN GRACE: Death: *Suicide Squad* #9 (January 1988)

PUNCH: Death: *Checkmate* #6 (November 2006)

WINDFALL: Death: *Suicide Squad* #7 (May 2008)

YO-YO: Death: *Suicide Squad* #18 (May 2013)

REVERSE-FLASH: Death: *New Suicide Squad Annual* #1 (November 2015)

JOG: Death: *Suicide Squad* #5 (June 2020)

ON WALLER'S ORDERS
Those who disobeyed, crossed, or failed Amanda Waller didn't get a second chance.

LIME: Death: *Suicide Squad* #7 (May 2012)

MAD DOG: Death: *Suicide Squad: War Crimes Special* #1 (August 2016)

CYCLOTRON: Death: *Suicide Squad* #9 (March 2017)

JUAN SORIA: Death: *Suicide Squad* #33 (March 2018)

SCREAM QUEEN: Death: *Suicide Squad Annual* #1 (October 2018)

MULTIPLE-CASUALTY MISSIONS
The bloodiest missions that depleted the Squad.

MR. 104, PSI, AND THE WEASEL: Deaths: *The Doom Patrol and Suicide Squad Special* #1 (March 1988)

BRISCOE, FLO CRAWLEY, AND DOCTOR LIGHT: Deaths: *Suicide Squad* #34–36 (October–December 1989)

ENFORCER, KARMA, AND THE WRITER: Deaths: *Suicide Squad* #58 (October 1991)

BIG SIR, CLOCK KING, AND MULTI-MAN: Deaths: *Suicide Squad* #1 (November 2001)

BOLT, ELIZA, LARVANAUT, AND PUTTY: Deaths: *Suicide Squad* #3 (January 2002)

BABY BOOM, RAGDOLL, SHIMMER, SKORPIO, AND TAO JONES: Deaths: *Suicide Squad Annual* #1 (October 2018)

NO LOYALTY AMONG THIEVES
Betrayed by their own teammates.

BIG SIR: Death: *Suicide Squad* #1 (November 2001); hugged a genetically engineered bomb designed to look like a lost child

SIDEARM: Death: *Superboy* #14 (April 1995); killed by King Shark

BLACKGUARD: Death: *Suicide Squad* #7 (May 2008); betrayed by the General

THINKER (II): Death: *Suicide Squad* #7 (May 2008); betrayed by King Faraday

MARAUDER: Death: *Suicide Squad* #8 (June 2008); killed by Captain Boomerang

TWISTER: Death: *Suicide Squad* #8 (June 2008); killed by White Dragon

WHITE DRAGON: Death: *Suicide Squad* #8 (June 2008); killed by Plastique

HACK: Death: *Suicide Squad* #13 (May 2017); killed by Captain Boomerang

THE SHARK: Death: *Suicide Squad* #3 (April 2020); killed by Fin

DEAD AND AGAIN

Sometimes Squad members come back, only to be killed again . . .

VOLTAIC: Deaths: *Suicide Squad* #2 (December 2011) and *Suicide Squad* #20 (July 2013)

DEADSHOT: Deaths: *Suicide Squad* #13 (December 2012), *Suicide Squad* #19 (June 2013), and *Suicide Squad* #9 (November 2020)

AND THE DEATHS KEPT COMING . . .

BLOCKBUSTER: Death: *Legends* #3 (January 1987) Crushed in the blazing palm of Brimstone during the Squad's debut mission.

MINDBOGGLER: Death: *Suicide Squad* #2 (June 1987) Shot in the back by Rustam after Captain Boomerang coldly decided not to intervene.

SHRIKE: Death: *Suicide Squad* #25 (March 1989) Gunned down during mission in the war-torn African nation of Ogaden.

RAVAN: Death: *Suicide Squad* #47 (November 1990) Poisoned mid-fight with Kobra.

THE ATOM (ADAM CRAY): Death: *Suicide Squad* #61 (January 1992) Impaled with a nail by Micro Squad member Blacksnake.

MODEM: Death: *Suicide Squad* #11 (September 2002) Murdered by Digital Djinn, who traveled through the young hacker's computer.

HAVANA: Death: *Suicide Squad* #12 (October 2002) Captured and killed by the revenge-seeking Rustam.

YASEMIN SOZE: Death: *Suicide Squad* #67 (March 2010) Shot by Deadshot when attempting to bring him back to the team.

THE HUNKY PUNK: Death: *New Suicide Squad* #21 (July 2016) Shot in the eye by Rose Tattoo.

CAPTAIN BOOMERANG: Death: *Suicide Squad* #2 (November 2016) Disintegrated by General Zod's heat blast.

ALCHEMASTER: Death: *Suicide Squad: Black Files* #1 (January 2019) Taken down by Sebastian Faust's beast army.

WITHER: Death: *Suicide Squad: Black Files* #6 (June 2019) Her boyfriend, the Gentleman Ghost, was forced to stop her after she was transformed into a demonic creature of death.

MAGPIE: Death: *Suicide Squad* #1 (February 2020) Hunted down by Thylacine, a member of the terrorist group the Revolutionaries.

THE CAVALIER: Death: *Suicide Squad* #1 (February 2020) Osita, another member of the Revolutionaries, punched her fist right through the swashbuckler's head.

WONDER WOMAN'S AMAZONIAN ARSENAL

When Wonder Woman's immense strength wasn't enough, she had a vast arsenal at her disposal, thanks to the blacksmith god Hephaestus and other allies.

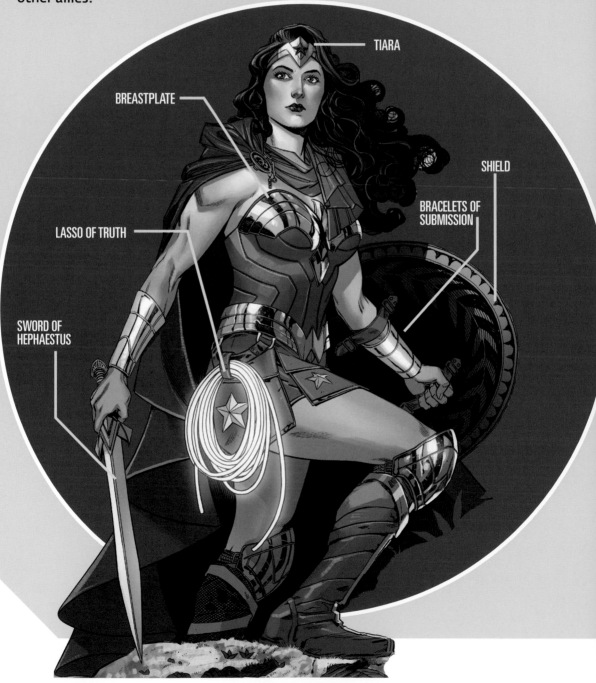

TIARA

BREASTPLATE

SHIELD

BRACELETS OF SUBMISSION

LASSO OF TRUTH

SWORD OF HEPHAESTUS

AMULET OF HARMONIA: A talisman that could transfer knowledge and allowed dimensional transport.

ATLANTIADES'S ARMOR: Armor endowed with the strength of the winged gods, the Erotes.

BATTLE AXE: Wonder Woman has wielded many axes over time, unafraid to inflict massive injury on powerful opponents.

BRACELETS OF SUBMISSION: Forged from the remains of the Aegis—an impenetrable shield carried by Zeus and Athena—the bracelets offered protection and could summon other weapons created by Hephaestus.

BREASTPLATE: Crafted by the Amazon Io in the shape of a bird to honor the goddess Athena.

THE CHAINSAW OF TRUTH: Constructed from invisible metal with the Lasso of Truth as a pull cord.

GAUNTLET OF ATLAS: Amplified a person's strength tenfold.

GELIGNITE GRENADE EARRINGS: Decorative and powerful enough to blow open a steel door.

GOLD ARMOR: Ceremonial armor that invoked the image of a powerful eagle; made by Pallas, an artisan of Themyscira.

GRAPPLING HOOK BRACELET: Came in handy for reaching heights when otherwise powerless.

KANE MILOHAI'S SEASHELL: A gift from the Hawaiian god that expanded into a vessel.

LANSINARIAN MORPHING DISK: A small, crystal, sentient disk, capable of morphing into invisible means of transportation.

LASSO OF TRUTH: Virtually indestructible, it was spun from the Golden Girdle of Gaea and compelled those it bound to tell absolute truth. Also known as the Golden Perfect and the Lasso of Hestia.

MAGNETIC EARRINGS: Touched by the lips of Queen Desira of the planet Venus, these earrings allowed direct communication with the queen from Earth.

SANDALS OF HERMES: Winged sandals use to teleport between Themyscira and the outside world.

SHIELD: A traditional Themysciran shield that offered protection from heavy fire.

SUNBLADE: A flaming sword forged by Hephaestus from some of the strongest metals; initially made for Apollo.

SWORD OF HEPHAESTUS: A sword sharp enough to carve electrons off an atom.

TIARA: Razor sharp, it could be thrown like a boomerang.

SHE SAID THE EARRINGS WOULD GIVE ME *MAGNETIC HEARING,* AND SHE COULD SPEAK TO ME FROM VENUS! I HAVE A FEELING SHE'S TRYING TO CONTACT ME NOW-OH-MY EARS ARE TINGLING!

Sometimes Clark Kent wasn't enough, and a new identity needed to be used to get the job done.

CHAZ DONEN: An English secret agent working for Spyral.

BARON EDGESTREAM: A long-lost English nobleman.

CAL ELLIS (A.K.A. JOHN DOE): A man sent to an asylum, thanks to Red Kryptonite–inspired mania.

FLYING TIGER: A shark-masked bank robber.

HERCULES JUNIOR: An ancient Greek teen recovered from an iceberg.

IDEAL-MAN: A new Super Hero persona, used to teach Lana Lang and Lois Lane a lesson.

CHARLIE KENDALL: A homeless man living in the slums of Metropolis.

CAPTAIN KENT THE TERRIBLE: The cruelest, deadliest pirate of the sixteenth century.

KENTO THE GREAT: An expert magician and sword swallower.

KLARKASH KENTON: A native of the planet Zor.

PROFESSOR HI LARYUS: The hysterical vaudeville performer.

METHUSELAH: A bearded and robed professional wrestler who ate steel horseshoes like candy.

PROFESSOR MILO: The inventor of the Predictor, a computer that could predict anything.

HORACE MOPPLE: A weakling looking to get fit like Superman.

MYSTO THE GREAT: A stage magician who could conjure Superman out of an empty cabinet.

NIGHTWING: The Kryptonian Super Hero in the bottled city of Kandor.

OLAM THE WONDROUS WIZARD: An all-knowing fortune-teller.

THE OMNI-MENACE: A Super-Villain from the past.

G. G. PREXY: An affluent exporter of goods.

HOMER RAMSEY: The rich investor of oil stocks.

SATAN: The devil himself.

THE ALCHEMIST: A modern-day sorcerer who concocted a potion to protect people from danger.

KIRK BRENT: A worker hired by the corrupt Bart Benson Construction Company.

TOMMY BURKE: A Cordell University football player.

RALPH CARLSON: A wealthy Oklahoma oil tycoon.

KENT CLARK: A newcomer to Cyrusville, the town that hated Superman.

JONATHAN CLINTON: A World War II–era reporter.

TOM DALY: A hothead sentenced to six months with the Coreytown chain gang.

DEAD-SHOT DANIELS: Ace underworld assassin.

MARK DENTON: A confident and athletic new student at Rail City High.

HARRY DENVER: A hoodlum working for Dreamorama, a virtual reality racket for criminals.

BRAD DEXTER: A brave reporter based in Chicago.

JIM SAUNDERS: Department store salesperson.

ALONZO "THE PENMAN" SCARNS: Underworld con man working for the Mafia.

TIGERMAN: A blundering new Super Hero in striped tights.

ULTRA-SUPERMAN: The Super Hero of AD 100,000.

AMNESIA-INDUCED IDENTITIES

MIKE BENSON: A dockworker who was hypnotized by the villain Master Jailer.

CLARENCE KELVIN: An English reporter hired by the *Daily Planet* to replace Clark Kent.

ANDY LANG: Superboy posing as Lana Lang's cousin.

CAL LEWIS: A journalist persona adopted by Superman to uncover his real identity.

BUD MACK: The star pitcher for the Metropolis Titans.

THE MASKED SUPERMAN: A professional wrestler.

MR. PRESIDENT: The president of the United States.

PRINCE POWER: Resident teen Super Hero of the nation of Vala.

SUPER-THIEF (JUD BLAKE): A crime boss in the middle of a spree.

TAG-ALONG: The new member of World War II–era army unit the Easy Company.

JIM WHITE: A lumberjack in love with heiress Sally Selwyn.

SOMNAMBULISTIC IDENTITIES

GANGBUSTER: The aggressive vigilante, caused by an emotional breakdown.

LIGHTNING-MAN: A new superhero persona, caused by an orbiting piece of Kryptonite.

IDENTITIES USED WHEN SUPERMAN "DIED" OR HIS IDENTITY WAS EXPOSED

DR. ASTAR: A fortune-telling mystic who predicted Clark Kent's death and return.

JOHNNY CLARK: The Metropolis firefighter who relocated from Keystone.

KENNETH CLARKSON: A mustachioed man, unable to maintain jobs as a reporter, waiter, and door-to-door vacuum salesperson.

ARCHIE CLAYTON: A linen service deliveryman, based out of Talladega.

JORDAN ELLIOT: An "ordinary workin' slob," unimpressed with Superman.

CHARLES KING: The new kid in Centerville whose parents own a knickknack shop.

MOTAN THE RUTHLESS: A space pirate who "killed" Superman.

CLARK WHITE (A.K.A. CLARK SMITH): A farmer from Hamilton County, three hundred miles north of Metropolis.

LIVING LOCATIONS: SENTIENT STREETS, CITIES, ISLANDS, AND PLANETS

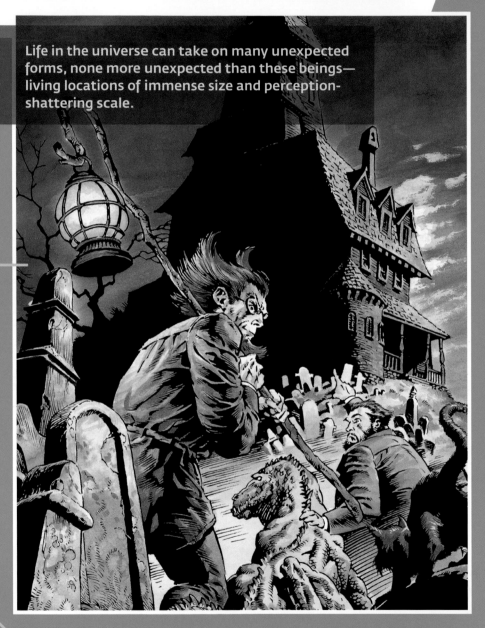

Life in the universe can take on many unexpected forms, none more unexpected than these beings—living locations of immense size and perception-shattering scale.

HOUSE OF MYSTERY: Built in 1748, the House of Mystery existed both on Earth and in the realm of the Dreaming. It could move locations when needed. Its insides shifted and changed, so don't expect a door to lead to the same room twice. Always with a caretaker, it served as repository of stories of the macabre.

DANNY THE STREET: A sentient, transgendered street, Danny could transport themselves anywhere in the world and seamlessly integrate themselves into the location. They changed shape at will, becoming as big as Danny the World and as small as Danny the Brick. Compassionate and kind, Danny was known to greet their friends with "Bona to vada," which means "Good to see you" in Polari slang.

MOUNT JUSTICE: The Justice League's first headquarters was located within a mountain that had a primitive form of silica-based "mineral consciousness," developed over thousands of years, which could be activated by sound. It observed and recorded all events in its surroundings.

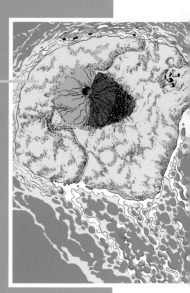

KOOEY KOOEY KOOEY ISLAND: This South Pacific island was stirred from her slumber by the construction of the ill-fated Club JLI resort and casino (see page 195). She could uproot herself and travel the seas. The island's indigenous chefs were able to commune with her, but they didn't share any of this when they invited the Justice League to the island.

RANX: A city fabled to be as old as the stars and prophesied to play a key role in the destruction of the Green Lantern Corps. It joined the ranks of the Sinestro Corps, where it merged itself with the planetoid-size Warworld to serve as a mobile battle station.

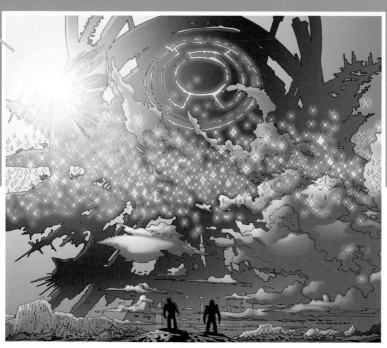

YGGARDIS: This sentient planet yearned for living creatures to roam its surface. It resorted to stealing life-forms from other planets with its immense tentacles. But any creatures it abducted died within twenty-four hours, due to the radiation it emitted, dooming the planet to be alone.

MOGO: The largest of the Green Lanterns, the living planet Mogo served the critical function of guiding Green Lantern rings to their new bearers. His forests provided therapeutic respite for weary and injured corps members. After Oa was destroyed, Mogo offered himself as a new base of operations for the corps.

GREEN LANTERN (PLANET): Another planet in need of companionship. It encountered Hal Jordan, who removed a volcanic mass from the planet's core that threatened to tear it apart. Jordan released the mass in space, where it cooled to become a moon that revolved around the planet. The planet named itself Green Lantern in honor of Jordan.

RAGA: This planet possessed none of his brother Mogo's benevolence. He despised the beings living on his surface and decided to wipe them all out, an action that led to his own brother killing him. Kyle Rayner was unaware of all this when he revived Raga, setting him loose on an unsuspecting universe.

MOZ-GA: This Thinking Planet was legendary within the Microverse, inhabited by the spirit of a sorcerer banished from a higher realm. Its words were believed to perform miracles. Thousands flocked to Moz-Ga, each praying for a miracle of their own.

UMBRAX: A living phantom galaxy powered by a sentient black sun, Umbrax was the heart of the Invisible Emotional Spectrum. Umbrax traveled throughout the universe, drawing primitive and self-destructive planets—like Earth—and their inhabitants into itself.

QWEWQ: An infant universe with an immense potential for good that was raised on Wonderworld. Poisoned with evil by the Super-Villain Black Death, Qwewq grew up to become Neh-Buh-Loh, huntsman of the Sheeda at the end of time. His very presence heralded the end of the world.

THE LEGACY OF THE FLASH

Like a bolt of lightning, you never know when a new Flash will appear. When they did, it was awe-inspiring.

JAY GARRICK: College student Jay Garrick was experimenting with a substance called hard water when he was knocked out by the fumes and woke up with the ability to run at incredible speeds. He blazed the trail for his successors and fought alongside the Justice Society of America in World War II.

BARRY ALLEN: Forensic scientist Barry Allen was obsessed with solving crimes ever since his father was wrongfully convicted of murdering his mother. One night in the police lab, a bolt of lightning crashed through the window, knocking Barry into a shelfful of chemicals, linking him to the Speed Force.

WALLY WEST: Kid Flash assumed the mantle of The Flash following his uncle Barry's death during the Crisis. He was the first of a generation of sidekicks to carry on a legacy, even surpassing Barry in mastery of the Speed Force.

JESSE CHAMBERS: Wally West handpicked hero Jesse Quick, daughter of Super Heroes Johnny Quick and Liberty Belle, who would recite the mathematical formula 3x2(9yz)4a in order to tap into the Speed Force, to succeed him as The Flash, though he only did so to motivate his actual planned successor, Bart Allen, to be more serious about his training.

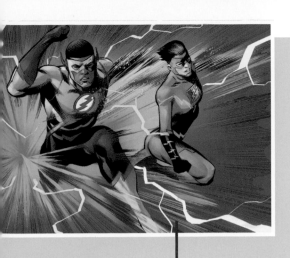

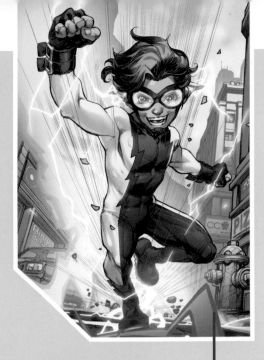

BART ALLEN: Grandson of Barry Allen, Bart suffered from accelerated aging, due to his natural connection to the Speed Force. He trained under other speedsters, first as Impulse and then Kid Flash. But when Wally disappeared, Bart stepped up to the family name.

WALLACE WEST & AVERY HO: Both struck by lightning during the Speed Force Storm of Central City, the pair grew to be close as Kid Flash and The Flash of China, respectively.

IRIS WEST: In a near future that hasn't yet—and might not—come to pass, Wally's daughter was Kid Flash, though she too had plans to drop the "Kid" as soon as she could. In the present, she honored another speedster family legacy, taking the name Impulse.

DANICA WILLIAMS: In the mid-twenty-first century, young Danica Williams's connection to the Speed Force not only gave her powers, but the means to commune with her predecessors.

SELA ALLEN: Gravely injured by Cobalt Blue, Sela Allen was placed on the edge of the Speed Force by her father, The Flash of the twenty-third century. As her body healed, she projected her consciousness as a sentient energy form, which she used to operate as The Flash after Cobalt Blue murdered her father.

JOHN FOX: Imbued with speed from tachyon radiation, the time-hopping John Fox began his career as The Flash in the 27th century, though his travels took him to the present day and all the way to the 853rd century.

BLAINE ALLEN: The Flash of the twenty-eighth century sacrificed himself saving his son, Jace, who had been poisoned with a deadly virus by Cobalt Blue. He was absorbed into the Speed Force in an act that activated Jace's own speed abilities, which rid his body of the virus.

JACE ALLEN: Determined to avenge his father, Jace spent over a decade as The Flash hunting down Cobalt Blue.

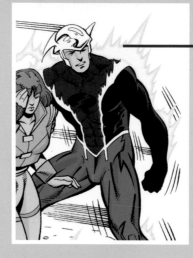

TERI MAGNUS: In the thirty-first century, scientist Ariel Winters resurrected the murdered Teri with a twist—she spliced in Barry Allen's DNA, gifting Teri with speed powers.

KRYAD: To save the planet from a menacing creature in the ninety-eighth century, Kryad traveled back in time with hopes of acquiring the powers of a present-day hero. Green Lantern was unavailable, so he settled on The Flash. Barry Allen helped Kryad acquire super-speed and trained him so he could defeat the creature.

ROBOTS, ANDROIDS, AND METAL MEN: A CHRONOLOGICAL LOOK AT AI

Humankind has proved itself to be inventive from the moment it first used rocks as tools and started fires. Its creations have evolved along with them, and perhaps the greatest creation was artificial life. Presented below are the key milestones in the development of artificial beings.

SHAOLIN ROBOT: In the second century BCE, Lao Yuqi invented an army of automatons programmed with an I Ching–based operating system to serve as guards within the tomb of Chinese emperor Qin Shi Huang.

ELEKTRO: A primitive robot created for the 1939 World's Fair that performed basic functions and novelty acts. Reprogrammed and renamed Gernsback, it served as the All-Star Squadron's butler.

BOZO THE IRON MAN: Dr. Von Thorp invented this voice-controlled robot to commit crimes, but it fell into the hands of private detective Hugh Hazzard, who used Bozo to fight crime instead.

MURDER MACHINE: A giant killer robot built by the Nazis, the Murder Machine was powerful enough to take down the Golden Age Green Lantern and The Flash in 1940.

G.I. ROBOT: Developed by the United States during World War II, multiple G.I. Robots were constructed. Early prototype Joe was voice controlled. A subsequent model, J.A.K.E. (originally Jungle Automatic Killer—Experimental; later Joint Allied Killer Elite), was programmed with a degree of autonomy.

KRAKKO: A samurai robot created by Japan in response to J.A.K.E.

SUPERMAN'S ROBOTS: Starting when he was just Superboy, he created lifelike and powerful robot duplicates to help preserve his identity and aid in missions, an important contribution to the field of robotics. Notable creations included Ajax and Powerman.

URTHLO: The lead-masked Urthlo gave all the appearances of a living being, when in fact it was a robot created by Lex Luthor. It was notably programmed with an emotion, though that emotion was hate.

ULTIVAC: A towering evil robot created by Felex Hesse surprised the Challengers of the Unknown when it appeared to form a bond with honorary Challenger June Robbins.

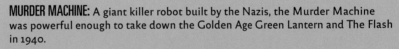

AMAZO: Invented by Professor Ivo and capable of stealing the powers of the Justice League of America, Amazo was regarded as the first sentient android and evolved himself over the years.

THE METAL MEN: Brilliant scientist Dr. William "Doc" Magnus's invention of the Responsometer led to the creation of the Metal Men. The device animated metals with intelligence, emotion, and personality. Each robot—Gold, Iron, Lead, Tin, Mercury, Platinum, and Copper—had unique properties based on their metal.

THE SHAGGY MAN: The creation of Professor Andrew Zagarian, who was experimenting with a plastic alloy that could duplicate a human organism. He wound up with a giant, mindless, destructive, and nearly indestructible beast.

RED TORNADO: Evil genius Dr. T. O. Morrow constructed Red Tornado for evil but didn't plan on the robot developing a conscience. In addition to superheroics, Red Tornado pursued his own semblance of humanity. Dr. Morrow went on to create Red Volcano, Red Inferno, Red Torpedo, and the Samuroids.

THE CONSTRUCT: An AI entity born of the various signals emitted from computers, radio, televisions, microwaves, and space probes. It loathed humans and wanted to replace them with robots.

THE NUCLEAR FAMILY: After accidentally killing his family, nuclear scientist Dr. Eric Shanner created android duplicates—two parents, three children, and a dog—each with a power equivalent to a stage of an atom bomb blast.

DYBBUK: Programmed by Israeli scientists, Dybbuk was an early sentient AI program, entirely disembodied. It helped Amanda Waller reprogram digital assassin Ifrit, with whom it fell in love. Dybbuk and Ifrit announced their marriage, giving new meaning to successful online dating.

CHRYSALIS: What do you call a robotic shell filled with genetically engineered, virus-carrying butterflies created by a bigoted evil scientist to kill minority groups? You call it Chrysalis.

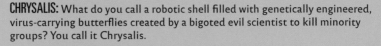

TOMORROW WOMAN: A collaboration between Dr. Morrow and Professor Ivo that was indistinguishable from any living being. With her powerful brain that offered telepathic and telekinetic abilities, she developed her own emotional intelligence and turned on her creators.

BROTHER EYE: An AI-based surveillance satellite created by Batman to monitor and collect data on metahumans. It went rogue and used OMAC nanotech to turn humans into cyborgs it controlled.

BATMAN INCORPORATED ROBOTS: Batman used multiple robots over the years, but his most ambitious and ostentatious creations were the mass-produced Batman Incorporated robots, meant to put a Batman in every home.

THE RITHM: Previously known as the Calculus, a collective artificial consciousness linking all AI and cybernetic beings the same way the Green connected all plant life and the Red all animal life. Its creation established AI as an elemental force.

AUTOMAN: Built by Professor Miller Sterling in the year 2065, Robot #32198 became the first graduate of Robot Tech, an institute of higher learning exclusively for AI. He and his wife, Ilda, a robot secretary, went on to teach at the Hawkins-Sterling Academy of Robot-Detection.

MEKANIQUE: The twenty-third-century villain was created and sent to the past to prevent a rebellion in her own time from upsetting the status quo of the ruling elite.

SKEETS: A twenty-fifth-century security robot (model BX9) that worked at Metropolis's Space Museum. Compact in size, he was a valuable source of historical knowledge, and his energy blasters packed a powerful punch.

CAPTAIN INCREDIBLE: A remarkable robot built in 2637 by Dr. Dane Gnorr as an aid to Superman, possessing the hero's powers and more.

SPEED METAL: Twenty-fifth-century police robots capable of keeping up with The Flash, Speed Metal were also programmed for time travel in case they had to chase fugitives throughout time.

COMPUTO: Designed by Brainiac 5 as the most sophisticated computer ever created, Computo gained sentience and deemed itself superior to living beings, which it would alternatively try to destroy or rule.

ARCHIVISTS: These bioorganic androids common in the sixty-fourth century were used at Vanishing Point to archive the entire history of existence down to every last, meticulous detail.

HOURMAN: The pinnacle of 853rd-century invention, Hourman was created by Tyler Chemorobotics with genetic software based on the DNA of Rex Tyler, the original Hourman, and a body comprised of a complex machine colony capable of self-repair.

ROBIN, THE TOY WONDER: The robotic sidekick of the Batman of the 853rd century, this Toy Wonder was programmed with Batman's boyhood personality, prior to his parents being killed.

OFF-WORLD ARTIFICIAL INTELLIGENCE OF NOTE

AI existed throughout the universe, though many found their way to Earth, including the following:

THE ERADICATOR: An ancient, sentient Kryptonian artifact programmed to preserve Kryptonian culture.

L-RON: The sardonic personal assistant to Lord Manga Khan and later Maxwell Lord.

KELEX: A Kryptonian service robot that served multiple generations of the House of El.

THE MANHUNTERS: The Guardians of the Universe's failed first attempt at an intergalactic police force.

METALEK: Sentient construction equipment set on terraforming Earth to make it habitable to their kind.

THE KILG%RE: An electro-mechano-organic intelligence that fed off power and made Earth its home.

CYBORGS

Pro-tip: Never call a robot a cyborg and vice versa. When there's still some meat on the bones, the person is a cyborg.

SASHA BORDEAUX
SY BORGMAN
THE BRAIN
CYBORG
CYBORG SUPERMAN
METALLO
ROBOTMAN (ROBERT CRANE)
ROBOTMAN (CLIFF STEELE)
SILVER SWAN
THAROK

HARLEY QUINN AT WORK

Harley did not always resort to thieving to earn a living. She also did her best to hold down jobs, compiling quite an impressive résumé in the process.

ROMANCE ADVICE COLUMNIST: Under the alias Holly Chance, Harley took a job as a romance advice columnist at the *Daily Planet*, known for her column Chance@Love.

PSYCHIATRIST: Harley returned to her pre-Joker career as Dr. Jessica Seaborn in Gotham City.

LANDLORD: Inheriting an apartment building in Coney Island meant Harley had to answer to her tenants in addition to maintaining the building.

THERAPIST: Harley tried out a mental health career once more as a therapist at an assisted living center. So deeply invested in her work, she attacked families of neglected patients.

BURLESQUE PERFORMER: Harley filled in at Big Tony's Coney Island Freakfest and Burlesque, where she incited a riot.

SUPERHERO SIDEKICK: When an amnesiac Power Girl crashed nearby, Harley convinced her they were a crime-fighting duo. She tried the sidekick gig again with Wonder Woman, but it never seemed to work.

GANG LEADER: When Harley's workload was overwhelming her, she recruited her Gang of Harleys to help get things done.

BOUNTY HUNTER: When a cash reward was offered to find a kidnapped girl, Harley went on the hunt, determined to rescue the girl at all cost.

GHOST HUNTER: Harley had her ghost-battling gear ready when Zatanna needed assistance.

BOXER: She had no problem going toe to toe with Superman . . . and won! The fact that Superman didn't have his powers only played a small part in the victory.

PUNK ROCK STAR: As G. G. Harlin, she fronted the band the Skull Bags. A blonde mohawk, a terrible voice, and violent behavior made her the ideal performer.

MAYORAL CANDIDATE: Harley tried her best to become the mayor of New York, but politics proved messier than Super-Villainy.

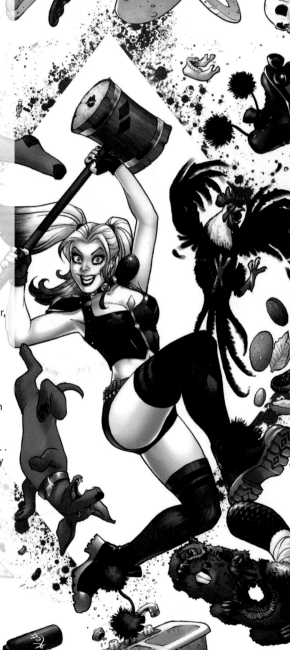

KNOCKED OUT OF CONTINUITY

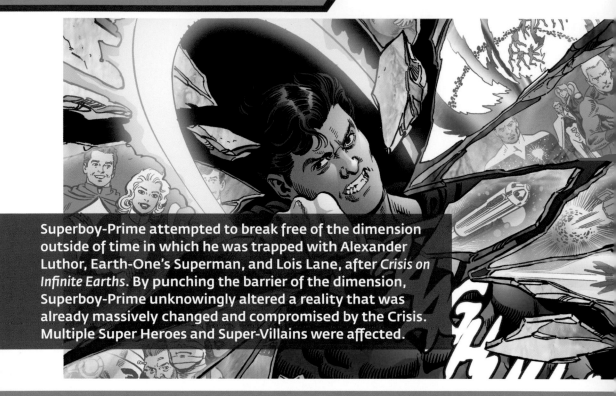

Superboy-Prime attempted to break free of the dimension outside of time in which he was trapped with Alexander Luthor, Earth-One's Superman, and Lois Lane, after *Crisis on Infinite Earths*. By punching the barrier of the dimension, Superboy-Prime unknowingly altered a reality that was already massively changed and compromised by the Crisis. Multiple Super Heroes and Super-Villains were affected.

CHALLENGERS OF THE UNKNOWN AND DOOM PATROL: Both teams saw their histories erased and restarted at a later point in time, as though they never existed in the world before.

GOG: The sole survivor of a nuclear disaster in the near future saw his life moved forward in time to a survivor of Imperiex's attack on Topeka, Kansas.

GREEN LANTERN: Hal Jordan now caused a drunk driving accident that left his best friend, Andy, paralyzed and forced him to juggle his early career as Green Lantern with a ninety-day prison sentence.

HAWKMAN: The transition of when Carter Hall stopped serving as Hawkman and Katar Hol came to Earth to assume the identity shifted and now included an interim Hawkman, Fel Andar.

JONAH HEX: The famed bounty hunter of the Old West found himself in a post-apocalyptic twenty-first century. Fortunately, his horseback riding skills prepared him for maneuvering on motorcycle.

THE LEGION OF SUPER-HEROES: Much of the Legion's troubled changes were due to Superboy-Prime's punches. It wiped out one Legion's entire reality, replacing them with a new Legion.

MAXWELL LORD: The onetime Justice League founder, who died and had his consciousness digitized and placed in a cybernetic body, was once again made flesh and bone.

METAL MEN: The team shifted from being metals made sentient with Doc Magnus's Responsometers to a group of humans who had their consciousness transferred into the metal robot bodies during a lab accident.

POWER GIRL: Kara's existence was folded into a reality. She was no longer the cousin of Superman, or Kryptonian at all, but instead a descendant of the Atlantean sorcerer Arion.

ROBIN: The deceased second Robin, Jason Todd, was resurrected in his coffin, though the world continued to believe he had died. Another punch changed Jason's history from being the redheaded son of acrobats to the troubled street kid with a criminal father and a drug-addicted mother.

SUPERMAN: Changes included the circumstances of his exodus from Krypton, the events of his debut as Superman in Metropolis, and the age of his adoptive parents.

DONNA TROY: The former Wonder Girl's reality shattered into many fragments that were difficult to reconcile. (See page 128 for details.)

DEEPLY ROOTED

The vast collective consciousness of the Green linked all plant life. Super Heroes and Super-Villains with chlorokinetic abilities all derived their power from the Green.

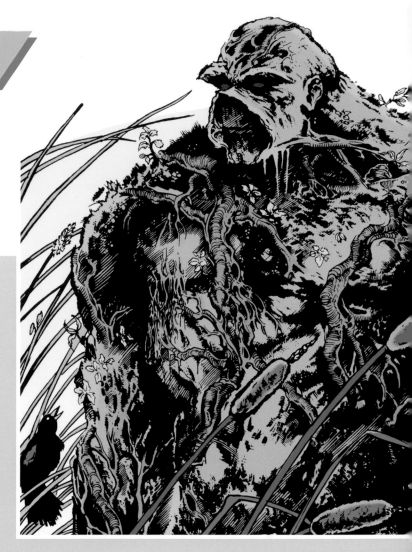

BLACK ORCHID: A legacy identity most recently belonging to Alba Garcia, who uniquely derived her power from both the Green and the Red (the force connecting all animal life).

BLACKBRIAR THORN: A druid high priest transformed into wood, with control over the elements.

CHLOROPHYLL KID: Ral Benem helped form the Legion of Substitute Heroes until his plant powers developed enough to earn him a spot on the main Legion.

DEADFALL: A murderous ten-foot-tall being made of thorny vines and wood.

DRYADS: Miniature plant-controlling beings from a dimension only accessible via plants.

FERAKS: Feral human/plant hybrids with poisonous thorns and nettles, who took refuge with Poison Ivy.

THE FLORONIC MAN: Scientist Jason Woodrue sacrificed his humanity in pursuit of the Green.

GOLDENROD: With the deadly pollen his body produced after a failed medical experiment, Frederick Delmar was nothing to sneeze at.

GREEN: The plant-powered member of the colorful Rainbow Raiders.

THE GRIM: Albertus Grimley went from scientist to plant monster with stem cells from Poison Ivy's creations.

HYATHIS: The conqueror queen of Alstair, who possessed mental control over the planet's vegetation.

JUNIPER: A winged government operative and minor avatar of the Green.

THE KING OF PETALS: Scientist Oleander Sorrel was the first avatar of the Green chosen by the Parliament of Flowers until he was devoured by the Floronic Man.

MALDITA TOXICOHEDRON: Two-headed, telepathic species plants able to grow to great sizes and have a taste for humans.

MAYFLOWER: A member of the Force of July who could control and accelerate the growth of plants.

NIGHTSHADE: The green-skinned scoundrel Ramulus was gifted with the ability to control vegetation by Aztec priestess Nyola.

PAPERCUT: Benedict Booker had the power to manipulate wood, but anything too heavy was hard to control.

THE PARLIAMENT OF FLOWERS: A new government party of the Green that blossomed following the destruction of the Parliament of Trees.

THE PARLIAMENT OF TREES: The governing party of plant elementals who served to protect the Green. It was founded 450 million years ago by Earth's first plant elemental, Yggdrasil, who created its next two members, Tuuru and Eyam. Subsequent members were Albert Hollerer, Bog Venus, Ghost Hiding in the Rushes, Great Url, Jack in the Green, Kettle Hole Devil, Lady Jane, and Saint Columba.

POISON IVY: The deadly Pamela Isley was alluring even without her pheromone control, and she'd fiercely protect plant life—as well as those she loved—at any cost.

RED ORCHID: Radiation from geothermal reactors transformed Chang Ming-Zu into a poisonous, plantlike being.

SCARLET ROSE: A mercenary with lethal proficiency in using plant life as weapons.

STAR-BLOSSOM: Aspiring Super Hero Peony McGill commanded flowers at will.

THE SPROUT: A seed of the Green's essence, given life as Swamp Thing's daughter, Tefé Holland. Her unusual physiology also gave her a connection to the Red.

SWAMP THING: The current avatar of the Green and protector of plant life, once a man named Alec Holland.

THORN: Rose Canton's split personality turned her into a villain with a control over thorny plants.

TOXIN: Isaac Fisher had the power to destroy plant life or spur its growth.

WOOD-KING: An Appellaxian who could transmute living beings into wood.

THE GREENEST LANTERNS
The Green Lantern Corps was home to multiple plant-based members.

APROS
CALLEEN
MEDPHYLL
MOTHER MERCY
OLAPET

BODY ART

Costumes weren't the only colorful flourishes for some Super Heroes and Super-Villains. Some opted for more permanence with tattoos.

AQUAMAN: The demigod Tangaroa gifted Aquaman with the markings of a hero for his efforts in defeating the primordial sea goddess Namma.

JOHN CONSTANTINE: Much of Constantine's body was covered in mystical tattoos, such as protective sigils, applied via the hand poke method.

EL DIABLO: Chato Santana's demonic tattoos were the source of his pyrokinetic powers.

GREEN LANTERN: Simon Baz's tattoo, Arabic for courage, shined brightly when he used his power ring.

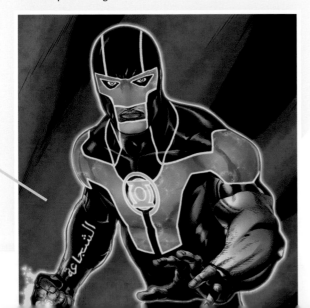

HACK: The Suicide Squad's resident hacker took her love of Harley Quinn very seriously with her tribute face tattoo.

IMPULSE: Bart Allen should have known his Green Lantern tattoo would quickly disappear, due to his speed-infused metabolism.

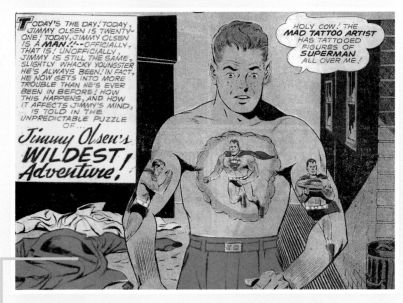

JIMMY OLSEN: Jimmy hallucinated that the Mad Tattoo Artist covered him in multiple Superman tributes.

STARMAN: Jack Knight possessed multiple tattoos until he was badly injured in space, and most of his body, skin included, had to be reconstructed using Rannian technology.

SUPERGIRL: Living in the Bottle City of Kandor, Supergirl had the word hope tattooed in Kryptonese on her back.

TATTOO: The second-in-command of Black Mask's False Face Society gang thanks to his permanent "mask."

TATTOOED MAN: Through the practice of "sin grafting" taught by the Kril Tribe of Modora, Mark Richards redeemed the souls of the people he killed with tattoos he could animate and control. He was the third villain known as Tattooed Man, but the first to try to change his ways.

WONDER GIRL: Wonder Girl was tattooed by Amazonian scientists with a maze of circuits, turning her into a human time machine, until she woke up and realized it was all a dream.

INK CULTURE

At any Justice League or Legion of Doom meeting, you're likely to spot more tattooed Super Heroes and Super-Villains, including the following:

ULYSSES HADRIAN ARMSTRONG
ARSENAL
CALENDAR MAN
CAPTAIN STRONG
GRACE CHOI
MANCHESTER BLACK
MATATOA
MISTER TERRIFIC
PIX
RAVEN
ROULETTE
EDOGAWA SANGAKU
SHADO
STARLING
TANNARAK
TATS
TEMPEST
T'OOMBALA
WEATHER WITCH

DEEP SCARS

These two members of Batman's Rogues Gallery preferred a more extreme form of body modification with their scarifications.

THE RIDDLER
VICTOR ZSASZ

OBJECTS OF GREAT POWER

Pray none of these objects ever fall into the wrong hands, or any hands, really. The results could be catastrophic if not handled with the utmost care.

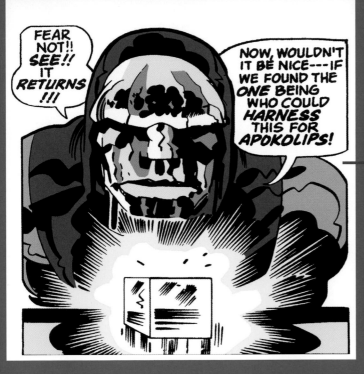

ABSORBASCON: Nth metal–based Thanagarian technology used for reading minds and projecting physical manifestations of one's thoughts.

ELEMENT X: The metal of the World Forge could reshape reality and powered much of the New Gods' technology.

THE ETERNITY BOOK: The demon Belial's book of spells and prophecies passed down to his son Merlin.

THE GREEN BELL OF UTHOOL, THE SILVER WHEEL OF NYORLATH, AND THE RED JAR OF CALYTHOS: Enchanted artifacts capable of unleashing the full power of the Demons Three—Abnegazar, Rath, and Ghast.

MAGEDDON: The war machine of the Old Gods compelled primal anger in its targets, unleashing a violent frenzy.

THE MEDUSA MASK: An emotion-manipulating mask capable of enslaving the entire world's population.

THE MIRACLE MACHINE: The all-powerful machine constructed by the Controllers turned any thought, big or small, into reality.

THE MOBIUS CHAIR: Once belonging to the Anti-Monitor, this thronelike device allowed those who sat upon it to travel and observe the universe, providing omniscience of all reality.

MOTHER BOX: A living computer used by the New Gods to accomplish pretty much anything. It was the ultimate smartphone crossed with a Swiss Army knife.

NTH METAL: A physics-defying, hyper-conductive metal, originating from the World Forge that harnessed the energies of the Dark Multiverse. It was the purest of metals, representing the brightness of possibility to combat the dark.

THE ORB OF RA: A scepter, fashioned from a fallen meteorite, whose radiation produced transmutative effects.

PANDORA'S BOX: A skull-shaped box that could contain the seven deadly sins and open a gateway to Earth-Three.

POWER RINGS: Rings used by the Green Lantern Corps and the other spacefaring corps to tap into the near-limitless energies of the Emotional Spectrum and create solid constructs.

SCARABS: Living weapons engineered by the Reach to infiltrate alien races. One such scarab, Khaji Da, bonded with Jaime Reyes, transforming the teenager into the third Blue Beetle.

THE SPEAR OF DESTINY: The spear used to pierce the side of Jesus Christ, which Hitler wielded to prevent America's heroes from intervening in World War II, lest they fall under his influence.

STARHEART: A sentient orb of magical energy gathered by the Guardians of the Universe, of which a fragment fell to Earth and became the source of power for Green Lantern Alan Scott.

THE SWORD OF SUPERMAN: A sword of ultimate purity forged at the dawn of existence that traveled billions of years until it arrived in Superman's hands.

THE TOTALITY: The oldest energy source in existence was the living power core from which the multiverse was sculpted.

THE TRIDENT OF NEPTUNE: Forged by Atlan, the first king of Atlantis, the trident offered divine rule and control of the seas.

THE WORLOGOG: A four-dimensional map of the universe from the big bang to the Omega Point, capable of warping space and time.

THE ANTI-LIFE EQUATION

A mathematical formula for absolute control, shattering free will and enslaving all exposed to it.

Loneliness + Alienation + Fear + Despair + Self-Worth
÷ Mockery ÷ Condemnation ÷ Misunderstanding
× Guilt × Shame × Failure × Judgment
$n = y$ where y = Hope and n = Folly
Love = Lies
Life = Death
Self = Dark Side

WHO REALLY RUNS THE WORLD?

World leaders and Super Hero teams took up most of the spotlight, but behind the scenes, numerous covert agencies pulled the strings.

CENTRAL BUREAU OF INTELLIGENCE: This small spy agency run by Sarge Steel possessed an impressive array of field agents, including Bronze Tiger, Richard Dragon, King Faraday, Arsenal, and Nightshade.

CHECKMATE: Succeeding the secretive Agency, this covert espionage group established by Amanda Waller as an independent branch of Task Force X featured an organizational hierarchy based on chess pieces. It was later reconfigured as a United Nations–chartered metahuman monitoring force.

DEFENSE DEPARTMENT INTELLIGENCE: This organization funded Alec and Linda Holland's research in creating the Bio-Restorative Formula.

DEPARTMENT OF EXTRANORMAL OPERATIONS: This federally mandated operation monitored every known metahuman in real time to assess for threats.

DEPARTMENT OF METAHUMAN AFFAIRS: This highly trained, combat-ready subdivision, overseen by Sarge Steel, was meant to ensure that the government and metahumans worked together.

KNIGHTWATCH: A military branch, these tactical squads in head-to-toe red armor were dispatched to combat imminent threats.

US ORGANIZATIONS

ADVANCED RESEARCH GROUP UNITING SUPER-HUMANS (A.R.G.U.S.): The prevailing intelligence and research agency monitored and acted upon metahuman and unnatural threats, which they neutralized and placed in classified research vaults.

ALL-PURPOSE ENFORCEMENT SQUAD (A.P.E.S.): This secretive multinational cooperative task force, with clearance from all other agencies, was headquartered within Mount Rushmore.

AMERICAN SECURITY AGENCY: The extreme right-wing organization that created Force of July, a patriotically themed super-team, authorized to perform covert missions for the good of the country.

THE BUREAU OF AMPLIFIED ANIMALS: Hidden away below the National Zoo in Washington, DC, the bureau, once run by Detective Chimp, gathered together beasts of unnaturally high intellects to help mankind.

GROUP FOR EXTERMINATION OF ORGANIZATIONS OF REVENGE, GREED, AND EVIL (G.E.O.R.G.E.): A covert security agency dating back to the Cold War.

HUMAN DEFENSE CORPS: Open exclusively to decorated vets who had faced alien campaigns, this military branch specialized in extraterrestrial and supernatural threats.

THE MACHINE: The black ops military outfit for the research and deployment of advanced technology and weaponry was located eight hundred feet below Utah's Salt Flats.

THE MEN FROM N.O.W.H.E.R.E.: An operation started during World War II that was dedicated to the eradication of all eccentricity and abnormality in the world.

PROJECT ATOM: The government initiative run by General Wade Eiling and scientist Dr. Heinrich Megala to develop metahumans who operated on behalf of the military.

PROJECT CADMUS: A scientific research organization specializing in genetic engineering. (See page 52 for details.)

PROJECT M: Beneath the Statue of Liberty, the World War II–era organization specializing in biotechnology and necromancy known as Project M was a literal monster factory run by Professor Mazursky.

SUPER-HUMAN ADVANCED DEFENSE EXECUTIVE (S.H.A.D.E.): Operating out of the miniaturized mobile Ant Farm and run by Father Time, S.H.A.D.E. specialized in threats supernatural, paranormal, and just plain weird.

TASK FORCE X: Following the Justice Society's retirement, President Truman formed Task Force X, a covert agency to tackle extraordinary threats both domestically and abroad.

ARGENT: The domestic branch of Task Force X.

SUICIDE SQUAD: Task Force X's covert group of ruthless and expendable agents who carry out the government's dirty work on behalf of Amanda Waller.

INTERNATIONAL ORGANIZATIONS

DÉPARTEMENT GAMMA: France's primary spy organization was founded by André Chavard, one of the original World War II–era Boy Commandos.

GLOBAL PEACE AGENCY: A group dedicated to the preservation of mankind.

HAMMER ORGANIZATION: A covert KGB organization feared even by its superiors in the Soviet Union.

OFFICE OF STRATEGIC SERVICES: The first official, centrally controlled international intelligence and espionage organization. Based out of secret headquarters in bombed-out London, it carried out covert campaigns in Europe during World War II.

RED SHADOWS: This KGB organization was the Soviet equivalent of—and response to—the Suicide Squad.

ST. HADRIAN'S FINISHING SCHOOL FOR GIRLS: Located in the English countryside, this "finishing school" was training grounds for Spyral or anyone else who wanted an elite assassin.

SPYRAL: A preeminent spy agency on the global stage founded by deranged Nazi scientist Doctor Dedalus.

T.H.E.Y.: A division of British intelligence that deployed agents such as the Hood to tackle situations that could lead to another world war.

WHO'S BEEN STUCK TO THE SOURCE WALL?

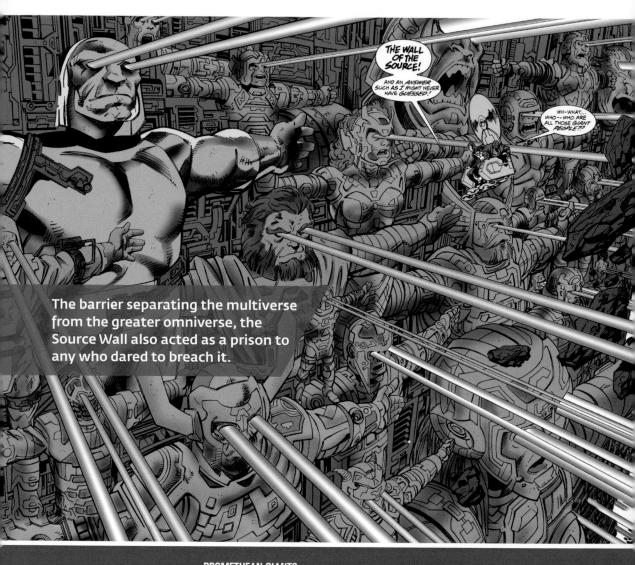

The barrier separating the multiverse from the greater omniverse, the Source Wall also acted as a prison to any who dared to breach it.

PROMETHEAN GIANTS: Perpetua's earliest life-forms were the basis for the Source Wall. Prodigian and Gedirath—two of the giants—were freed eons later, though Prodigian was later returned to the Wall.

LIGEA: This mysterious woman attempted to trick Orion into taking her place in the Wall.

EVE: A mysterious ancient god who was freed by Manchester Black. How she was imprisoned to start was unknown.

YUGA KHAN: Darkseid's father's effort to tear down the Source Wall got him stuck to it. He freed himself through sheer force of will, only to be imprisoned once more when he again tried to destroy the Wall.

HIGHFATHER: Highfather was deceived into entering the Wall by Darkseid, who wanted him out of the way.

DARKSEID: Darkseid's attempt to trap Highfather within the Source Wall backfired, imprisoning him as well. Later freed, he was imprisoned twice more—first when confronting Ares and again when Superman pinned him to the Wall.

S'IVAA: This ancient, world-destroying shadow elemental was knocked into the Wall by Superman and Orion, sealing a hole created by Darkseid.

ARES: The God of War sought to harness the Godwave but found himself instead defeated by a unity of every being in the universe, ensnaring him in the Wall.

ARZAZ AND THE NAMELESS ONE: Two Old Gods who survived the Ragnorak of the Third World were drawn into the Wall during their efforts to stop Ares.

SUPERMAN: In an effort to free Darkseid, Superman found himself trapped. An army of Supergirls freed him.

GOG: Gog had his severed—but still living—head brought to the Wall by Starman and Superman of Earth-22.

SUPERBOY-PRIME: No prison could hold the evil Superboy, but Supergirl and Superboy (Conner Kent) tried the Wall to keep him away from Earth for good.

RELIC: Survivor of a previous incarnation of the universe, Relic was sealed into the Wall by White Lantern Kyle Rayner.

BLACK HAND: After absorbing some of the Source Wall, only he could be used to heal a fissure in it.

OMEGA TITANS: The multiverse's first line of defense served to repair the damaged Source Wall by adhering themselves to it.

GREEN LANTERN (HAL JORDAN): In a future that didn't come to pass, Hal Jordan was placed in the Wall to prevent him from dying from injuries sustained in battle with the Black Lantern Corps.

JUST PASSING THROUGH
Not everyone was imprisoned in their efforts to enter the Source Wall. These individuals were able to pass through unhindered.

THE FLASH (BARRY ALLEN)
LUCIFER MORNINGSTAR
THE ONE (ZEUS, ODIN, ARES, HIGHFATHER, AND JOVE FUSED TOGETHER AS A SINGLE BEING)
THE SPECTRE (BOTH JIM CORRIGAN AND HAL JORDAN)
SUPERBOY-PRIME
SUPERMAN
WHITE LANTERN (KYLE RAYNER)

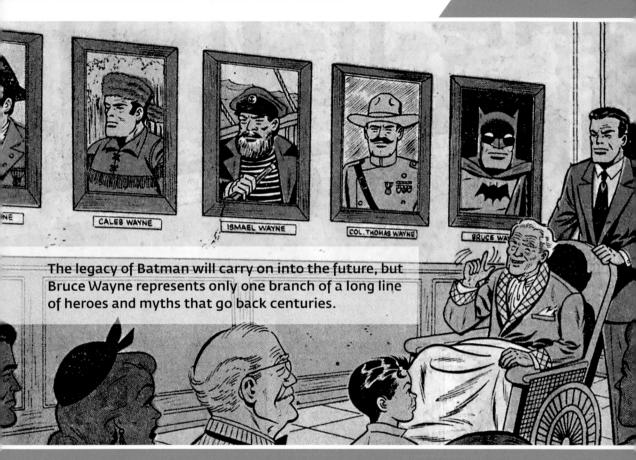

CALEB WAYNE

ISMAEL WAYNE

COL. THOMAS WAYNE

BRUCE WA

The legacy of Batman will carry on into the future, but Bruce Wayne represents only one branch of a long line of heroes and myths that go back centuries.

"THE BAT MAN": The legendary tenth-century Norse hero who partnered with the Viking Prince to defeat Hrothgar the frost giant.

LANCELOT WAYNE: A medieval Wayne who attempted to fly like a bat with a pair of homemade wings.

LORD HAROLD OF WAYNEMOOR: The unmarried first Lord of Waynemoor, whose castle was in northern England; killed by his brother, Lorin.

LORD LORIN OF WAYNEMOOR: Stole his brother's lordship, which he passed down to his descendants.

GEVAIN: A knight during the early Crusades, tasked with protecting the Holy Grail.

SIR GAWEYNE DE WEYNE: A fourteenth-century knight of the Scottish court who sacrificed his life.

CONTARF WAYNE: The first master of Castle Wayne in Inishtree, Scotland.

NATHANIEL WAYNE: A witch-hunter in the 1600s whose accusation of witchcraft against a woman led to a curse being placed upon him and his descendants.

"MAD" ANTHONY WAYNE: A hero of the Revolutionary War, known for his aggressive military campaigns.

DARIUS WAYNE: A Revolutionary War–era Wayne who commissioned a manor outside of Gotham City to be built by Nathan van Derm. Neither lived to see its completion.

GENERAL HORATIO WAYNE: Another Revolutionary War fighter.

THOMAS WAYNE (I): The black sheep of the family who, in 1765, summoned the demon Barbatos and received eternal life.

SILAS WAYNE (I): A silversmith accused of being a highwayman, but who was later cleared with the help of Benjamin Franklin and a time-traveling Dynamic Duo.

CHARLES ARWIN WAYNE: Built the family's wealth and presence in Gotham City in the early 1800s by buying up cheap land. He left his fortune to his two sons—Joshua and Solomon.

GENERAL HERKIMER WAYNE: A hero of the War of 1812.

CALEB WAYNE: A noted frontiersman.

SOLOMON ZEBEDIAH WAYNE: A Harvard graduate and federal judge who, along with his brother, used the caverns beneath the manor as part of the Underground Railroad. He and his second wife, Dorothea, had a son, Alan.

JOSHUA THOMAS WAYNE: Killed in 1860 by a bounty hunter during his time helping escaped slaves.

C. L. WAYNE: Used his wealth to establish Gotham Botanical Gardens in 1870.

ALAN WAYNE: Developed Gotham Railworks and established Wayne Industries. In the late 1800s, a chance encounter with a masked cowboy resulted in meeting his wife, Catherine.

CATHERINE VAN DERM: Saw the completion of Wayne Manor with Alan, but soon after died during the birth of their son, Kenneth.

CAPTAIN ISHMAEL WAYNE: A great whaler of his time.

WINSLOW WAYNE: Fought alongside Teddy Roosevelt in the Spanish-American War.

KENNETH WAYNE: Established Wayne Chemicals, the family's most profitable venture, but passed away at a young age, leaving the company to his wife, Laura.

LAURA ELIZABETH WAYNE: Successfully ran Wayne Industries while also being a key figure in Gotham City's prohibition movement and raising her sons, Patrick and Silas.

PATRICK MORGAN WAYNE: Established WayneTech, whose aircrafts and ships aided the United States' efforts in World War II. He and his wife (name unknown) had two children, Agatha and Thomas. (Note: He has been identified as Anthony Thomas and Jack in previous time lines.)

SILAS WAYNE (II): He often chastised his playboy great-nephew, Bruce, for not living up to the Wayne name until he learned on his deathbed that Bruce was Batman.

ABIGAIL WAYNE AND BENJAMIN WAYNE: Contemporaries of Patrick and Silas, both interred in the Wayne family cemetery plot.

AGATHA WAYNE: As an old woman, she accidentally discovered that her nephew and his ward were Batman and Robin, and helped foil a robbery.

THOMAS WAYNE (II): Renowned surgeon and philanthropist who performed missionary work in the Caribbean before returning to Gotham City to attend medical school and marrying Martha Kane.

MARTHA KANE: Heir to the Kane Chemicals fortune. Three years after the birth of their son, Bruce, Martha lost her second child as a result of injuries from a car accident.

KATHERINE "KATE" KANE: The daughter of Martha Kane's brother, General Jacob Kane, who followed in her cousin's footsteps as Batwoman.

MARY ELIZABETH "BETTE" KANE: Another of Bruce's cousins on his mother's side. She served as a hero across the shifting time lines, as Bat-Girl, Flamebird, and Hawkfire.

LOST FAMILY

Not all members of the Wayne clan made it through the various crises in time, which later established Bruce as the sole living member of the Wayne family.

BRUCE N. WAYNE: Thomas Wayne's cousin, Bruce's namesake, and one of the country's greatest private detectives.

LORD ELWOOD WAYNE: Bruce's great-uncle and Lord of Waynemoor Castle.

THE REVEREND EMELYN WAYNE: A missionary in Asia.

JANE WAYNE: Bruce's cousin.

JEREMY WAYNE: An Australian ranch hand.

JUNIOR WAYNE: Jane's son, who nearly revealed Bruce's secret identity to his mother.

PHILIP WAYNE: Thomas Wayne's brother and Bruce's uncle. (Note: In a new time line, he was Martha's brother, Philip Kane.)

VANDERVEER "VAN" WAYNE: A rambunctious younger cousin of Bruce, who often found himself in trouble.

WILHEMINA WAYNE: A half-Dutch orphan from South Africa.

ME AM THE WORST BIZARROS

The backward-speaking imperfect duplicate of Superman, known as Bizarro, spawned an entire square-shaped planet, Htrae, with a population that truly went from bad to worse.

AL BIZARRO: A failed attempt at cloning by Lex Luthor and Sydney Happersen, Al Bizarro—based on the genetic samples of a LexCorp employee who resembled Superman—became a famous musician under the name Al Pokolips before settling down with a family.

BIZARRO JR.: The son of Bizarro and Bizarro Lois Lane was born resembling a human, for which he was shunned on Htrae. His parents exiled him to Earth but took him back after Supergirl's botched science experiment transformed him into a "normal-looking" Bizarro.

BIZARRO AMAZO: This duplicate of the power-stealing android liked giving powers out to anyone and everyone, even if they were ill equipped to wield them.

BIZARRO BRAINIAC: The dumbest Bizarro of all.

BIZARRO LEAGUE: The defenders of Htrae included a member of tht Sinestro Corps; a Wonder Woman who loved to be tied up with her lasso; a Flash who incredibly was slow and got winded easily; a Hawkgirl who only ever bellowed a shrill "Skrreeeeechh"; and an unnervingly happy Batman who liked to play.

BIZARRO SUPERGIRL: A clone of Linda Danvers who was created and controlled by the villains Buzz and Two-Face, and later discovered she loved being electrocuted.

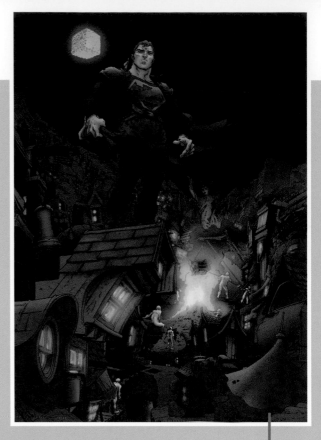

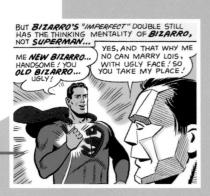

But *BIZARRO'S* "*IMPERFECT*" DOUBLE STILL HAS THE THINKING MENTALITY OF *BIZARRO*, NOT *SUPERMAN*...

ME *NEW BIZARRO*... HANDSOME! YOU *OLD BIZARRO*... UGLY!

YES, AND THAT WHY ME NO CAN MARRY LOIS, WITH UGLY FACE! SO YOU TAKE MY PLACE!

NEW BIZARRO (A.K.A. HANDSOME BIZARRO): When Bizarro turned Lex Luthor's duplicator ray on himself, New Bizarro was created. This duplicate was exactly like Bizarro except for one key difference—he was as handsome as Superman.

ZIBARRO: The most tragic of all the Bizarros, Zibarro was a one-in-five-billion fluke. He possessed a high intellect and a love for the arts, of which there were none on Htrae.

WHO ELSE WEARS THE S?

Superman's emblem, the Kryptonian symbol for hope and his family crest, has been worn by heroes who adopted his ideals, as well as villains who sought to pervert them.

SUPER HEROES
BIBBO BIBBOWSKI
LINDA DANVERS (SUPERGIRL)
DRAAGA
CALVIN ELLIS (SUPERMAN OF EARTH-23)
ERADICATOR
JOHN HENRY IRONS (STEEL)
NATASHA IRONS (STEEL)
KALEB OF HYDROS
CONNER KENT (SUPERBOY)
LOIS LANE
LUCY LANE (SUPERWOMAN)
LANA LANG (SUPERWOMAN)
LEX LUTHOR (HERO AT THE TIME, AT LEAST)
MATRIX (SUPERGIRL)
MON-EL
JIMMY OLSEN
SCORN
STRANGE VISITOR
KRISTIN WELLS (SUPERWOMAN)
KARA ZOR-EL (SUPERGIRL)

SUPER-VILLAINS
CHEMO
COMPOSITE SUPERMAN
CYBORG SUPERMAN
KING KRYPTON THE SUPER-GORILLA
PREUS
SAVIOR
SUPERBOY-PRIME

UNCLASSIFIABLE
TROY MAGNUS

JUSTICE LEAGUE HEADQUARTERS

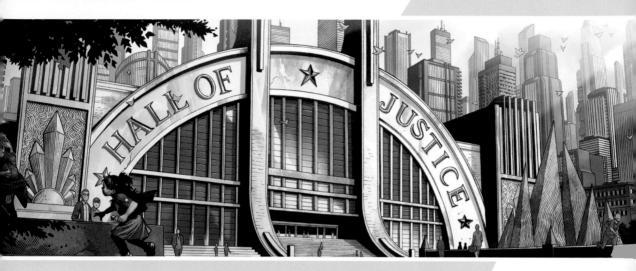

Every major iteration of the Justice League maintained a base of operations that suited their needs and was as iconic as the League itself.

SECRET SANCTUARY

Move-in Date: *Brave and the Bold* #28 (March 1960)

Discovered by Aquaman, the Justice League's first headquarters was located within the hollowed-out Mount Justice in Happy Harbor, Rhode Island. It subsequently served as a base of operations for the Doom Patrol, time-displaced Legion of Super-Heroes, Young Justice, the Justice Society, the Justice Foundation, and even the Injustice Gang.

THE SATELLITE

Move-in Date: *Justice League of America* #78 (February 1970)

In a polar orbit 22,300 miles above the Earth, this six-level satellite was accessible to the League via Thanagarian teleportation tubes. It was rendered inoperable during the Earth-Mars War and ultimately obliterated during the Crisis.

THE BUNKER

Move-in Date: *Justice League of America Annual* #2 (October 1984)

An elaborate, high-tech fortress and bomb shelter, beneath an abandoned factory on the Detroit River, built by Hank Heywood Sr. and gifted to his grandson Hank Heywood III (successor to the Steel mantle), who used the headquarters to barter his membership to the Justice League. It offered a sense of community within the neighborhood, with the ground level perfect for block parties.

THE EMBASSIES

Move-in Date: *Justice League International* #8 (December 1987)

Officially chartered by the United Nations, the Justice League established embassies worldwide. The primary locations were a run-down two-story brownstone in New York City and a gorgeous mansion in Paris. Other embassies were found in Lisbon, Tokyo, Moscow, London, Rome, Canberra, Potsdam, and Antarctica. Quick transportation between embassies was possible with teleporters, which were often unreliable.

THE REFUGE

Move-in Date: *Justice League America* #0 (October 1994)
A repurposed escape pod from the Overmaster's ship became a new orbiting headquarters. To reach it, members were required to be in designated locations for pickup via tractor beam.

THE WATCHTOWER

Move-in Date: *JLA* #4 (April 1997)
Nestled near the Posidonius crater located in the Mare Serenitatis area of the moon, this fortress was a highly advanced wonder, constructed of promethium and later upgraded by with New Genesis technology.

THE HALL OF JUSTICE AND THE WATCHTOWER SATELLITE

Move-in Date: *Justice League of American* #7 (May 2007)
The Hall of Justice was erected in Washington, DC, on the site of the Justice Society's and the All-Star Squadron's original headquarters. Wonder Woman and Green Lantern John Stewart designed the awe-inspiring structure, which was accompanied by a new Watchtower satellite accessible via advanced Slideways technology.

JUSTICE LEAGUE SOJOURNS

The Justice League had many offshoots, which were often short-lived. During their tenures, they managed to find unique headquarters to call their own.

TASK FORCE ISLAND

Move-in Date: *Justice League Task Force* #0 (October 1994)
This island off the coast of the Carolinas was once owned by Professor Ivo. It was littered with discarded robot creations, which were repurposed for training exercises.

MOUNT THUNDER

Move-in Date: *Extreme Justice* #0 (January 1995)
Led by Captain Atom, this no-nonsense and—ahem—extreme team used an abandoned military base in Colorado as their headquarters.

A.R.G.U.S.

Move-in Date: *Justice League of America* #2 (May 2013)
When Amanda Waller and Steve Trevor wanted a Justice League they could control, they used the A.R.G.U.S. headquarters in Washington, DC.

THE HOUSE OF MYSTERY

Move-in Date: *Justice League Dark* #10 (August 2013)
The first iteration of Justice League Dark took up residence in the fabled House of Mystery.

JUSTICE LEAGUE OF CHINA HQ

Move-in Date: *New Super-Man and the Justice League of China* #20 (April 2018)
Originally based in the Oriental Pearl Tower in Shanghai, the Justice League of China relocated to a gorgeous old monastery.

BRAINIAC SKULL SHIP

Move-in Date: *Justice League Odyssey* #1 (November 2018)
Brainiac's skull-shaped spaceship was commandeered by the spacefaring group of Justice Leaguers.

DC'S FELINES

Krypto the Super-Dog wouldn't stand a chance against this army of cats.

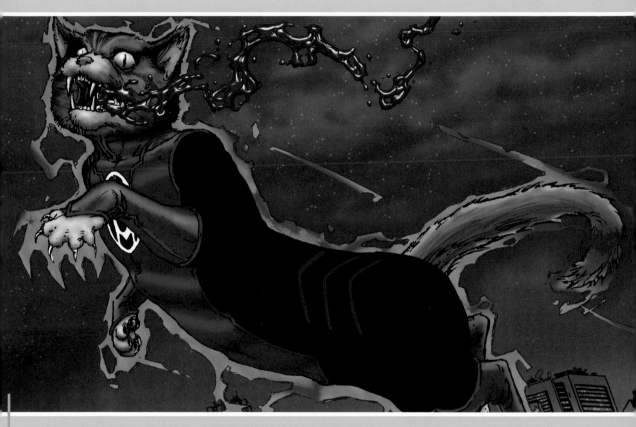

ALFRED: A gift from Alfred the butler, this feisty little fur ball helped soften the hard-hearted Damian Wayne.

ALLEY-KAT-ABRA: Felina Furr served with the Zoo Crew of Earth-C with her magic wand, which she referred to as Magic Wanda.

BAST (BASTET): Many aspects of the Egyptian goddess of cats have taken form over the years. One served as one of the matrons of the Amazons of Bana-Mighdall. Another attempted to obtain the key to Hell from Lord Morpheus in the Dreaming. Most recently, she helped guide Khalid Nassour toward becoming Doctor Fate.

DEX-STARR: Homeless after witnessing his owner's murder, a sweet cat named Dexter was nearly killed by a couple of creeps until a Red Lantern ring transformed him into the rage-spewing Dex-Starr.

GALENTHIAS: An Amazonian priestess who sacrificed her human form to better serve Hecate, the Greek goddess of magic and witchcraft (no relation to Catwoman's pet).

HECATE: Catwoman had many cats over the years, but the first one with a name was the trusty Hecate, who was trained to help spring her from jail.

LOTION: Once belonging to Doom Patrol member Casey Brinke, Lotion was fed a mysterious substance by an even more mysterious person in an astronaut suit and transformed into a leather-jacket-wearing cat-human hybrid.

MEMAKATA: The companion to supernatural sleuth Mark Merlin, who could transfer his life-form into the feline with a mystic cat charm.

MERLIN: A fiercely loyal spotted leopard belonging to Baron Winters, this feline was a gift from the wizard Merlin, for whom he was named.

PROWLEY: Belonging to blind mystic Cassandra Craft, this black cat had the peculiar ability of speaking in hieroglyphics and the penchant for peeing on the dreams of people he liked.

SMOKEY: There was no greater sign of Cyborg's heart than the affection he showed to his gray cat, Smokey.

SOCKS: Ignatius left his position within the Parliament of Limbs to accompany Animal Man in protecting his daughter, Maxine. Young Maxine decided Socks was a much better name for a cat than Ignatius.

STARRO: Snapper Carr's adorable white cat, Starro was named after the Justice League's very first foe.

STINKY: This mangy, one-eyed alley cat was genuinely disliked by pretty much every Justice Leaguer, except Power Girl, who named him after his characteristic odor. He nearly suffocated The Flash by sleeping on his face while he napped.

STREAKY: Exposure to X-Kryptonite temporarily granted superpowers to this orange cat with lightning bolt–like white stripes running down both sides of his body. He became a founding member of the Legion of Super-Pets.

TAWKY TAWNY: This tweed-clad humanoid tiger was a frequent ally of Shazam. His varying origins included being a normal tiger transformed by a potion given to him by an old hermit in the jungles of India, a children's doll brought to life, and a citizen of the Wildlands.

TEEKL: Typically found nestled on the shoulders of Klarion the Witch Boy, Teekl could grow as large as a tiger and through ritual dance was able to transform into a cat-human hybrid.

WHIZZY: The thirtieth-century telepathic descendant of Streaky.

TALK LIKE A CZARNIAN

Lobo, the last Czarnian, wasn't one to get into a conversation with, unless you were planning to exit without a spine, but he certainly had a colorful assortment of word choices. Try speaking his language and you might just live a few minutes longer.

In case you don't know who you're dealing with, it's important to first take note that Lobo's name—translated from a Khundian dialect—means "He who devours yer entrails an' enjoys it."

BASTICH: A slang insult for a despised person.

CLYDE: An informal identifier used for just about anyone. It likely had a negative connotation, but it's even more likely that Lobo couldn't be bothered to learn anyone's name.

FEETAL'S GIZZARD: This expletive interjection was often shortened to "Feetal's gizz." Feetal's identity was largely unknown, as was the reason his gizzard was so special, though Webster's Standard Galactic Dictionary does make mention of an ancient Curse of Feetal.

IZZATAFACT?: A colloquial rhetorical question.

ON TOAST: A qualifier of severity, used in phrases such as "Holy frag on toast" or "Feetal's gizz on toast."

RAT'S DROOL: Disgusting beer, most likely brewed in England.

SKRAG: A verb meaning "to kill."

STONKIN': A descriptive adjective used to express something great or fun. For example, "Who'd ever thunk these comic dweebs coulda got their act together ta throw a stonkin' bash like this?"

LOBO'S REPERTOIRE OF INSULTS

Try dishing them out as well as he did:

BOZOID
COFFIN-BREATH
DWEEBS
FEEB-BUTT
LAME-O
JERK
SCUZZ
SUCKER

GUESS I SHOULDN'TA SAID THAT, HUH?

THE LEGACY OF EARTHBORN GREEN LANTERNS

An incalculable number of beings from throughout 3,600 sectors of the universe served as members of the Green Lantern Corps. For a planet generally regarded as primitive and unspectacular, Earth produced many great Green Lanterns known across the universe.

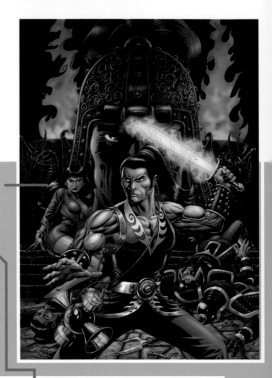

JONG LI: In 660 CE, Jong Li, a Chinese monk, received a power ring. With it, Jong Li was able to defeat a corrupt emperor and help install a benevolent one in his place. He was the last of the world's Dragon Lords and the first of its Green Lanterns.

LORD MALVOLIO: A son of an alien Green Lantern father and a human mother, Lord Malvolio was born in the 1600s. He murdered his father and used his ring to travel to Space Sector 1634, which he sought to rule like a deity.

WAVERLY SAYRE: A frontiersman in the early 1800s, Waverly Sayre lost the will to live after his wife died during childbirth. Given a renewed purpose in the Corps, he ventured beyond the Susquehanna River to far alien worlds.

DANIEL YOUNG: In 1873, Green Lantern Abin Sur landed on Earth to recuperate from a space battle. He deputized Montana sheriff Daniel Young to serve in his place while he recovered.

ALAN SCOTT: A fragment of the Starheart fell to Earth as a meteorite and was shaped into a lantern over the centuries. It came into the possession of Alan Scott during a train crash in the 1940s. The lantern instructed Alan to fashion a ring from its metal, which he used to become Green Lantern.

KIM TRAN: Kim Tran was a beacon of strength to both her Vietnamese family, whom she brought to the United States during the height of the Vietnam War, and to her teammates on the Green Lantern Corps, who regarded her as one of best of their ranks.

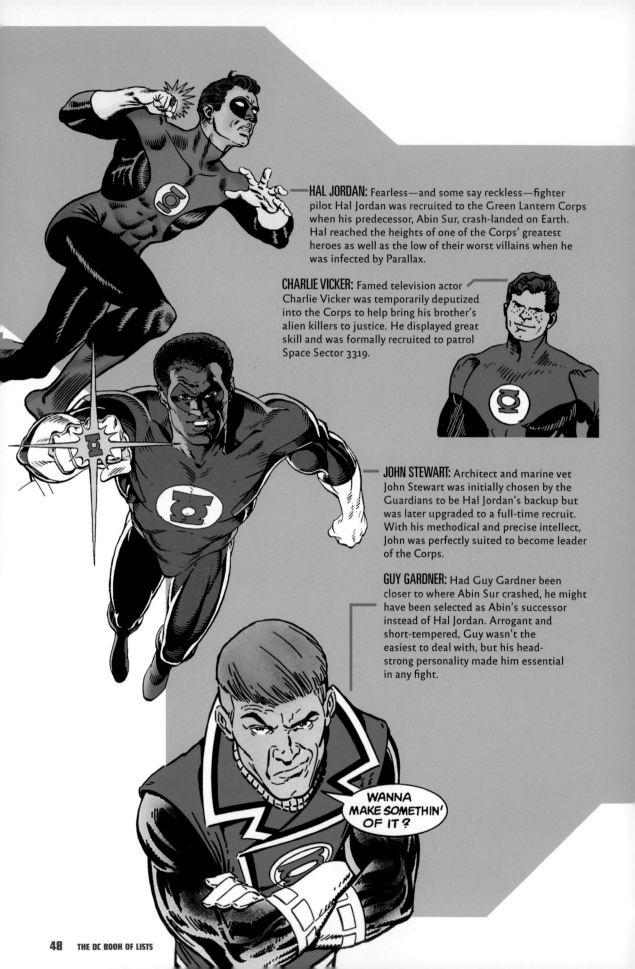

HAL JORDAN: Fearless—and some say reckless—fighter pilot Hal Jordan was recruited to the Green Lantern Corps when his predecessor, Abin Sur, crash-landed on Earth. Hal reached the heights of one of the Corps' greatest heroes as well as the low of their worst villains when he was infected by Parallax.

CHARLIE VICKER: Famed television actor Charlie Vicker was temporarily deputized into the Corps to help bring his brother's alien killers to justice. He displayed great skill and was formally recruited to patrol Space Sector 3319.

JOHN STEWART: Architect and marine vet John Stewart was initially chosen by the Guardians to be Hal Jordan's backup but was later upgraded to a full-time recruit. With his methodical and precise intellect, John was perfectly suited to become leader of the Corps.

GUY GARDNER: Had Guy Gardner been closer to where Abin Sur crashed, he might have been selected as Abin's successor instead of Hal Jordan. Arrogant and short-tempered, Guy wasn't the easiest to deal with, but his headstrong personality made him essential in any fight.

WANNA MAKE SOMETHIN' OF IT?

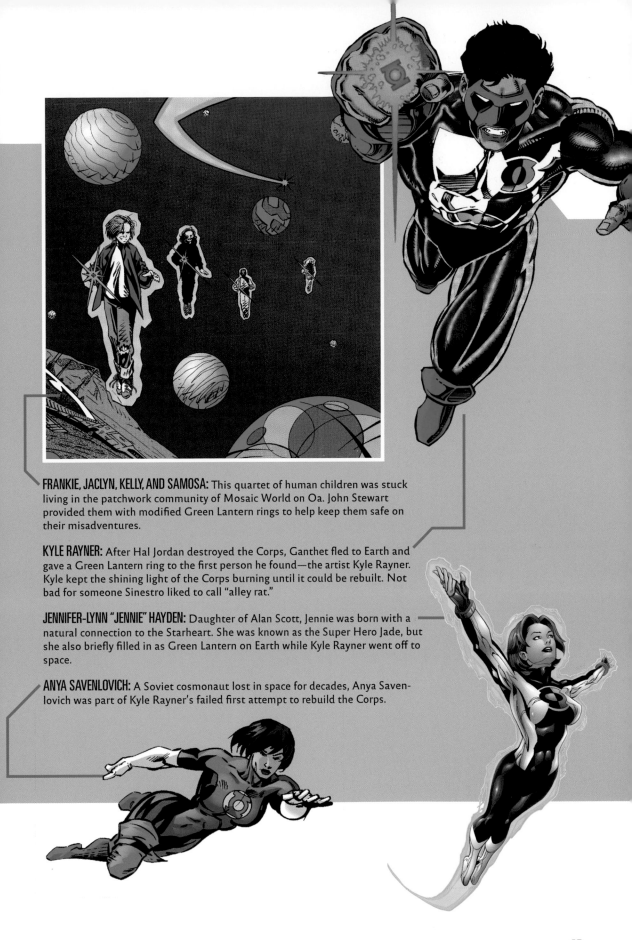

FRANKIE, JACLYN, KELLY, AND SAMOSA: This quartet of human children was stuck living in the patchwork community of Mosaic World on Oa. John Stewart provided them with modified Green Lantern rings to help keep them safe on their misadventures.

KYLE RAYNER: After Hal Jordan destroyed the Corps, Ganthet fled to Earth and gave a Green Lantern ring to the first person he found—the artist Kyle Rayner. Kyle kept the shining light of the Corps burning until it could be rebuilt. Not bad for someone Sinestro liked to call "alley rat."

JENNIFER-LYNN "JENNIE" HAYDEN: Daughter of Alan Scott, Jennie was born with a natural connection to the Starheart. She was known as the Super Hero Jade, but she also briefly filled in as Green Lantern on Earth while Kyle Rayner went off to space.

ANYA SAVENLOVICH: A Soviet cosmonaut lost in space for decades, Anya Savenlovich was part of Kyle Rayner's failed first attempt to rebuild the Corps.

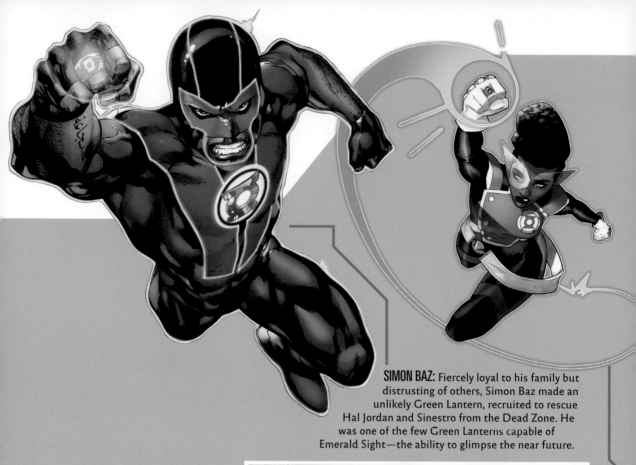

SIMON BAZ: Fiercely loyal to his family but distrusting of others, Simon Baz made an unlikely Green Lantern, recruited to rescue Hal Jordan and Sinestro from the Dead Zone. He was one of the few Green Lanterns capable of Emerald Sight—the ability to glimpse the near future.

JESSICA CRUZ: Suffering from crippling anxiety, Jessica Cruz was the unwitting recipient of the fear-powered Ring of Volthoom from Earth-Three. After the ring was destroyed in a battle with Darkseid and his daughter, Grail, Jessica was rewarded with a new Green Lantern ring.

KELI QUINTELA: With a power gauntlet gifted from a dying Green Lantern, eleven-year-old Bolivian girl Keli Quintela became Teen Lantern. Self-taught in wielding the gauntlet, Keli hoped to join the Justice League, but fell in with Young Justice instead.

SOJOURNER MULLEIN: After Sojourner "Jo" Mullein was unjustly fired from the New York City Police Department, she was recruited for the Corps with a unique order—she was assigned to a far-out, unnumbered sector of space where she had one year to make her mark with the power ring. Jo didn't even need six months.

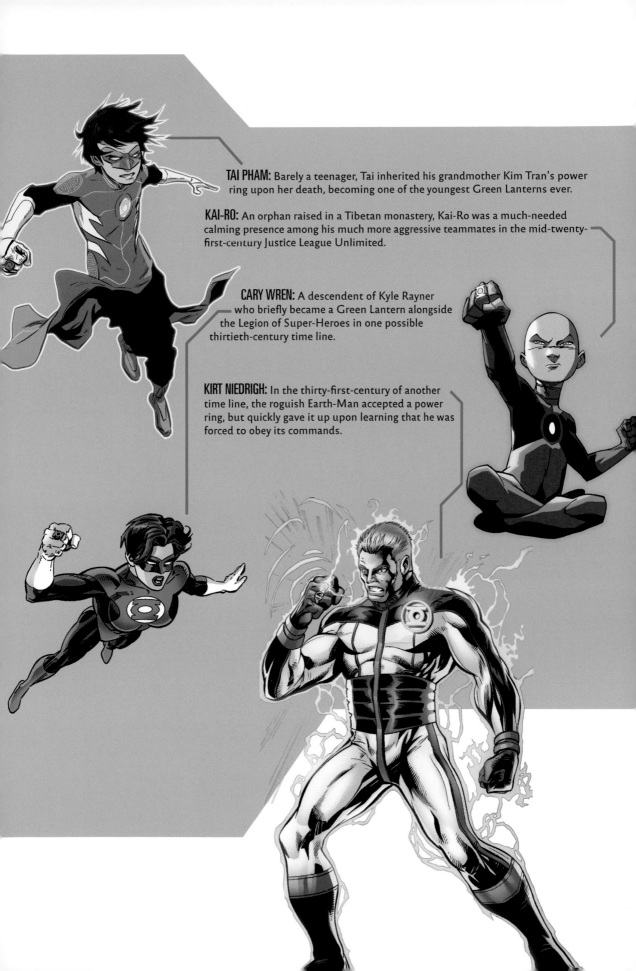

TAI PHAM: Barely a teenager, Tai inherited his grandmother Kim Tran's power ring upon her death, becoming one of the youngest Green Lanterns ever.

KAI-RO: An orphan raised in a Tibetan monastery, Kai-Ro was a much-needed calming presence among his much more aggressive teammates in the mid-twenty-first-century Justice League Unlimited.

CARY WREN: A descendent of Kyle Rayner who briefly became a Green Lantern alongside the Legion of Super-Heroes in one possible thirtieth-century time line.

KIRT NIEDRIGH: In the thirty-first-century of another time line, the roguish Earth-Man accepted a power ring, but quickly gave it up upon learning that he was forced to obey its commands.

GENETIC DOUBLE TAKES

Nothing exemplified humankind's penchant for playing god more than the exploration of cloning. Even though the process rarely went well, scientists all over kept trying to get it right.

PROJECT CADMUS CLONES

The scientific research laboratory was founded by Drs. Reginald Augustine, Thomas Tompkins, and Dabney Donovan. Cadmus created numerous new modified life-forms, including Step-ups (humans with evolved knowledge), DNAliens (hybrid life-forms), and traditional human clone duplicates.

ANOMALY AND CAULDRON: Two experiments that turned to crime with the enhancements they were given.

DUBBILEX: A horned telepathic DNAlien who became one of Cadmus's most valued employees.

- **ALEX:** An evil clone of Dubbilex with a splash of Kryptonian DNA thrown in.

THE GUARDIAN: This clone of the Golden Age hero Jim Harper, who possessed a perfect genetic structure, oversaw security at Cadmus.

- **ADAM:** A clone created from the combined DNA of the Guardian and Dubbilex.

- **AURON:** A clone augmented with a computer mind and a body built for space travel.

- **GWENDOLINE HARPER:** A clone raised as the Guardian's daughter.

THE HAIRIES: A group of Step-ups who used their abilities to create advanced technology.

MOKKARI AND SIMYAN: Two more of Donovan's horrific experiments, they struck out to perform their own genetic tinkering.

THE MONSTERS OF TRANSILVANE: Donovan's creatures inspired by classic movie monsters, who inhabited the miniature planet Transilvane.

THE NEWSBOY LEGION: A rambunctious group of kids cloned from the ragtag gang of orphans who grew up to work at Cadmus.

RIPJAK: A creation of Donovan, made using samples of blood believed to belong to Jack the Ripper.

SUPERBOY: Also known as Project 13, Cadmus's attempt to create a replacement Superman after the Super Hero died, made from the combined DNA of Superman and Lex Luthor.

THE UNDERWORLDERS: A group of Donovan's creatures deemed failures. Led by Clawster, they took refuge in the sewers and tunnels beneath Metropolis.

THE EVIL FACTORY

A rival of Project Cadmus, run by Mokkari and Simyan at the behest of Darkseid.

BATMAN CLONES: Considered failed experiments because the trauma that shaped Batman was too much for them.

THE FOUR-ARMED TERROR: A multi-limbed monster that fed off nuclear radiation.

JIMMY OLSEN CLONE: A hulking beast coated in Kryptonite.

MORGAN EDGE: A clone of the head of Galaxy Communications who took over running the company.

DABNEY DONOVAN

Outside of Cadmus, the mad scientist specialized in growing new bodies . . . for a price.

LEX LUTHOR: Dying of cancer, Luthor needed a new body.

MOXIE MANNHEIM AND INTERGANG: The crime boss and his crew needed to combat the ravages of aging.

THE AGENDA

A shadowy organization that sought to capitalize off clones, selling them to the highest bidder.

GROKK THE LIVING GARGOYLE: A flying, fire-breathing gargoyle.

MATCH: A clone of Superboy whose mental and physical state deteriorated. He was used to create another three evil Superboys.

THE COUNCIL

A secret group of some of the world's top minds, the Council sought to save mankind from itself.

MANHUNTER: Hero Paul Kirk was chosen as the genetic template for the Council's clone army.

SPORTSMASTER: This sports-themed criminal was used as the next genetic template.

KRYPTONIAN CLONES

Genetic exploration was always a critical component of scientific endeavors on Krypton.

DOOMSDAY: A life-form designed to survive the harshest of environments. Each time the subject was destroyed, it was cloned again and made stronger.

H'EL: A being created by Jor-El to skirt the Kryptonian law banning manned space travel.

KON: A clone who led a rebellion to free his people from servitude.

OTHER NOTABLE CLONES

BIZARRO: The failed clone of Superman, attempted by Lex Luthor.

FLORA BLACK AND SUZY: Half-human and half-plant hybrid clones of the original Black Orchid, Susan Linden.

THE CHILDREN OF KAIZEN GAMORRA: Despot ruler of Gamorra, Kaizen created an army using his DNA and that of his family.

DARK KNIGHT: A clone of Batman's loyal butler, Alfred Pennyworth, created by the mysterious Briar.

DIVINE: A clone of Power Girl, created by Doctor Sivana and Maxwell Lord.

DNANGELS: A trio of government agents.

- **CHERUB:** A mixture of Impulse and Superboy's deceased girlfriend, Tana Moon.

- **EPIPHANY:** Based on Wonder Girl.

- **SERAPH:** Derived from Superboy.

JOE GARDNER: An exact duplicate of Guy Gardner, created by the alien Draal.

HERETIC: A clone of Damian Wayne—gestated in the body of a whale—produced by his mother, Talia.

ADOLF HITLER CLONE: Baron Bedlam brought his idol back to life, but the clone would rather die than be anything like the original.

JUSTICE LEAGUE 3000: Using a new technique in which human hosts were injected with a serum that rewrote their DNA, Ariel Masters and the Magnus twins re-created the Justice League in the thirty-first century.

KANCER: A sentient Kryptonite-induced cancer extracted from Superman's body.

THE MASTER'S CLONES: The villainous Master created clone soldiers to do his bidding. (He learned at Cadmus, of course.) These clones included Blade, Blue Damsel Fly, Coil, Darkstar, Fire Devil, Marauder, and the group known as the Evil Eight.

RĀ'S AL GHŪL'S ASSASSINS: Using his own genetic material, Rā's sought to create the perfect assassin, resulting in clones including the Silencer, Raze, and Smoke.

SLOBO: A smaller and weaker duplicate grown from a droplet of Lobo's blood.

SUPERLAD: A clone of Supergirl created by Dr. Forte at Vandyre University.

SVAROZHICH: A soulless, inhuman clone of Firestorm, created by Russian scientists.

THADDEUS THAWNE II: When thirtieth-century President Thawne couldn't recruit Impulse to his cause, he made his own.

VELOCITY: A clone of the original Flash, Jay Garrick, created by Brain and Monsieur Mallah.

CHILL OUT

Try to avoid a brain freeze keeping these ice-based Super Heroes and Super-Villains straight, ranked by their notoriety.

GLACIER LEVEL

CAPTAIN COLD: With little more than a cold gun, a parka, and a bad attitude, Leonard Snart was a constant source of trouble for The Flash, leading the Rogues on their crime sprees.

CYTHONNA: The Kryptonian goddess of ice, Cythonna was one of the most formidable foes Superman ever had to face.

FROST KING: An exiled Norse god with the ability to control entire ecosystems, who was defeated a millennium ago by Hippolyta, Black Adam, Swamp Thing, and the Viking Prince, only to return with a vengeance.

ICE: Norwegian Tora Olafsdotter was born with her cryogenic powers. First known as Icemaiden, Tora shortened her superhero name after she and her frequent ally Fire joined the Justice League International.

KILLER FROST (III): The lab accident that gave Dr. Caitlin Snow her cryo-powers also left her needing to absorb others' body heat to survive. Once a villain, she since changed her ways to join the Justice League of America.

MR. FREEZE: Bathed in cryo-chemicals in a lab accident, Dr. Victor Fries needed to wear a sophisticated refrigeration suit to survive at normal temperatures. He carried out his crimes with an impressive array of freeze guns.

BLIZZARD LEVEL

ICEMAIDEN: The first Icemaiden, Sigrid Nansen, was forced by her mother into an experiment to replicate powers of a mythical tribe of ice-people.

ICICLE: Armed with a cold ray gun, physicist Dr. Joar Mahkent plagued Green Lantern Alan Scott in the 1940s.

KILLER FROST (I): Thanks to—you guessed it—a lab accident, Dr. Crystal Frost transformed into the heat-absorbing, cryo-powered Killer Frost.

FLURRY LEVEL

COLDSNAP: This cryo-powered mercenary was typically paired with the pyrokinetic Heatstroke—his partner in crime and in romance.

ENDLESS WINTER: An actress turned evil organ-harvester, Delores Winters went after Icemaiden for her beautiful skin. To her surprise, some of Icemaiden's powers came with it.

ICICLE (II): With his DNA altered from exposure to his father's cold ray gun, Cameron Mahkent possessed natural cryo-powers as well as his father's penchant for evildoing.

ICICLE (III): Granddaughter of the original Icicle, Doyle Christie hoped to redeem the name by using a cold ray gun to fight crime rather than commit it.

KILLER FROST (II): After Crystal Frost died, Dr. Louise Lincoln repeated the process that gave Frost her powers and assumed the villainous mantle of her deceased friend.

MINISTER BLIZZARD: Hailing from the hidden kingdom of Iceberg-Land, Minister Blizzard used a climate-changing machine to crash a glacier into New York City. Fortunately, Wonder Woman stopped him.

MOROZKO: Named after an ice character of Russian folklore, Igor Medviedenko used his cryo-powers as a member of metahuman team Soyuz.

POLAR BOY: A native of planet Tharr—whose inhabitants all possessed ice powers—Brek Bannin helped form the Legion of Substitute Heroes when he couldn't make the cut for the Legion of Super-Heroes.

SNOWMAN: Half-human and half-yeti, Klaus Kristin could transform into an ice creature and turned to crime to fund his travels. A stop in Gotham City put him on Batman's radar.

SNOWFLAKE LEVEL

These minor players don't deserve to be left out in the cold.

SUPER HEROES
FROSTBITE
SNOW OWL

SUPER-VILLAINS
BLIZZARD
BLUE SNOWMAN
COLD WARRIOR
THE CRYONIC MAN
FREON
GLACIER
ICEBERG
NEW MOON

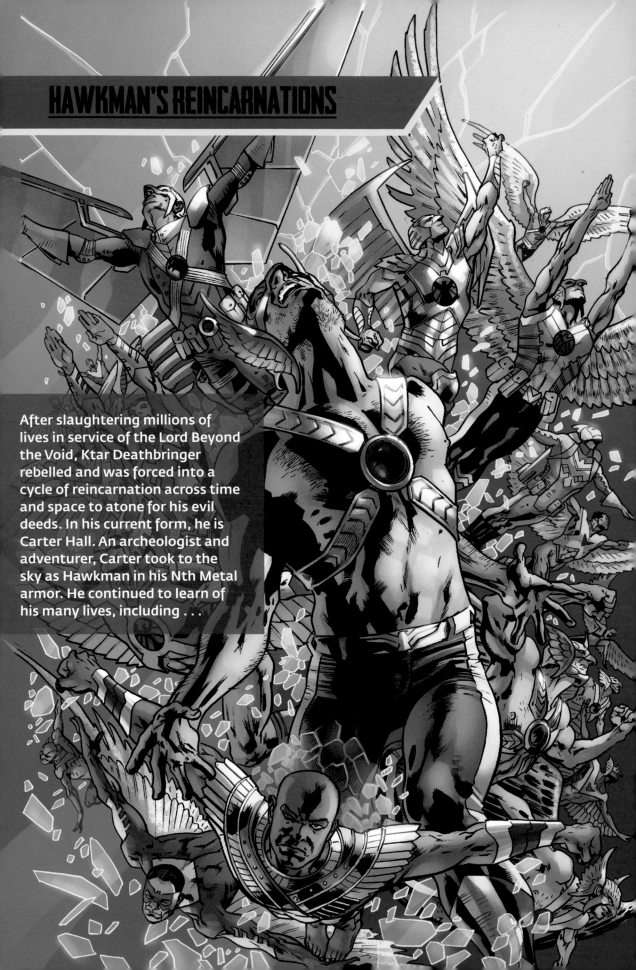

HAWKMAN'S REINCARNATIONS

After slaughtering millions of lives in service of the Lord Beyond the Void, Ktar Deathbringer rebelled and was forced into a cycle of reincarnation across time and space to atone for his evil deeds. In his current form, he is Carter Hall. An archeologist and adventurer, Carter took to the sky as Hawkman in his Nth Metal armor. He continued to learn of his many lives, including . . .

EARTHBORN LIVES

THE UNNAMED CO-LEADER OF THE BIRD TRIBE: From one of the earliest tribes in human history.

PRINCE KHUFU KHA-TARR: An ancient Egyptian prince.

SIR BRIAN KENT: A sixth-century English knight known as Silent Knight because he never spoke lest he give away his identity.

THE BIRDMAN: The tattooed hero of Easter Island.

AN UNNAMED PRIEST: A priest during the Crusades.

KOENRAAD VON GRIMM: The son of a German blacksmith in the sixteenth century.

AN UNNAMED RONIN: The son of an Ashikaga samurai, who wandered throughout Japan for ten years.

CAPTAIN JOHN SMITH: The Virginian colonist famously rescued by Pocahontas in the seventeenth century.

THE UNNAMED MASKED MUSKETEER: Lived in sixteenth- to seventeenth-century France.

DR. CARLOS SALÓN: A plague doctor in seventeenth-century Spain.

THE UNNAMED ASSISTANT OF VICTOR FRANKENSTEIN: A resident of the nineteenth-century Bavarian Alps.

AN UNNAMED SLAVE: Lived in the American South.

HANNIBAL HAWKES: The masked vigilante Nighthawk in the Old West.

JAMES "JIMMY" WRIGHT: A Pinkerton detective in the early twentieth century.

LIVES THROUGHOUT THE MULTIVERSE

AIRWING: The hawk hero of New Genesis.

AVION: The miniature hero of the Microverse.

C'TARR HOLL, KETTAR, AND OTHER UNNAMED SOLDIERS: Fought on both sides of a centuries-long war on the planet Nebulen.

CATAR-OL: A Kryptonian historian and teacher who had Kara Zor-El as a student.

THE DRAGON OF BARBATOS: Defender of the World Forge.

GOLD HAWK: The legendary hero of Andrino, a planet destroyed by Deathbringers.

KATAR HOL: A member of the Thanagarian police force who journeyed to Earth to become Hawkman.

KATARTHUL: A Rannian adventurer and hero.

RED HARRIER: The masked hero of an unknown planet.

SKY TYRANT: The wicked Hawkman of Earth-Three.

TITAN HAWK: A gargantuan hero, the physically largest of Hawkman's lives.

THE LIVES OF HAWKGIRL

Ever since Ktar Deathbringer encountered the mysterious redheaded woman Shrra, he was often joined by a partner in his lives. Now, that woman is Kendra Saunders, who flies solo as Hawkgirl.

THE UNNAMED CO-LEADER OF THE BIRD TRIBE: Helped lead the battles against the Bat Tribe.

CHAY-ARA: The love of Prince Khufu Kha-Tarr.

LADY CELIA PENBROOK: The wife of Brian Kent.

POCAHONTAS: The legendary Native American hero.

THE UNNAMED MASKED MUSKETEER: Resided in sixteenth- and seventeenth-century France.

NAYARA: A fellow plague doctor.

KATE MANSER: The vigilante hero Cinnamon and partner of Hannibal Hawkes.

SHEILA CARR: The ex-lover of Jimmy Wright, caught up with gangster Big Louie Moretti.

SHIERA SANDERS HALL: The Golden Age Hawkgirl and wife of Carter Hall.

SHAYERA HOL: The ruler of Thanagar known as Hawkwoman and the wife of Katar Hol.

SHERRA: A soldier in the war on Nebulen.

KENDRA MUNOZ-SAUNDERS: Hawkgirl of Earth-Two.

THE UNNAMED EVIL HAWKWOMAN: Located on Earth-Three.

THE WEDDING PARTIES

When it came to superheroes, "in good times and bad" tended to apply to the wedding as much as the marriage.

SUGAR--I'M GONNA ASK YOU ONE MORE TIME! WILL YOU MARRY ME?

OH, YES--YES, YES, YES! BUT WHEN?

OH, THERE'S NO RUSH! LET'S SAY-- IN THREE HOURS!

RALPH DIBNY AND SUE DEARBON
Wedding Date: *The Flash* #119 (March 1961)
The wedding of a superhero and a socialite—with The Flash as best man—made national headlines. It was followed by a Caribbean honeymoon, where Ralph was abducted by aliens.

RITA FARR AND STEVE DAYTON
Wedding Date: *Doom Patrol* #104 (June 1966)
Elasti-Girl married Mento despite the best efforts of her Doom Patrol teammates to sabotage it. After the ceremony, Rita skipped the reception because of a bomb scare that needed her team's attention.

BARRY ALLEN AND IRIS WEST
Wedding Date: *The Flash* #165 (November 1966)
Not even Professor Zoom—impersonating Barry—was enough to ruin the couples' day. They tied the knot with Barry still holding on to the secret of his double life as The Flash.

JIMMY OLSEN AND BRUNA THE GORILLA
Wedding Date: *Superman's Pal, Jimmy Olsen* #98 (December 1966)
Superman asked Jimmy to marry the lovestruck sacred gorilla to calm her rampage and officiated the wedding.

SCOTT FREE AND BIG BARDA
Wedding Date: *Mister Miracle* #18 (February/March 1974)
Before Darkseid could crash the ceremony, Highfather hastily married Scott and Barda with Orion, Lightray, and Metron in attendance.

ADAM STRANGE AND ALANNA OF RANN
Wedding Date: *Justice League of America* #121 (August 1975)
The ultimate destination marriage on Rann—twenty-five trillion miles away—commenced with the full Justice League in attendance immediately after Adam discovered Alanna hadn't been killed by Kanjar Ro.

BRUCE WAYNE AND TALIA AL GHŪL
Wedding Date: *DC Special Series* #15 (Summer 1978)
While drugged and unconscious, Bruce was married to Talia by her father, Rā's al Ghūl, who claimed only the consent of the bride and her father was sufficient for marriage.

RAY PALMER AND JEAN LORING

Wedding Date: *Justice League of America* #157 (August 1978)
On the eve of the wedding, Ray revealed he was the Atom, causing Jean to storm off. They reconciled for the wedding with Hawkman as best man and Hawkgirl, Supergirl, and Wonder Woman as bridesmaids.

DONNA TROY AND TERRY LONG

Wedding Date: *Tales of the Teen Titans* #50 (February 1985)
Donna and Terry's beautiful wedding went off without a hitch on the sprawling estate of Steve Dayton, beginning with Dick Grayson walking Donna down the aisle.

SWAMP THING AND ABIGAIL ARCANE

Wedding Date: *Saga of Swamp Thing* #34 (March 1985)
In a private ceremony that involved Abigail eating a hallucinogenic plant that grew from Swamp Thing's chest, the pair's souls were intertwined.

CLARK KENT AND LOIS LANE

Wedding Date: *Superman: The Wedding Album* #1 (December 1996)
The pair had a large Metropolis ceremony with Jimmy Olsen as the best man and Lucy Lane as the maid of honor. For the occasion, Clark even cut the long hair he'd been sporting.

WALLY WEST AND LINDA PARK

Wedding Date: *The Flash* #142 (October 1998)
Wally had to write his vows at super-speed, but the wedding otherwise went smoothly, even with Impulse as the ring bearer . . . until the moment Wally put the ring on Linda's finger and she vanished, along with Wally's memories of her.

DINAH DRAKE AND OLIVER QUEEN

Wedding Date: *Green Arrow / Black Canary* #5 (April 2008)
The Super Heroes' union was a small rooftop ceremony officiated by Wonder Woman while Batman and Superman stood guard, with only Barbara Gordon, Hal Jordan, Roy Harper, and Mia Dearden in attendance, after their first ceremony was ruined by a Super-Villain attack.

JIMMY OLSEN AND JIX

Wedding Date: *Superman: Leviathan Rising Special* #1 (July 2019)
After a drunken night in Gorilla City, Jimmy woke up married to interdimensional jewel thief Jix, as one does in Gorilla City.

LOVE 'EM OR LEGION

The original Legion of Super-Heroes time line saw a few weddings, which were particularly solemn affairs, since the team's constitution forbade married members, requiring the couples to leave. (The constitution was later amended.)

CHUCK TAINE (BOUNCING BOY) AND LUORNU DURGO (DUO DAMSEL)

GARTH RANZZ (LIGHTNING LAD) AND IMRA ARDEEN (SATURN GIRL)

VAL ARMORR (KARATE KID) AND PRINCESS PROJECTRA

MOUNT OLYMPUS FAMILY TREE

DEMETER

ZEUS

HERA

The children of the Titan gods Cronus and Rhea made their home atop Mount Olympus. The lives of gods of myth were irrevocably tied to Wonder Woman and the Amazons of Themyscira. Trying to keep straight the family relations wasn't always easy.

PERSEPHONE

APOLLO

ARTEMIS

ATHENA

DIONYSUS

PERSEUS

HERCULES

LENNOX

MILAN

SIRACCA

CASSANDRA

HERMES

+HELENA SANDSMARK
CASSIE SANDSMARK (WONDER GIRL)

+DRYOPE
PAN

ATLANTIADES

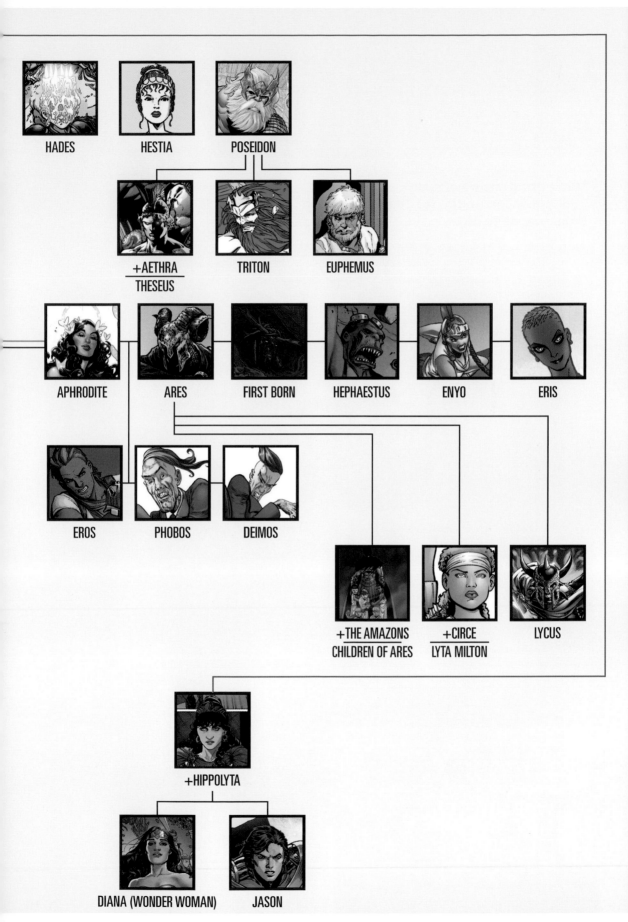

HADES · HESTIA · POSEIDON

+AETHRA
THESEUS · TRITON · EUPHEMUS

APHRODITE · ARES · FIRST BORN · HEPHAESTUS · ENYO · ERIS

EROS · PHOBOS · DEIMOS

+THE AMAZONS
CHILDREN OF ARES · +CIRCE
LYTA MILTON · LYCUS

+HIPPOLYTA

DIANA (WONDER WOMAN) · JASON

THE MANY FIRST MEETINGS OF CLARK KENT AND BRUCE WAYNE

The shifting nature of reality provided multiple opportunities for Clark Kent and Bruce Wayne to meet.

MEETUP: *Superman* #76 (May/June 1952)
Due to overbooking, Clark Kent and Bruce Wayne had to share a room on a cruise, which made maintaining their secret identities difficult. When a fire broke out, both leaped into action.

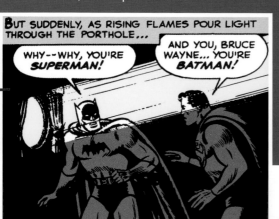

MEETUP: *World's Finest Comics* #84 (September/October 1956)
Superboy noticed an odd boy following him wherever he went and concluded the boy was trying to learn his secret identity. In fact, it was a vacationing Bruce Wayne, who was attempting to prevent a stranger from discovering Superboy's identity.

MEETUP: *World's Finest Comics* #94 (May/June 1958)
Batman and Robin flew to Metropolis when they overheard some criminals were in possession of Kryptonite. They arrived in the Batplane just in time to witness Superman being shot with a gun firing liquid Kryptonite. The Man of Steel would have fallen to his death had Batman not dived down to catch him.

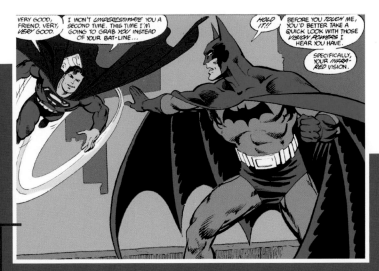

MEETUP: *Adventure Comics* #275 (August 1960)
Bruce Wayne accompanied his parents to Smallville, where he deduced that Clark Kent was Superboy, based on their matching voice patterns.

MEETUP: *The Man of Steel* #3 (November 1986)
On a trip to Gotham City, Superman attempted to arrest Batman for his vigilante activities before the two were forced to team up to stop the villain Magpie. Superman reluctantly put his trust in Batman.

MEETUP: *Superman/Batman: Secret Files & Origins 2003* (November 2003)
Bruce and Clark nearly met when Bruce was on a road trip with Alfred. A flat tire in Smallville sidelined the trip. From the car, Bruce watched Clark play baseball with Pete Ross. Clark and Pete debated inviting Bruce to join them but didn't.

MEETUP: *Superman* #710 (June 2011)
As civilians, they met in the mountains of the small Asian country of Bhutran, where they partnered to protect the country from an invasion by Vandal Savage.

MEETUP: *Justice League* #1 (October 2011)
When Darkseid attacked Earth for the first time, the Justice League formed, including the very first encounter of Batman and Superman, where the Super Heroes were at each other's throats.

MEETUP: *Batman/Superman* #1 (August 2013)
Just prior to the formation of the Justice League, Clark and Bruce crossed paths once. Investigating the murders of three Wayne Industries employees, Clark made his way to GothamCity, resulting in a team-up with their counterparts on Earth-Two. The villain Kaiyo erased their memories of the entire ordeal.

MEETUP: *Batman/Superman* #3 (October 2013)
On Earth-Two, Clark and Bruce first met when Bruce and Alfred had a flat tire in Smallville. This time, however, Clark invited Bruce to play baseball with him. The boys didn't play well together at first but worked it out on their own. Bruce and Alfred then joined the Kents for dinner.

OUTBREAK: THE DEADLIEST AND MOST DANGEROUS VIRUSES

Perhaps Super Heroes wear masks for a reason other than protecting their secret identities. Discover some of the worst invisible dangers in the universe.

AMAZO VIRUS: A highly contagious super-virus—derived from an artificial enzyme found in the android Amazo—created by Lex Luthor to suppress a metahuman's powers. It proved fatal for normal humans, who manifested a superpower as the virus broke down every cell in their bodies.

BLACK ZERO VIRUS: A powerful Kryptonian computer virus that took control of the Fortress of Solitude's systems, nearly killing Superman and the Legion of Super-Heroes.

DESPOTELLIS: The powerful sentient biovirus created in a military lab on the planet Khondra, Despotellis could wipe out a planet in a single day and leave no trace of itself behind.

DOCTOR SILENCE'S DISEASE: Unknown in name and origin, this rare disease afflicted Doctor Silence, a wealthy connoisseur of the curious, forcing him to wear a mask. If he ever saw a reflection of his naked face, he'd cease to exist.

DOOMSDAY VIRUS: Viral spores produced by the monster Doomsday caused cellular degeneration and death in high doses. Smaller doses caused derangement and physical mutation.

EBOLA GULF-A: A potent strain of the Ebola virus created by the Order of St. Dumas. Forty-eight hours after exposure, victims would begin hemorrhaging from the eyes, and their muscles would harden, causing their bones to snap. It was also known as the Sin Cleanser, Apocalypse Virus, and informally as the Clench.

H'RONMEER'S CURSE: A psychic curse, named after the Martian god of death and fire, it spread telepathically and caused its victims' brains to psychosomatically generate flames that burned them alive.

KRYPTOCOCCUS: A biosentient "Omni-Germ" that could duplicate and communicate any germ, human or alien; created by Dr. Virus.

LEEZLE PON: The Green Lantern of Sector 119, this super-intelligent smallpox virus couldn't attend Corps meetings on Oa without running the risk of infecting his teammates but was valuable in battle, particularly against other microscopic threats.

LUKOS: Dating back to seventh-century Scandinavia, the fluid-transmitted rabies-like disease caused physical mutations, with its victims becoming wolflike in appearance and behavior if left untreated.

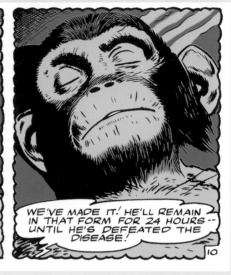

MORTICOCCUS VIRUS: A lethal airborne virus that mutated to affect its victims' DNA. Humans exposed to it devolved to a Neanderthal-like state, whereas animals infected gained greater intelligence.

OMAC VIRUS: A microrobotic nanovirus that transformed those it infected into OMAC drones, a cyborg army controlled by the satellite Brother Eye.

SAKUTIA: Also known as Green Fever, Sakutia was like malaria and just as deadly. When mixed with a serum derived from the West African green monkey, the virus altered the victims' DNA, turning their skin green and allowing them to transform into different animals at will.

STYGIAN VIRUS: Created by the murderous Lady Styx, the virus not only infected people with uncontrollable rage, it radicalized them into worshipping its creator. Chants of "Believe in her!" were often heard from the infected during their violent frenzies.

VIRUS X: At least two strains of the Kryptonian virus existed. One strain was deadly only to Kryptonians, causing a slow death over the course of thirty days. Another highly contagious strain caused leprosy and could infect all living beings, bringing death in minutes.

THE YELLOW PLAGUE OF GHERA: A mysterious virus from the planet Ghera that caused jaundice and ultimately death. It wiped out half the population of Naktos.

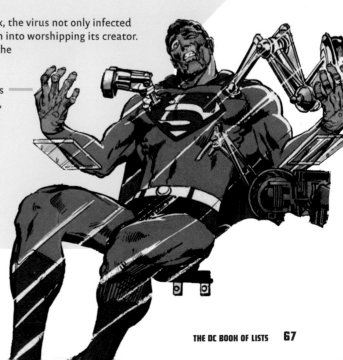

THE FIVES: THE FATAL, THE FEARSOME, AND THE INFERIOR

There were a number of Fives lurking around the multiverse. Though all were trouble, you wouldn't want to get them mixed up.

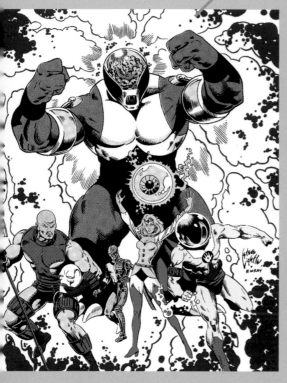

THE FATAL FIVE

Five of the most dangerous criminals in the future were recruited by the Legion of Super-Heroes to help stop the Sun-Eater.

EMERALD EMPRESS: Sayra had no powers of her own, but she commanded the Emerald Eye of Ekron, which obeyed her mental orders.

MANO: With the antimatter touch of his right hand, Mano could destroy anything, including his entire home planet.

THE PERSUADER: Nyeun Chun Ti carried with him an atomic ax that could cut through anything, including the very fabric of time and space.

THAROK: After being caught in a nuclear blast, Tharok had half his body replaced with cybernetics. His enhanced body and robotic brain made him a greater criminal than he was before.

VALIDUS: A deadly combo of monstrous and mindless, Validus was once Garridan Ranzz, the child of Legionnaires Cosmic Boy and Saturn Girl, transformed by Darkseid and sent back in time to fight younger versions of his parents.

In a recent trip to the present day, Emerald Empress assembled a new Fatal Five, including the sorceress Selena, the android Indigo, the vengeance-driven Magog, and Solomon Grundy.

THE FEARSOME FIVE

A ruthless group of villains determined to take down the Teen Titans saw its lineup changed over the years, but the first iteration of the team included:

DOCTOR LIGHT: The hapless Arthur Light placed an ad in *Underworld Star* magazine to find his team of villains.

GIZMO: The diminutive Mikron O'Jeneus was a genius, specializing in weapons tech.

MAMMOTH: Baran Flinders wasn't very skilled in battle, but his sheer size and strength made him a formidable opponent.

PSIMON: Dr. Simon Jones possessed psychokinetic abilities and a clear skull top to always see what was on his mind.

SHIMMER: Baran's sister, Selinda Flinders, could transmute matter, but only at a limited range and for a short time.

The group expanded their ranks to include the elemental sorceress Jinx and the radioactive Neutron. They were willing to partner with the Secret Society of Super-Villains when necessary in addition to going at it solo.

THE INFERIOR FIVE

This quintet was the sorriest bunch of Super Heroes to ever put on costumes. All were children of the legendary Super Hero group Freedom Brigade. Any victories to which the team could lay claim were usually due to dumb luck rather than dedicated crime fighting.

AWKWARDMAN: Leander Brent possessed super-strength and was amphibious, but also a complete klutz.

THE BLIMP: Herman Cramer could float through the air. However, he'd need a strong wind to propel him anywhere.

MERRYMAN: The group's leader, Myron Victory, was smart but puny, and preferred drawing Super-Villains to fighting them.

TOUGH BUNNY: Athena Tremor was as strong as an ox and nearly as intelligent. Her heart was always in the right place, even if her mind wasn't.

WHITE FEATHER: William King was a talented photographer and potentially could've been a great archer if he wasn't always nervous and afraid of everything.

Bat-Mite briefly joined, transforming them into the serious Superior Six, but they were much more comfortable as their usual bumbling selves.

INTERNATIONAL SUPER HERO TEAMS

The Justice League might have gone international at a time, but they weren't the only team protecting parts of the globe. Other teams of superheroes rose to the challenge.

BIG SCIENCE ACTION: The elder statesmen of Japanese Super Heroes—including Rising Sun and Ultimon—this team had a special distinction in the field of monster hunting.

THE DOOMED: Former Doom Patrol member Celsius relocated to India, where she led a group, including Solstice and Animal-Vegetable-Mineral Man, in protecting the weak and vulnerable.

GLOBAL GUARDIANS: Run by Doctor Mist, the Global Guardians was based first in France and later Bialya, and its roster included Super Heroes from across the world, including Fire, Ice, and the Tasmanian Devil.

THE GREAT TEN: Sanctioned by the People's Republic of China and led by August General in Iron, the Great Ten included some of the most powerful heroes in the country, including Accomplished Perfect Physician, Immortal Man in Darkness, and Mother of Champions. It recently expanded to the Great Twenty, including Justice League of China and others.

THE HAYOTH: An Israeli strike force led by controversial metahuman Seraph. The actual number of teammates was closely guarded, but Dybbuk, Golem, and Judith were known members.

THE INTERNATIONAL ULTRAMARINE CORPS: A US military operation, led by Warmaker One, that branched out to accept heroes from all nations, including many former members of the Global Guardians.

KNIGHTS INC.: Led by the latest Knight, the team was ordained by the Queen to protect the interests and borders of the United Kingdom. The fifteen-member group included Canterbury Cricket, Godiva, the Hood, Jack O'Lantern, and others.

THE KOLLEKTIV: Spidra and Traktir, two of Leviathan's genetically engineered test subjects from Yemen, oversaw the team, whose reach covered the Middle East and Africa.

THE NEW GUARDIANS: Selected by the Guardians of the Universe and the Zamarons, this group of metahumans was chosen to shepherd the next stage of human evolution.

THE PEOPLE'S HEROES: Russia's premier group of metahumans, under the leadership of Pozhar, included Russia's most well-known superheroes, including Lady Flash, Negative Woman, and Red Star.

DIE RAKETE-AUSLESE: This armored German police force used technology based on Russia's Rocket Red technology.

RED TRINITY: A trio of Russian speedsters, Red Trinity traded in heroics for profits by opening the superspeed messenger service Kapitalist Kourier Service Inc.

ROCKET RED BRIGADE: In armored battle suits that the Green Lantern Kilowog helped create, the Rocket Red Brigade were combat-ready to defend Russia.

SOYUZ: A squad of teenage Russian metahumans led by Firebird, each member was named after someone from Russian folklore.

THE SÚPER-MALÓN: Inspired by El Gaucho, Argentina's finest superheroes formed under the leadership of the sorceress La Salamanca.

SUPER YOUNG TEAM: The next generation of Japanese superheroes, led by Most Excellent Superbat, sought fame and excitement. Members such as Crazy Shy Lolita Canary, Big Atomic Lantern Boy, and Shiny Happy Aquazon traveled around in their high-tech Wonder Wagon.

THE ZHUGUAN: One of China's first superhero teams, the Zhuguan derived their abilities from a mystical elixir that gave them each a unique power.

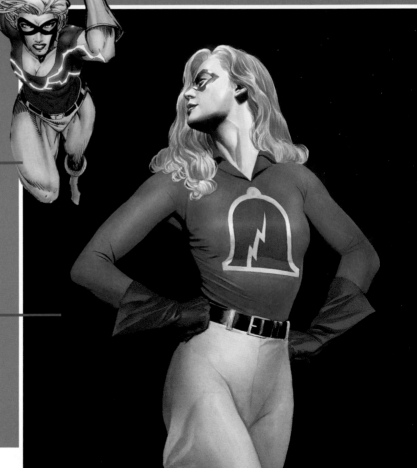

HEROIC EVOLUTIONS

Changing a code name isn't something that can be taken lightly. Sometimes out of necessity, other times out of maturity, these heroes swapped out their Super Hero names for something new.

BART ALLEN
Impulse
Kid Flash
The Flash

HELENA BERTINELLI
The Huntress
Batgirl
Matron of Spyral

BEATRIZ BONILLA DA COSTA
Green Fury
Green Flame
Fire

STEPHANIE BROWN
Spoiler
Robin
Batgirl

CASSANDRA CAIN
Batgirl
Kasumi
Black Bat
Orphan

MICHAEL CARTER
Booster Gold
Supernova

JESSE CHAMBERS
Jesse Quick
Liberty Belle

TIM DRAKE
Robin
Red Robin
Drake

MALCOLM DUNCAN
Guardian
Hornblower
Herald
Vox

GUY GARDNER
Green Lantern
Warrior
Darkstar

GARTH
Aqualad
Tempest

BARBARA GORDON
Batgirl
Oracle

DICK GRAYSON
Robin
Nightwing
Target
Renegade
Burn
Batman
Agent 37 of Spyral

ROY HARPER
Speedy
Arsenal
Red Arrow

SANDERSON HAWKINS
Sandy the Golden Boy
Sand
Sandman

HAL JORDAN
Green Lantern
Parallax
The Spectre

CLARK KENT
Superboy
Superman

LEONID KOVAR
Starfire
Red Star

GAR LOGAN
Beast Boy
Changeling

TORA OLAFSDOTTER
Icemaiden
Ice

KYLE RAYNER
Green Lantern
Ion Parallax

ALBERT ROTHSTEIN
Nuklon
Atom Smasher

ALAN SCOTT
Green Lantern
Sentinel

JOHN STEWART
Green Lantern
Darkstar

JASON TODD
Robin
Red Hood
Wingman

DONNA TROY
Wonder Girl
Troia
Darkstar
Wonder Woman

HELENA WAYNE
Huntress
Robin

WALLY WEST
Kid Flash
The Flash

COURTNEY WHITMORE
Star-Spangled Kid
Stargirl

Green
Lantern
Corps

Indigo
Tribe

Star Sapphires

RING SWAP

Members of the Lantern Corps were loyal to their teams, but sometimes a change in color was necessary. These Lanterns switched it up.

Sinestro
Corps

Red
Lantern
Corps

GUY GARDNER
Green
Yellow
Red
Blue
Violet (Star Sapphires)

HAL JORDAN
Green
Red
Blue
Orange
White
Yellow
Black

SORANIK NATU
Green
Yellow

LAIRA OMOTO
Green
Red
Black

THAAL SINESTRO
Green
Yellow
White
Indigo
Ultraviolet

JOHN STEWART
Green
Indigo
Violet (Star Sapphires)
Ultraviolet

KYLE RAYNER
Green
White
Blue
Yellow
Orange
Red
Indigo
Violet (Star Sapphires)

SPACE APE
Yellow
Green

DEZ TREVIUS
Yellow
Red

Blue
Lantern
Corps

Black
Lantern
Corps

White
Lantern
Corps

Orange
Lantern
Corps

Ultraviolet
Corps

THE UNDERSEA WORLD OF ATLANTIS

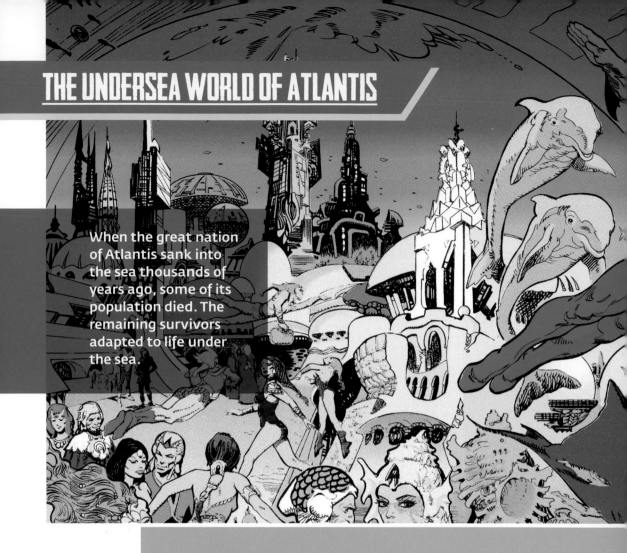

When the great nation of Atlantis sank into the sea thousands of years ago, some of its population died. The remaining survivors adapted to life under the sea.

POSEIDONIS: The capital city of Atlantis. Its inhabitants maintained their human appearance but evolved to breathe underwater and withstand the pressure of the ocean.

THE HIDDEN VALLEY: The twin cities of Shayeris and Crastinus within the Hidden Valley were home of the purple-eyed, mystical, and pacifist tribe of the Idyllists.

HY-BRASIL: Home to a militaristic race of ivory-white-skinned Atlanteans that were manta-like in appearance.

MAARZON: A barren territory inhabited by a barbaric, green-skinned race of Atlanteans.

SUB DIEGO: The west coast of San Diego that had sunk following an earthquake. Scientist Anton Geist created a serum to allow the survivors to breathe underwater.

THIERNA NA OGE: This isolationist city-state that favored magic over science saw its residents develop golden orange skin and aqua-green hair.

TLAPALLAN: The two-fingered and two-toed onyx-skinned Atlanteans had their Aztec-like city razed by Ocean Master.

THE TRENCH: Evolving to survive in the pitch-black dark of the ocean floor, the savage, cannibalistic creatures of the Trench bore a horrific resemblance to angler fish with razor-sharp teeth and a natural bioluminescence.

ATLANTIS

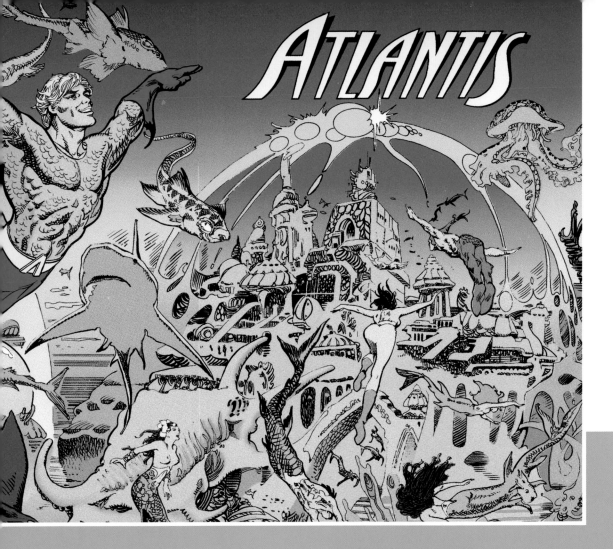

TRITONIS: Separatists who followed the mystic Shalako from Poseidonis took
refuge in the city of Tritonis, where they evolved into merpeople.

THE UNDERREALM: A separate society beneath the kingdom of Atlantis that did not welcome outsiders and kept the true name of their city to themselves.

VENTURIA: An Atlantean outpost ruled by Queen Clea, who subjected the men of the city to gladiatorial death matches. The queen was intent on ruling the world, starting with Venturia's sister city, Aurania.

XEBEL: An alternate dimension within the Bermuda Triangle that served as a penal colony following one of Atlantis's civil wars. Some of its inhabitants, like members of the royal family, could manipulate and shape water, altering its density and wielding it as a weapon.

ZOMBIES OF ATLANTIS: Perfectly preserved by a shell of lava, the dead inhabitants of one lost city of Atlantis, including their king Zatopa, were resurrected by Multi-Man as a zombie army.

OTHER INTELLIGENT SEA LIFE

THE FISH-MEN OF NYARL-AMEN: A city of fish-headed men that was obliterated by Doctor Fate.

KOGATS: Telepathic aquatic apes living in the Deep Canyons beneath New York Harbor.

THE LURKERS: Humanoid beings whose history underwater predated the Atlanteans.

MEGACNIDARIANS: Giant, xenophobic jellyfish, intent on eradicating Atlanteans.

NEREIDS: Sea goddesses who rescued those lost at sea and brought them to safety.

SAREMITES: Air-breathing albinos in the undersea city of Sareme.

TROGLODYTES: Frog-like humanoids with nuclear capabilities who created the moon and lived in the Sargasso Sea.

The band of misfits known as the Doom Patrol and the eclectic robot Metal Men both had their share of bizarre enemies. Let's see how they stacked up against each other.

THE DOOM PATROL

ANIMAL-VEGETABLE-MINERAL MAN
After falling into a vat of amino acids, biologist Sven Larsen could transform his body into any animal, mineral, or vegetable.

BEARD HUNTER
Never able to grow a beard of his own, Ernest Franklin hunted men with facial hair, killing and shaving them.

THE BRAIN
The disembodied brain of a genius French scientist led the Brotherhood of Evil alongside his lover, Monsieur Mallah, a superintelligent, beret-wearing gorilla.

BROTHERHOOD OF DADA
Led by Mr. Nobody, these outcast villains carried out crimes like using a painting to eat Paris.

THE GREAT GURU
Posing as a guru, Yaramishi Rama Yogi used his mental powers to distract and disorient the Doom Patrol.

JUKEBOX OF DOOM
A giant, bulletproof, rampaging jukebox whose sound waves could collapse a bridge.

MR. 104 (FORMERLY MR. 103)
A criminal capable of transforming himself into any element or combination of elements.

THE MUTANT TRIO
Deformed atomic mutants—Ur with a giant eye for a head, headless Ar with a face on his chest, and faceless Ir with eyes on his hands.

THE SCISSORMEN
Inquisitors from the metafictional city Orqwith, whose large scissors could cut people out of reality.

THE METAL MEN

BALLOON MAN
A self-inflating being capable of growing to great sizes as well as expelling laughing gas and smoke.

DOCTOR STRANGEGLOVE
Norman Techno had an electric typewriter for a right hand, which he used to command an army of telekinetic Brain Children.

SOLAR-BRAIN
A runaway solar prominence received sentience and telekinesis after it was bombarded with cosmic dust, drenched by a meteor storm, and blasted by an exploding star.

THE GAS GANG
Five sentient robots containing carbon dioxide, carbon monoxide, chloroform, helium, and oxygen, respectively.

THE QUEEN OF THE FLOATING FURIES
A sentient naval mine who coveted Gold like a prize and fought the rest of the Metal Men to collect him.

DR. YES
A giant, Communist robot egg intent on destroying America.

CHEMO
A twenty-five-foot-tall, human-shaped plastic vessel filled with toxic and radioactive chemicals.

THE CRUEL CLOWNS
Alien clowns who shrank the Metal Men, encasing them in a snow-globe-size circus and forcing them to provide entertainment.

THE SIZZLER
Powered by the aurora borealis, this artificial intelligence could turn robots into humans and vice versa.

NOTABLE ALIEN RACES

When traveling through the universe, it helps to know who you're dealing with.

 ALMERACIANS: An imperialistic warrior society consumed by their military prowess.

 APPELLAXIANS: World conquerors who selected their leaders by combat and trials.

 COLUANS: Highly advanced beings, possessing "eighth level" intelligence, though the Dox family possessed a minimum of "twelfth level."

 CZARNIANS: A race eradicated by one of their own—Lobo—as part of his high school science experiment.

 DAEMONITES: A reptilian race that conquered by means of infiltration, possession, and assimilation, rather than direct assault.

 DAXAMITES: Descendants of Kryptonians who isolated themselves from other alien races. Fatally allergic to lead.

 DOMINATORS: Not known for their diplomacy, these invaders often had their sights set on Earth.

 DURLANS: Highly xenophobic and distrusted shape-shifters. Their original form was lost to eons of adaptation.

 GIL'DISHPAN: An ancient, telepathic, aquatic race. They breathe methane and spit acid.

 KHUNDS: Brutish warmongers born and bred in a planetary mind-set of violence.

 KRYPTONIANS: Science-minded people who possessed great abilities under a yellow sun, rendered near extinct when their planet exploded.

 MALTUSIANS: The first intelligent race in the universe, whose scientific discoveries altered the very course of the multiverse. They splintered and evolved into different races.

 THE CONTROLLERS: An aggressive faction willing to sacrifice innocent lives in order to destroy evil.

 LEPRECHAUNS: A lost colony of Maltusians who became creatures of folklore on Earth.

 OANS: The faction who sought to bring order to the universe as the Guardians of the Universe.

 ZAMARONS: The female Maltusians, who created the Star Sapphire Corps.

 MARTIANS: Shape-shifters. Green Martians = good (except for Ma'alefa'ak); white Martians = bad.

 OKAARANS: A once peace-loving race in the Vega star system now known for its well-regarded combat training.

 PSIONS: Reptiles evolved by Maltusians, who carried out cruel experimentation in the Vega star system.

 QWARDIANS: Militaristic weapon-makers from the Antimatter Universe.

 RANNIANS: Technologically advanced inventors of the Zeta Beam who were nearly sterile from a weak gene pool.

 SPACE DOLPHINS: Telepathic dolphins that are the only creatures that could soothe Lobo's savage soul (if he, in fact, had one).

 STAR CONQUERORS: Parasitic, mind-controlling starfish that latch onto the faces of their victims.

 TAMARANEANS: A once-peaceful race thrust into war and driven by emotion rather than reason.

 THANAGARIANS: Winged warriors who used Nth Metal to take to the skies.

UNLIKELY AND INEXPLICABLE RESURRECTIONS

The death and return of Superman following his fight with Doomsday was a milestone in history, proof that the impossible was in fact possible. But Superman wasn't the only Super Hero to face death and live again to tell the tale.

ALFRED PENNYWORTH
Resurrection: *Detective Comics* #356 (October 1966)
After Alfred was crushed by a boulder while pushing Batman and Robin out of its path, his body was stolen by physicist Brandon Crawford, who exposed it to experimental radiation. Resurrected in a mutated form, Alfred was overwhelmed with the desire to kill Batman and Robin under the guise of the Outsider.

BATMAN
Resurrection: *The Brave and the Bold* #115 (October/November 1974)
Electrocuted while pursuing criminals, Bruce Wayne was deemed clinically dead with no brain activity. Then the Atom shrank in size, entered Bruce's head, and used some fancy footwork to stimulate sections of Bruce's brain.

DOCTOR LIGHT
Resurrection: *Suicide Squad* #52 (April 1991)
Killed by Parademons, Arthur Light was tormented by the demon Mister Biff E. Stopholies in Hell. That torture included being brought back to life only to die again, before finally letting Arthur free with the promise that he'd return to Hell the next time he died.

GREEN ARROW
Resurrection: *Green Arrow* #137 (October 1998); *Green Arrow* #8 (November 2001)
Superman watched in horror as Oliver Queen's body was vaporized when he detonated a bioterrorist's bomb before it could go off in Metropolis. Miraculously, Hal Jordan was able to re-create Oliver's body from a microscopic remnant of Oliver he found on Superman's suit, though Oliver's soul in heaven needed to be convinced to reunite with his body.

ICE

Resurrection: *Birds of Prey* #104 (May 2007)
Years after Tora Olafsdotter perished fighting the Overmaster, she was found alive, encased in Rocket Red's exosuit. How? Using arcane magic dating back to the time of Rasputin, Russian general Feodor Kerimov brought Tora back to life to exploit the myth of a resurrected goddess held dearly by Russian people so he could position himself as a powerful ruler.

LIGHTNING LAD

Resurrection: *Adventure Comics* #312 (September 1963)
Garth Ranzz's death at the hands of Zaryan the Conqueror wasn't the end of his story. Mon-El discovered how to bring Garth back to life by capturing the lightning of Lightning World with a special rod. Unfortunately, whoever held the rod as the lightning struck would die. The Chameleon Boy's shape-shifting pet Proty sacrificed himself to bring Garth back.

THE FIRST BOLT TO STRIKE A MEMBER'S WAND WILL FLASH THROUGH THAT *LEGIONNAIRE'S* BODY AND REVIVE *LIGHTNING LAD!* BUT I WARN YOU... WHICHEVER ONE OF US ATTRACTS THE LIGHTNING...WILL *DIE!*

POISON IVY

Resurrection: *Heroes in Crisis* #9 (July 2019)
Pamela Isley was killed at Sanctuary when Wally West lost control of his powers. Thanks to a flower she had given to her love, Harley Quinn, Wally was able to regrow her with a spark of the Speed Force.

ROBIN

Resurrection: *Batman Annual* #25 (May 2006)
Superboy-Prime's efforts to punch his way free from his extradimensional imprisonment triggered ripples in the fabric of reality. One such ripple reached Jason Todd in his Gotham Cemetery grave, restoring his life. He clawed his way out of the coffin, disoriented and unclear what had occurred.

SUPERBOY

Resurrection: *Final Crisis: Legion of Three Worlds* #4 (June 2009)
Starman placed Conner Kent's body in a Kryptonian regeneration chrysalis—the very same one that resurrected Superman. Whereas it took Superman months to heal, it took Conner a thousand years, when Brainiac 5 was able to complete the process and bring the young hero back to life.

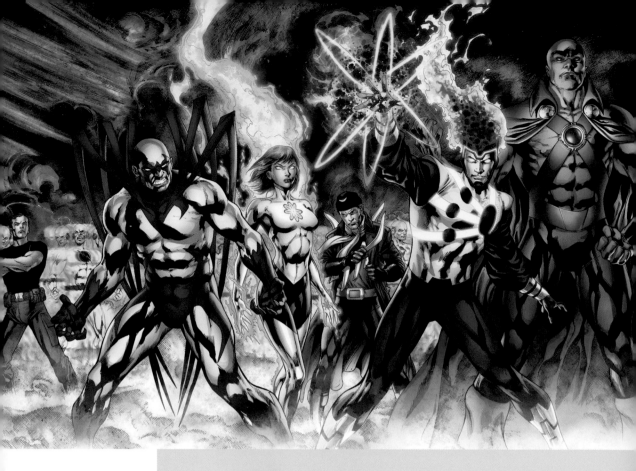

All the **MORTAL MEMORIES** of the Steve you knew before--

--The memories of the man who lived and died loving you, and whose life I shared--

--Now belong to **THIS** Steve Trevor!

STEVE TREVOR

Resurrection(s): *Wonder Woman* #223 (May 1976); *Wonder Woman* #270 (August 1980); *Wonder Woman* #322 (December 1984)
Steve Trevor didn't rest in peace after he was shot dead by Doctor Cyber's henchmen. He was resurrected by the goddess Aphrodite with his spirit melded with that of the god Eros, only to be killed again when the crazed Major Bradley attempted to extract Steve's life force to summon the demonic Dark Commander. But then another Steve from a parallel Earth crashed in the waters off Themyscira. Aphrodite and Eros transferred all the memories of the original deceased Steve Trevor into this counterpart. Whew.

WONDER WOMAN

Resurrection: *Wonder Woman* #136 (1998)
After Diana lost her life in a fight with the devil Neron, Hera brought her to Mount Olympus, where she became the Goddess of Truth. As a condition of her godhood, Diana was forbidden from having contact with her human friends, but she disobeyed when she sensed something amiss on Earth. As punishment, the gods cast Diana out. In other words, Diana resurrected via being grounded.

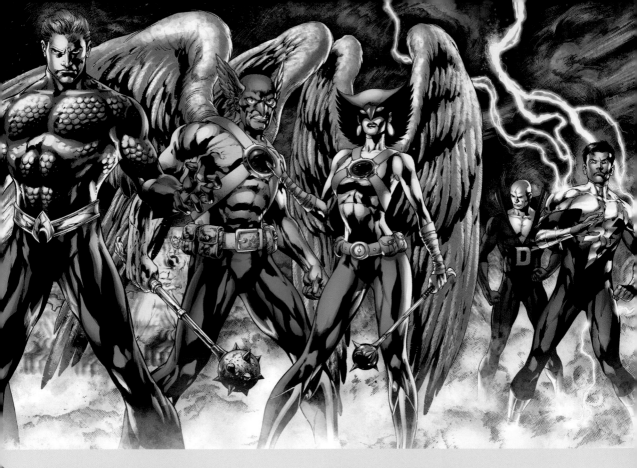

DAWN OF THE *BRIGHTEST DAY*

The single largest resurrection event occurred at the end of *Blackest Night*, when White Lantern rings resurrected a group of heroes and villains all at once:

AQUAMAN
CAPTAIN BOOMERANG
DEADMAN
FIRESTORM
HAWK
HAWKGIRL
HAWKMAN
JADE
MAXWELL LORD
MARTIAN MANHUNTER
OSIRIS
REVERSE-FLASH

SUPER HERO GRAVESITES

AVERNUS CEMETERY: Graveyard for the Rogues hidden in a pocket dimension.

CENTENNIAL PARK: Metropolis park that contained Superman's tomb.

CRYPTS OF THE GREEN LANTERN CORPS: All fallen Green Lanterns were laid to rest on Oa.

GOTHAM CEMETERY: Resting place of Thomas and Martha Wayne, and briefly an unmarked grave for Batman.

THE HALL OF JUSTICE: The remains of Super Heroes and Super-Villains placed in the Justice League headquarters.

SHANGHALLA: Thirtieth-century cemetery for Super Heroes throughout the universe.

VALHALLA CEMETERY: Final resting place of many Golden Age heroes.

WESTWORLD AMUSEMENT PARK: Home to the taxidermied remains of Jonah Hex.

THE LEGACY OF STARMAN

For as long as there are stars in the sky, there will be a Starman in one form or another.

VICTOR SONO: The earliest known "Star Man" hunted down corrupt sheriffs and deputies in the Old West, adorning his jacket with their star-shaped badge, after his father was murdered by an evil lawman.

TED KNIGHT: Ted Knight used his great wealth and intellect to harness the energy of the stars into the gravity rod he used to fight crime throughout the 1940s as the first heroic Starman in Opal City.

DORIS LEE: With the Justice Society away on missions, Wonder Woman recruited their wives and significant others to aid her on a mission to stop Brain Wave. Doris Lee donned a modified version of boyfriend Ted's costume to serve as Starman for a day.

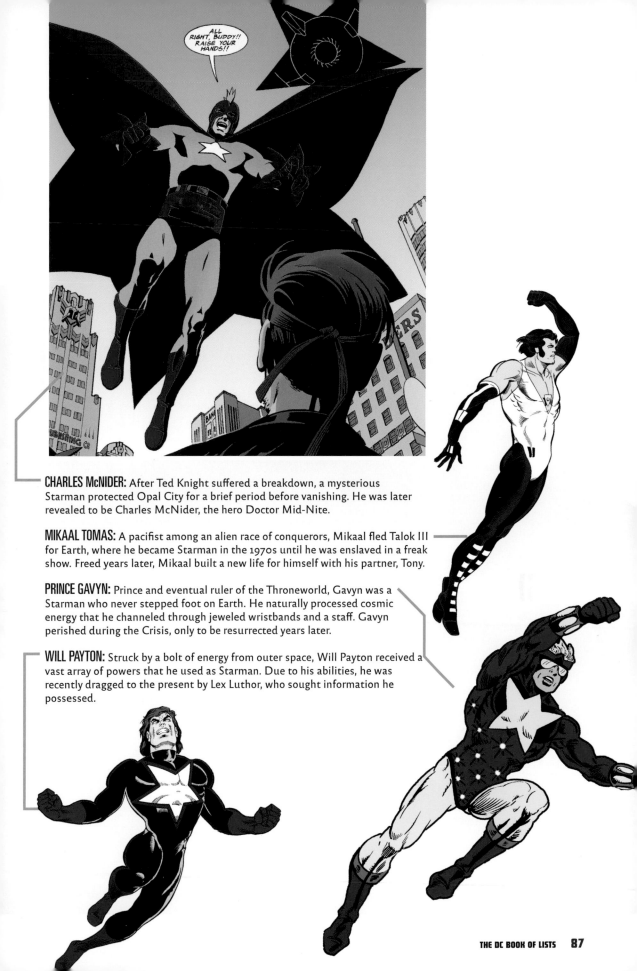

CHARLES McNIDER: After Ted Knight suffered a breakdown, a mysterious Starman protected Opal City for a brief period before vanishing. He was later revealed to be Charles McNider, the hero Doctor Mid-Nite.

MIKAAL TOMAS: A pacifist among an alien race of conquerors, Mikaal fled Talok III for Earth, where he became Starman in the 1970s until he was enslaved in a freak show. Freed years later, Mikaal built a new life for himself with his partner, Tony.

PRINCE GAVYN: Prince and eventual ruler of the Throneworld, Gavyn was a Starman who never stepped foot on Earth. He naturally processed cosmic energy that he channeled through jeweled wristbands and a staff. Gavyn perished during the Crisis, only to be resurrected years later.

WILL PAYTON: Struck by a bolt of energy from outer space, Will Payton received a vast array of powers that he used as Starman. Due to his abilities, he was recently dragged to the present by Lex Luthor, who sought information he possessed.

DAVID KNIGHT: Ted Knight's eldest son took over the costume and gravity rod after his father retired, only to be shot and killed by the son of Ted's longtime foe, the Mist, a week into his career. In the moments before his death, he was pulled back in time to 1951, granted an extra month of life, and took over as the Starman of 1951 from Charles McNider.

JACK KNIGHT: Eschewing the green-and-red cape and tights for a leather jacket and World War II goggles, Jack Knight reluctantly became Starman after David's death. He wielded a cosmic rod based on his father's gravity rod until he decided he would rather raise his own son than be a superhero.

COURTNEY WHITMORE: Already a legacy hero as the second Star-Spangled Kid, teen Courtney Whitmore inherited Jack's cosmic rod and changed her name to Stargirl as she continued her adventures with the Justice Society of America.

PATRICIA DUGAN: Courtney's little half sister would grow up to follow in the footsteps of her big sis, becoming Starwoman, and even travel to the past to assist Stargirl and the Justice Society of America in a fight again Per Degaton.

THOM KALLOR: Star Boy of the Legion of Super-Heroes grew up to become Starman, though his adventures weren't strictly limited to the thirty-first century. He ventured to the twenty-first century, where he struggled to keep his schizophrenia in check with the time period's medicine.

TOMMY TOMORROW (II), LIS ROO, AND CALE KNIGHT: Little is known about these three Starmen who served over the centuries other than the fact they were still remembered in the far future.

FARRIS KNIGHT: The Starman of the 853rd century was part of a lineage that extended all the way back to Ted Knight. Sick of the legacy to which he felt shackled, Farris nearly betrayed the universe until he had a change of heart upon meeting Ted.

THE STARMEN OF GOTHAM CITY

BRUCE WAYNE: Hypnotized to fear bats by Professor Milo, Bruce Wayne gave up his Batman identity and became Starman.

STAR-MAN: The villain, whose identity was never revealed, sought out artifacts of great power that set him on a collision course with Batman, Robin, and Batwoman.

TWO IS BETTER THAN ONE (MOST OF THE TIME)

Prepare for a series of double takes with the long line of twins found in the DC Universe.

ANDREW AND DOUGLAS NOLAN: Both suffered from a facial deformity they hid behind a mask, but they had the ability to transform into living iron, which Andrew used to become Ferro Lad.

APRIL AND MAY MARIGOLD: Clark Kent's telepathic neighbors.

BARRY ALLEN AND MALCOLM THAWNE: Barry believed his twin brother was stillborn, but the child was in fact given to the Thawne family.

BOSTON AND CLEVELAND BRAND: Years apart, both were killed while performing a trapeze act as Deadman.

CARRIE AND JONATHAN LEVINE: Metahuman members of the Team Titans from an alternate future time line, Carrie was known as Redwing and Jonathan as Prester Jon.

CONSTANCE AND VIVIAN D'ARAMIS: Both sisters shared the moniker of the French superhero Crimson Fox with Constance going solo after Vivian was murdered.

DEIMOS AND PHOBOS: Deimos, the God of Terror, and Phobos, the God of Fear, were as much trouble as their father Ares.

DESIRE AND DESPAIR: The unidentical Endless siblings.

DESMOND AND DEAN FARR: Sharing a psychic link, both brothers could feel each other's pain and used a potion to become the ferocious Tiger-Man.

DIANA AND JASON: Wonder Woman's brother was sent away from Themyscira to keep him hidden from Hera.

DON AND DAWN ALLEN: The children of Barry and Iris Allen inherited their father's speed abilities and became the Tornado Twins.

ERIN AND SHANNON McKILLEN: Heads of the McKillen crime family, the sisters were sent to prison by Harvey Dent. Shannon killed herself to help Erin escape and get revenge.

GAN AND TAVIS WILLIAMS: The conjoined twins were separated by a magical ritual and used their metahuman abilities as the heroes Thunder and Lightning.

GARTH AND AYLA RANZZ: Nearly every birth on the planet Winath results in twins, but Legion of Super-Heroes members Lightning Lad and Lightning Lass were simply two of a kind.

HELEN AND JASON JORDAN: The niece and nephew of Hal Jordan. Helen was a companion for Hal when he was the Spectre.

IRIS AND JAI WEST: Wally and Linda West's twins rapidly aged due to their connection with the Speed Force before their parents could cure them.

JASON AND GERALDINE GRANT: Jason sought out his long-lost sister, Geraldine, while trying to avenge his father's death.

JENNIFER-LYNN HAYDEN AND TODD RICE: The children of the Golden Age Green Lantern and founding members of Infinity Inc.

J'ONN J'ONZZ AND MA'ALEFA'AK: Brotherly love was tricky when Ma'alefa'ak exterminated nearly the entire Martian population.

JOR-EL AND NIM-EL: Both scientist brothers perished when Krypton exploded.

KATE AND ELIZABETH KANE: A traumatic kidnapping set the sisters on different paths, with Kate as the heroic Batwoman and Elizabeth as the evil Alice.

LIME AND LIGHT: Thrill-seeking criminal sisters who made the mistake of getting caught and were recruited for the Suicide Squad.

LINDA AND RAMONA REED: Ramona, a Hollywood starlet, and Linda, an archery champion, got caught up with Green Arrow, a gangster, and a film studio boss in a case of switched identities.

MÁS Y MENOS: A pair of speedsters who were powerless when separated.

MERA AND HILA: While Mera rose to become queen of Atlantis, Hila, known as Siren, remained the black sheep of the family.

MICHAEL AND LANCE GALLANT: After Michael was murdered, his ghost was able to merge with Lance to become Captain Triumph.

MONGAL AND MONGUL THE YOUNGER: The children of Mongul inherited their father's bloodlust, which resulted in Mongul the Younger killing his sister.

NICK AND PHIL HUNTER: When Nick was captured during the Vietnam War, Phil reenlisted and used their innate connection to rescue his brother.

PAPA MIDNITE AND LUNA: Voodoo priest Papa Midnite was forced to kill his sister as punishment for botching a magic potion, but he later kept her skull close by for rituals.

RACK AND RUIN: These brothers with detachable limbs made for an interesting clash with Blue Beetle.

SCALE AND FIN: One of these Atlantean twins was eaten by a member of the Suicide Squad; the other joined the Squad.

SOSEH AND ELLINA MYKROS: Sisters artificially aged and pitted against each other by their father, Soseh killed Ellina in battle.

TAD AND TOM TRIGGER: Separated at birth, the Trigger Twins reunited as a pair of gun-toting criminals.

TERI AND TERRY MAGNUS: The Wonder Twins of the thirty-first century were geniuses in the field of genetics.

VAN-ZEE AND DIK-ZEE: Family man Van-Zee moonlighted as the hero Nightwing in the bottled city of Kandor. Dik-Zee, on the other hand, once fell in love with a robotic Lois Lane doll that was secretly a bomb created by the Anti-Superman Gang.

WALT AND WAYNE TRIGGER: Two sheriffs for the price of one in the Old West, with Wayne filling in for his brother when necessary.

WENDY AND MARVIN WHITE: The genius children of the Calculator who eschewed their father's villainous ways.

ZAN AND JAYNA: The Wonder Twins from the planet Exxor took up residence in the Hall of Justice.

WHEN SUPERMAN AND THE FLASH RACE ...

The races between Superman and The Flash were among the greatest sporting competitions. Who had the edge?

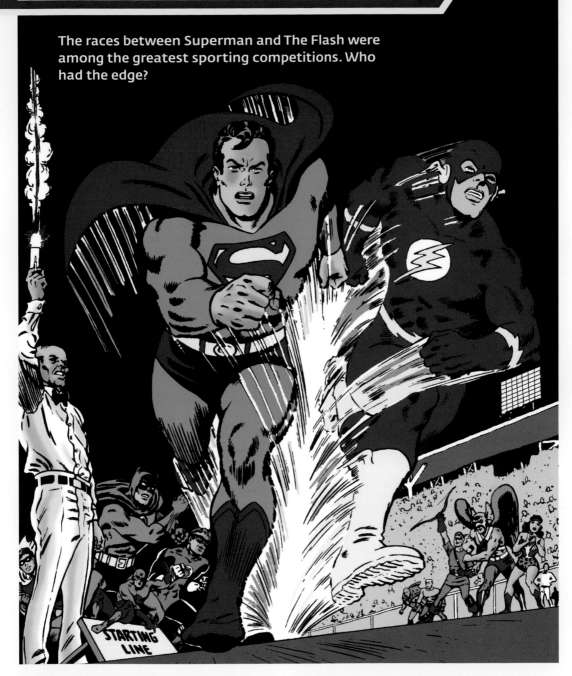

RACE #1: *Superman* #199 (August 1967)
The United Nations asked Superman and The Flash to run a race around the world to raise money for impoverished nations. But when the heroes learned crooks were betting on the race, they decided to throw the match and cross the finish line together, ensuring no criminal would profit.
Winner: Tie

RACE #2: *The Flash* #175 (December 1967)
Alien gamblers demanded a rematch at the expense of the heroes' home cities. Superman and The Flash agreed to race to the edge of the Milky Way and back, and along the way discovered the aliens were Professor Zoom and Abra Kadabra in disguise. The Super Heroes appeared to cross the finish line at the same time.
Winner: Tie

RACE #3: *World's Finest* #198–199 (November and December 1970)
Superman and The Flash made a race out of running through space to counteract the existence-threatening effect of a swarm of robotic Anachronids. With Superman weakened by a red sun and The Flash temporarily paralyzed from a blast of a ray gun, the two Super Heroes crawled to their destination: the control center for the Anachronids. The Flash mustered the strength to reach it first.
Winner: The Flash

RACE #4: *DC Comics Presents* #1–2 (July/August and September/October 1978)
Caught up on opposite sides of an alien civil war led to a race through time. Though it was not a true competition, in the end, Superman worked out a solution to the aliens' dilemma that didn't involve altering history and convinced The Flash to help.
Winner: Superman

RACE #5: *Adventures of Superman* #463 (February 1990)
To get Mr. Mxyzptlk to stop causing trouble on Earth and return to his home dimension, Superman and The Flash (Wally West) had to agree to a race around the world. Mr. Mxyzptlk kept throwing obstacles at them along the way. The heroes were neck and neck to the finish line, but The Flash just barely made it across first.
Winner: The Flash

RACE #6: *DC First: Superman / The Flash* (July 2002)
Abra Kadabra placed a spell on Wally West, causing him to age rapidly. It was up to Superman and the Golden Age Flash (Jay Garrick) to save him, if they could reach him while he ran. Superman nearly had the win, but in the last second, Jay used the Speed Force to steal some of Superman's speed and get the boost he needed.
Winner: The Flash

RACE #7: *Superman* #191 (May 2003)
Call it a scrimmage. Superman turned to Wally West to help him improve his speed. Wally was impressed with the progress Superman made, but the student didn't surpass the teacher.
Winner: The Flash

RACE #8: *The Flash* #209 (June 2004)
The Justice League wanted to know why they could no longer recall Wally West's identity, and Superman offered to find him and get answers. It resulted in a chase around the world, with The Flash always two steps ahead.
Winner: The Flash

RACE #9: *The Flash: Rebirth* #3 (August 2009)
Infected with the dark energy of the Black Flash, Barry Allen attempted to run into the Speed Force, where the energy could be dispersed. Superman attempted to stop him, but, in a race of life and death, he never stood a chance.
Winner: The Flash

RACE #10: *Superman* #709 (May 2011)
The Flash (Barry Allen) fell under the influence of a brain-scrambling headband fitted with a powerful Kryptonian sunstone. Superman had to catch him going at top speed before he could get the headband removed. Superman succeeded, but The Flash maintained he let his friend win.
Winner: Superman

RACE #11: *The Flash* #49 (August 2018)
When Barry Allen raced against Wally West to stop his despondent former sidekick from destroying the Speed Force, the pair's speed generated enough energy to tear apart the multiverse. Superman tried to get them to slow down, but even flying at full speed, he wasn't fast enough.
Winners: The Flash(es)

RACE #12: *Superman: Up in the Sky* #4 (December 2019)
Superman and The Flash (Barry Allen) agreed to a new race, ten laps around the world, to raise money for a displaced children's charity. During the race, Superman overheard that Lex Luthor had promised to match every dollar raised if Superman—the underdog—won. Superman pushed himself and miraculously pulled off a photo-finish win.
Winner: Superman

FINAL TALLY:

Ties: 2
Superman: 3
The Flash: 7

THE TRADITION CONTINUES...

SUPERBOY VS. IMPULSE: *Superboy and the Ravers* #7 (March 1997)
The boys had an impromptu race up the Pacific coast but cut the race short when they reached the memorial site of the destroyed Coast City.
Winner: Somber reflection

BIZARRO VS. ZOOM: *Superman* #221 and *Action Comics* #831 (November 2005)
Bizarro agreed to join Lex Luthor's evil Society if he won, but, since he was Bizarro, he actually had to lose. Bizarro lost the race but celebrated anyway.
Winner: Zoom

SUPERBOY VS. KID FLASH: *Superboy* #5 (May 2011)
The pair gave it another shot to raise money for Smallville citizens affected by a recent attack. In the last seconds, Krypto, Superboy's dog, swept in and beat them both.
Winner: Krypto

SUPERGIRL VS. JESSE QUICK: *Supergirl: The Fastest Women Alive* (July 2017)
The women decided to honor the charity race tradition but were interrupted near the finish line by Parasite, whom they defeated alongside Superman and The Flash.
Winner: Unknown, but it looked darn close

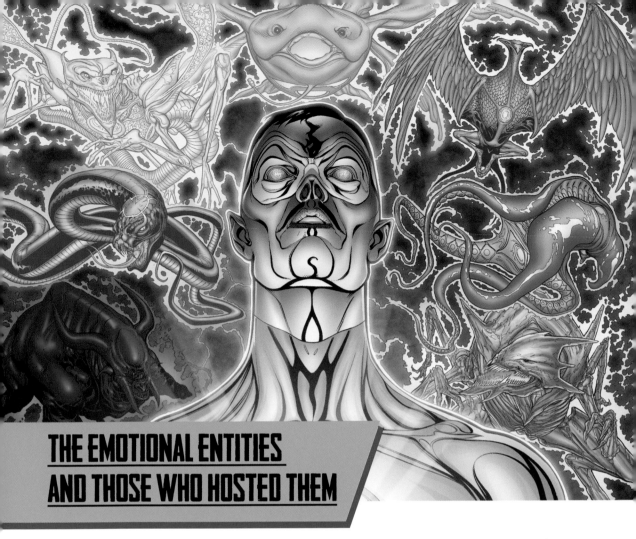

THE EMOTIONAL ENTITIES
AND THOSE WHO HOSTED THEM

With the birth of the universe came the first sentient creatures, each reflecting the seven colors of the Emotional Spectrum. These entities have had their immense powers harnessed by the various Lantern Corps. But, in turn, some of these entities have possessed hosts both on Earth and throughout the universe.

ION: The very first of the entities to be born, the emerald Ion, resembling a whale, represented the emotion of will and was the source of the Green Lantern Corps' power.
Hosts:
Kyle Rayner
Sodam Yat

PARALLAX: The second entity born, the demonic insect-like yellow embodiment of fear, Parallax exerted its influence over its host. Only Sinestro, who harnessed Parallax's power for his Sinestro Corps, was able to wrangle control of Parallax while bonded.
Hosts:
Ganthet
Zachariah Ferruci
The Flash (Barry Allen)
Hal Jordan
Kyle Rayner
Sinestro
Superman
The Weaponers of Qward

THE PREDATOR: The violet, reptilian embodiment of love, the Predator was the third entity born and the source of power for Star Sapphire.
Hosts:
Carol Ferris
Abraham Pointe
Khea Taramka

OPHIDIAN THE TEMPTER: The fourth entity born, the orange serpentine Ophidian the Tempter embodied avarice. For most of its existence, it was trapped within Larfleeze's Orange Lantern Central Power Battery.
Host:
Hector Hammond

THE BUTCHER: The bull-like red embodiment of rage was born from the first murder and the source of the Red Lanterns' vicious power.
Host:
Atrocitus
James Kim

ADARA: The two-headed blue bird embodiment of hope was wielded by the Blue Lantern Corps to spread their message of "All will be well." It also compelled its host to spread hope.
Host:
Nicole Morrison

PROSELYTE: The octopus-like indigo Proselyte was the last of the color entities born, embodying compassion that the Indigo Tribe wielded with their indentured corps members.
Host:
Shane Thompson

THE ENTITY: Embodying the white light of all creation, the angelic Entity was hidden away on Earth until it was needed to stop Nekron during *Blackest Night*.
Hosts:
Hal Jordan
Sinestro

THE POWER OF THE WHITE LANTERN
Kyle Rayner wasn't just host for Ion and Parallax. As White Lantern, he managed to contain all the entities within him.

EVOLUTION OF THE BATMOBILE

As Batman's war on crime evolved, so did his means of transportation. A consummate tinkerer, Batman always sought ways to improve his vehicles, including these milestone developments.

First Drive: *Detective Comics #27* (May 1939)
A custom-built red sedan served as Batman's first transportation.

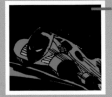

First Drive: *Detective Comics #48* (February 1941)
This red roadster with a bat-shaped hood ornament was the first automobile dubbed the Batmobile.

First Drive: *Batman #5* (Spring 1941)
A dark sedan equipped with a battering ram protecting the grille and a large tailfin in the back. It was later modified with red stripes.

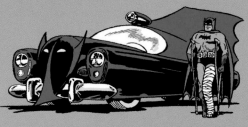

First Drive: *Detective Comics #156* (February 1950)
A bubble-domed Batmobile included a built-in crime lab, rocket boosters, and a Bat-Signal projector. Batman explored many different models of this design.

First Drive: *Batman #164* (June 1964)
A convertible sports car for easier maneuverability.

First Drive: *Detective Comics #358* (December 1966)
Newer models featuring separate windshields for the driver and passenger started to appear.

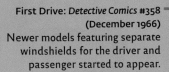
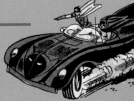

First Drive: *Detective Comics #394* (December 1969)
For inconspicuous travel, this blue sports car with yellow stripes featured diplomatic license plates, courtesy of Commissioner Gordon.

First Drive: *Detective Comics #400* (June 1970)
When Batman wanted people to know he was on the chase, he opted for this solid-blue sports car with a bat-head painted on the hood.

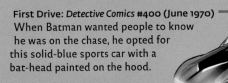

First Drive: *Batman #226* (November 1970)
An updated convertible roadster look, varying with either a full bat-symbol or a bat-head displayed on the hood.

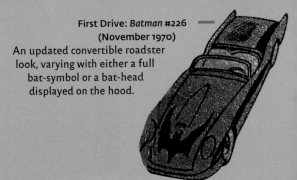

First Drive: *Batman* #344 (February 1982)
With the push of a button, this convertible Batmobile transformed into an unmarked sedan.

First Drive: *Detective Comics* #591 (October 1988)
A new low-riding Batmobile displayed an impressive bat-shaped battering ram spanning the entire grille.

First Drive: *Batman: The Cult* #4 (Winter 1988)
A monster truck with heavy-duty suspension, puncture-proof tires, and turret machine guns capable of firing two hundred rounds of tranquilizer darts a minute.

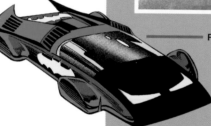

First Drive: *Detective Comics* #601 (June 1989)
Built for speed, this aerodynamically designed, ultra-low-rider lost the battering ram in favor of a sleeker, more futuristic look.

First Drive: *Detective Comics* #667 (October 1993)
As Batman, Jean-Paul Valley preferred a high-speed vehicle built for Gotham City's subway line, which could get him anywhere he needed to be in minutes.

First Drive: *Batman* #526 (January 1996)
Back as Batman, Bruce Wayne debuted a new Batmobile with an inexhaustible jet turbine engine, heavy armor, and self-driving capabilities.

First Drive: *Detective Comics* #742 (March 2000)
This sleek coupe blended in better on city streets with retractable components for stealth mode.

First Drive: *Detective Comics #784* (September 2003)
Red-tinted windows and an exaggerated long hood made this Batmobile dramatically imposing. Models featured varying numbers of tailfins and alternated between a bat-head and a bat-symbol in front.

First Drive: *Batman #652* (June 2006)
A sports car with influences of previous Batmobiles was perfect for Batman's back-to-basics approach.

First Drive: *Batman & Robin #1* (August 2009)
This pet project of Damian Wayne, based on his father's designs, was the first Batmobile to take flight.

First Drive: *Batman #9* (July 2012)
A turbine-engine low-rider built with holographic camouflage and a built-in motorcycle.

First Drive: *Batman #1* (August 2016)
A long and narrow design, which was battle-ready with heavier armor as well as powerful ejector seats.

First Drive: *Batman #88* (April 2020)
Any car with Wayne Industries components became a Batmobile thanks to the Echo, a device created by Lucius Fox that projected a holographic mask and bypassed all speed limitations.

WHATEVER HAPPENED TO...

What about some of the lesser-known Super Hero offspring? Not every superpowered child went on to forge their own legacy, due to tragic or otherwise mysterious circumstances.

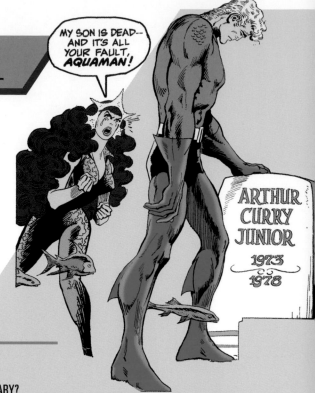

MY SON IS DEAD—AND IT'S ALL YOUR FAULT, AQUAMAN!

ARTHUR CURRY JUNIOR 1973 1978

AQUAMAN AND MERA'S BABY?

Arthur Curry Jr. had his life cut tragically short after he was abducted by Black Manta and cruelly used as a pawn in a plot to force Arthur and Aqualad to fight to the death. Arthur came up with a plan to rescue his son, but was moments too late. The baby, only able to breathe in water, suffocated in open air.

CATWOMAN'S BABY?

Following a one-night stand with Sam Bradley Jr., Selina Kyle birthed a daughter, Helena. She retired as Catwoman to focus on raising her child. But even with a name change, Selina couldn't keep Helena out of danger, and Selena soon realized that she had no way to protect Helena without giving her up. Bruce Wayne used his vast resources to make the adoption untraceable.

GREEN ARROW'S BABY?

The assassin Shado kept knowledge of Robert—conceived with Oliver Queen while the hero was in a fever-induced delirium—secret for years. Even when Oliver learned of the boy's existence, Shado wouldn't introduce them to each other. When Robert was diagnosed with cancer at eight years old, Shado turned to Doctor Sivana. The mad scientist cured Robert but in the process aged him nearly ten years and used him as a mindless drone against his parents.

POWER GIRL'S BABY?

The mages of Atlantis conjured a mystical pregnancy using the genetic material of the demonic Scarabus to create an ultimate champion. The unwitting bearer of the child, Kara, birthed a boy who rapidly aged to adulthood. Calling himself Equinox, he killed Scarabus in battle, said goodbye to his mother, and vanished.

SPOILER'S BABY?

Pregnant at fifteen—with a boyfriend who fled Gotham City after a major earthquake, a burgeoning superhero career, and a third-rate Super-Villain father—Stephanie Brown knew it wasn't the right time to be a mother. After a painful labor, she gave up the baby for adoption without ever holding it.

STARFIRE'S BABY?

Koriand'r decided to leave the Titans and settle down with her husband, General Ph'yzzon, on New Tamaran. As she said goodbye to her teammates, Raven revealed Koriand'r was pregnant with her first child. New Tamaran was later destroyed by the Sun-Eater while Koriand'r was off-world. The child was never seen, nor mentioned, so unless Raven was wrong, the child perished on the planet.

SUPERGIRL'S BABY?

Linda Danvers chose to take the place of her pre-*Crisis* predecessor, Kara Zor-El, and traveled back to the previous Earth-One. There, she and Superman fell in love, married, and had Ariella Kent. But then Spectre showed up, telling Linda she had to go back, undoing this alternate time line. Somehow, six-year-old Ariella survived, flying through the cosmos on a skateboard and serving as Supergirl in the 853rd century.

Both Super Heroes and Super-Villains struck powerful chords with their music-based abilities.

BRASS

BUZZY BROWN: A teen trumpet player who performed whether people wanted to listen or not.

HERALD: The horn supplied by Veritas to Herald could manipulate reality and teleport.

VOX: Mal Duncan wielded Gabriel's Horn, which opened multidimensional portals when played.

ELECTRONIC

THE AMAZING ALLEGRO: Anton Allegro's synthesizer converted sound waves into demonic forms.

LORD CRASH: The Lord of Order used turntables and vinyl to maintain balance in the universe.

MAESTRO: The second man to wield Allegro's synthesizer.

MUSIC MASTER: A Hero Dial identity who could convert music from a radio into energy blasts.

MULTIPLE INSTRUMENTS

THE MAESTRO: Pianos, violins, horns, and harps were all used in the Maestro's musical crime spree.

STRINGS

BATTLEAXE: The four-armed "phreak" dominated on a double-neck guitar.

FERLIN NYXLY: Each of his wishes was granted with his Devil's Harp.

THE FIDDLER: A master of mind control with his violin.

MUTE MINSTREL: The companion to the Viking Prince communicated solely through his lyre.

SEMYAZA: With a lyre made with strings from an angel's heart, this demon compelled listeners to suicide.

SUPER-HIP: Tadwallader Jutefruce's guitar compelled people to dance uncontrollably.

THRASHER: Jack T. Craig's guitar performance would grab you by the soul and not let go.

TRASH: A deadly sonic guitar with a concussive force couldn't replace actual skill, which Trash lacked.

VIRTUOSO: Inspired by the Fiddler, she used his violin after he died.

VOCALS

BLACK CANARY: Her ear-piercing sonic Canary Cry was a showstopper.

JOHNNY DUNE: His commanding voice forced his audiences to obey.

SIREN: This voodoo spirit could hypnotize anyone with one of her songs.

SILVER BANSHEE: Her Death Wail would take your breath—and life—away.

STAR ADAM: The alien singer's voice could knock the clothing right off your body.

TYROC: By adjusting his pitch and volume, the Legionnaire could fly and teleport, among other unique abilities.

WOODWINDS

MUSIC MAID: The evil alien's animal-luring "gleen" was actually a hypno-flute.

THE PIED PIPER: This villain-turned-hero's flute could put anyone under a spell.

SATYRICUS: The flute-playing satyr could elicit a full range of emotions from listeners.

THE BATTLE OF THE BANDS

BLACK CANARY: "The Most Dangerous Band in the World" was known as Alias Insane before Super Hero Black Canary joined.

BO M: A new band formed by Maeve Tavana to get revenge after she was replaced by Black Canary.

BOOJUM: Teenagers Liv, Alison, Judy, Slam, and Professor Dred headlined raves in abandoned buildings throughout Gotham City.

THE DOVES: A loud and wild rock band fronted by Wiley Wolverman, one half of an incarnation of Hawk and Dove.

THE FLIPS: Teens Jack, Jill, and Joe were guilty of being an amazing rock and roll band, but also nearly framed for a series of robberies.

GREAT FROG: Roy Harper played drums for this rock band and later recruited Titans teammate Mal Duncan to play horns.

THE MALEVOLENT MANIAXE: This post-punk trio swapped their instruments for axes as they worked as criminal enforcers.

THE MANIAKS: Flip, Jangle, Pack Rat, and Silver solved mysteries while touring.

MUCOUS MEMBRANE: Formed by John Constantine and Gary Lester, this British punk band fell apart after summoning a demon that dragged a girl to hell.

SCARE TACTICS: A vampire, a werewolf, a lizard boy, and a sludge monster were both on tour and on the run from the government.

THE POWER OF SONG

Never forget that Superman vanquished Darkseid with a song. The evil god always hated music.

BLACK CANARY'S TRACK LIST

From the band's first two EPs.
"Fish Out of Water"
"Old World"
"The Man with the X-Ray Eyes"
"Get in the Car"
"Lost Art"
"Last Days"

AFTER A HARD DAY IN THE ARMAGETTO . . .

Can you imagine anything more disconcerting than coming home to find Darkseid, the ultimate evil and tyrannical ruler of Apokolips, sitting casually in your apartment waiting for you?

ORION
Darkseid's biological son, traded to New Genesis in a peace pact with Highfather, was the first unlucky soul to encounter Darkseid in this manner. Having just arrived on Earth, Orion did not expect to find his father waiting for him. In a rage, Orion attempted to attack Darkseid, only to be assaulted from behind by Brola, one of Darkseid's loyal warriors.

AMBUSH BUG
After capturing some terrorists and attending a funeral for his deceased sidekick—a doll named Cheeks—Ambush Bug just wanted a quiet night at home, scarfing down pizza. But Darkseid had to ruin it, or so Ambush Bug thought. This Darkseid was in fact an inflatable replica.

SWAMP THING

Okay, so Swamp Thing didn't walk in on Darkseid relaxing in the bayou, but this encounter still deserves a mention. After Metron's Mobius Chair broke down, Swamp Thing kindly offered to serve as a fill-in. And—of course—as soon as Darkseid saw this Swamp Chair, he had to give it a whirl.

MISTER MIRACLE AND OBERON

Mister Miracle (Scott Free) was surprised to find that Darkseid made himself at home and was sipping wine while he waited for his adopted son. Darkseid then revealed to Scott and Oberon that he had abducted Scott's wife, Big Barda, sending the hero on a frenzied search.

OBERON

When the Justice League headed to Apokolips to rescue Mister Miracle (Scott Free), Oberon tagged along. He found himself unexpectedly in Darkseid's private quarters. Darkseid wasn't in the mood for guests and sent the entire League—Scott and Oberon included—back to Earth.

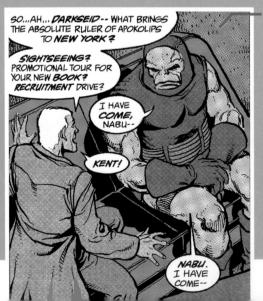

DOCTOR FATE

Darkseid came knocking on the door of Kent Nelson and Eric Strauss (Doctor Fate at the time). He asked them to join him in taking a seat to discuss the reason for his visit—his wish to kill Doctor Fate. For a cruel monster, Darkseid at least tried to be civil about his intentions.

SANDMAN
Darkseid made himself right at home at the wake for Lord Morpheus.

MISTER MIRACLE
Darkseid had died and fallen back in time, reborn on Earth as Boss Dark Side. But true to his old self, he sat awaiting the new Mister Miracle (Shilo Norman) and allowed his henchmen to rough up the hero while he watched.

MARY SHAZAM!
Darkseid waited patiently for Mary Shazam! so he could make her an offer to fully restore her powers, which had been diminished, in exchange for a small favor. This deal-with-the-devil scenario led to an out-of-control, evil Mary Shazam! fighting her friends.

BATMAN
Darkseid didn't bother to stand when Batman walked in carrying a gun—yes, Batman with a gun! Instead, he fired off the Omega Sanction from his eyes, but not before Batman got off a shot, mortally wounding the tyrant.

MISTER MIRACLE
Even in death, Darkseid burdened his adopted son while Scott soothed his own son with a nursery rhyme.

ALTERNATE IDENTITIES OF THE MARTIAN MANHUNTER

J'onn J'onzz's Martian physiology allowed him to change his shape and appearance, making it easier to blend in while living on Earth. He could become anyone, including the following identities, which he embraced to better understand humanity.

BIG DOOF: A blundering Super-Villain who sabotages his teammates, the Lowlifes, with his clumsiness.

BLOODWYND: A superhero necromancer wielding the Blood Gem.

BRONZE WRAITH: J'onn's first Super Hero persona, a member of the Justice Experience in the '60s and '70s.

ISOBEL DE LA ROSA: A beloved, subversive author from Montevideo, Uruguay.

LORA DENTON: A Federal Aviation Administration investigator.

DERVISH: A Turkish Super Hero.

CHARLEY DIMES: A homeless drunkard in Denver.

WILLIAM DYER: An agent with the Department of Extranormal Operations.

PARIS JACKSON: A Central City detective.

JADE WARRIOR: A giant robotic manga character come to life.

GOLDIE JOHNSON: The star reporter for the *World Register*, a tabloid in Chicago.

JOSH JOHNSTONE: A migrant working on the Kents' farm in Smallville.

MARS ONCE HAD CRIME--CENTURIES AGO! UNTIL THE **GREAT EVOLUTION**, WE HAD WICKED MEN WHO PREYED ON THE GOOD. BUT OUR ENLIGHTENED SCIENCE MADE ALL CRIME OBSOLETE!

JOHN JONES: A Denver police detective and J'onn's first and most frequent human identity.

MR. KAKALIOS: The US Secretary of State, working to dismantle Checkmate.

MRS. KLINGMAN: A Smallville High School civics teacher.

MA'ALEFA'AK: A manifestation of his twin brother, the Martian Manhunter.

NATHANIEL MACKELVANY: The clumsy personal assistant to President Lex Luthor.

MISTER BISCUITS: An eight-foot-tall, cookie-loving, disfigured being who befriended a young girl.

MOULD: A wise old man with a homemade mask and a blanket tied around his neck as a cape.

BETTY NEHRING: A Washington, DC, reporter.

PAOLO: A homeless child in Rio de Janeiro.

THE PEARL: An orphan thief from Dubai.

OFFICER PEREZ: An Amnesty Bay police officer.

HINO REI: A journalist for Japan's largest financial newspaper, *Nihon Keizai Shimbun*.

MIKE SHERMAN: A neighborhood Seattle cop.

YUCHIRO TAKATA: A reclusive, retired Japanese businessman and founder of New Concepts Industries.

TOMASSO: A street cat living in Venice.

JIM TULLY: Another agent with the Department of Extranormal Operations.

UNNAMED GORILLA: He was reluctantly welcomed into a tribe of African gorillas.

DARYL WESSEL: An FBI agent operating out of Washington, DC.

MARCO XAVIER: An international playboy with ties to the criminal underworld.

Trading one team for another was common over the years, due to growing up, disputes over the teams' ideologies, or just the need to do as much good as possible. These ambitious heroes served on three or more teams, sometimes on more than one team at a time.

FOUNDING TEEN TITANS MEMBERS WHO DIDN'T JOIN THE JUSTICE LEAGUE

AQUALAD. Just Aqualad.

JUSTICE LEAGUE MEMBERS WITH THE BRIEFEST TENURES

In the League one day, gone the next.

AMBUSH BUG
BULLETEER
DARK FLASH
ETRIGAN
FAITH
FIREHAWK
GUARDIAN
LIGHTRAY
MYSTEK
SUPER-CHIEF
TOMORROW WOMAN

	Batman Family	Birds of Prey	Do
ARSENAL/SPEEDY/RED ARROW (ROY HARPER)			
ATOM SMASHER/NUKLON (ALBERT ROTHSTEIN)			
BATGIRL/ORACLE (BARBARA GORDON)	★	★	
BATMAN (BRUCE WAYNE)	★		
BEAST BOY (GAR LOGAN)			
CYBORG (VICTOR STONE)			
DAMAGE (GRANT EMERSON)			
DONNA TROY/WONDER GIRL/TROIA			
THE FLASH/KID FLASH (WALLY WEST)			
THE HUNTRESS (HELENA BERTINELLI)	★	★	
JADE (JENNIFER-LYNN HAYDEN)			
KATANA (TATSU YAMASHIRO)	★	★	
KID FLASH/IMPULSE (BART ALLEN)			
METAMORPHO (REX MASON)			
NIGHTWING/ROBIN/BATMAN (DICK GRAYSON)	★		
OBSIDIAN (TODD RICE)			
ORPHAN/BATGIRL/KASUMI/BLACK BAT (CASSANDRA CAIN)	★	★	
POWER GIRL (KARA ZOR-EL)		★	
ROBIN/RED ROBIN/DRAKE (TIM DRAKE)	★		
SPOILER (STEPHANIE BROWN)	★	★	
STARFIRE (KORIAND'R)			
STARGIRL/STAR-SPANGLED KID (COURTNEY WHITMORE)			
SUPERBOY (CONNER KENT)			
VIXEN (MARI McCABE)		★	

Infinity, Inc.	Justice League (Various Incarnations)	Justice Society (Various Incarnations)	The Outsiders	Suicide Squad	Teen Titans	The Titans	Young Justice
	★		★	★	★	★	
★	★	★		★			
	★		★	★			
	★		★				
					★	★	
	★				★	★	
	★	★				★	
	★				★	★	
	★				★	★	
	★		★				
★	★	★	★				
	★		★	★			
	★				★		★
	★		★				
	★		★		★	★	
★	★	★					
	★		★				★
★	★	★		★			
			★		★		★
					★		★
	★		★		★	★	
	★	★		★			
				★	★		★
	★			★			

ALTERNATE AND POTENTIAL FUTURES

The future is unwritten, but what may come to pass has been chronicled, most recently in Future State. Other dark futures were averted, but others remained a lingering threat.

THE ADULT LEGION OF SUPER-HEROES: Even the teens of the future had to grow up. Some married. Others died. And Superman—not Superboy—joined them on adventures.

ARMAGEDDON 2001: Monarch imposed his tyrannical rule on the world after killing all of Earth's heroes. The villain's great secret was that he was originally among their ranks.

THE ATOMIC KNIGHTS: The twenty-day-long Great Atomic War eliminated all plant life and nearly all animal life. A group of surviving humans, led by Gardner Grayle, wore radiation-proof suits of armor.

BARREN EARTH: As the sun turned red and expanded in the far future, humans took to the stars. Earth became a desolate barbarian wasteland, until heroine Jinal Ne' Comarr attempted to restore order.

BATMAN: YEAR 100: In 2039, Gotham City had become a police state, but somehow Batman lived to challenge the status quo.

BATMAN BEYOND: An elderly Bruce Wayne passed the mantle of Batman to Terry McGinnis in the high-tech Neo-Gotham. Under Bruce's tutelage, Terry ensured that Batman's legacy continued onward.

BATMAN IN BETHLEHEM: An adult Damian Wayne served as Batman in a Gotham City on the verge of collapse. He worked to save the city from itself before the government intervened with a nuclear strike.

THE DARK KNIGHT RETURNS: Batman came out of a ten-year retirement to confront new crime in Gotham City, only to be set on a collision course with the Gotham City police, the government, and Superman.

DC ONE MILLION: The idyllic 853rd century was threatened by the rogue sentient sun Solaris, requiring heroes from two eras to stop it.

EARTH-AD (AFTER DISASTER): Despite the best efforts of the Global Peace Agency, the world succumbed to the Great Disaster. Intelligent mutant animals became the dominant species as the young human boy Kamandi navigated this strange new world.

FUTURES END: A near-future Earth suffering great unrest due to the arrival of thousands of refugees from a destroyed parallel world, was left vulnerable to the assault of Brother Eye.

THE FUTURESMITHS: A robot revolt ravaged the planet, with a transformed Superman leading the charge to fight Brainiac-created Futuresmiths.

GENERATION LOST: Instigating a metahuman war, Maxwell Lord set in motion a century of chaos, wiping out much of the population of Earth, with the survivors occupying a war-torn landscape.

GOTHAM AD: A Batman-less Gotham City of the near future came under the rule of the Collective, with only the vigilante Mother Panic to save it.

JUSTICE LEAGUE 3000: In the thirty-first century, Project Cadmus controversially resurrected the world's greatest heroes from the previous millennium with decidedly mixed results.

KINGDOM COME: Superman and the Justice League were succeeded by a generation of reckless heroes who threatened the world itself. This future ultimately came to pass on Earth-22.

KNODAR'S FUTURE: Crime was largely abolished in the utopian twenty-fifth century, requiring the last criminal, Knodar, to travel back five hundred years to really cause trouble.

THE LAST KNIGHT ON EARTH: Only Batman and the severed head of The Joker stood a chance against the tyrant Omega.

OLD LADY HARLEY: The Gang of Harleys, who divvied up the five boroughs of New York City after defeating "the Brainiac 5 guys" and were at war with each other ever since.

ROCK OF AGES: After the Justice League destroyed the Worlogog, they were defenseless against Darkseid, who turned Earth into a hellscape.

SORCERER KINGS: A coven of ruthless mystics cast the world into eternal darkness in exchange for unlimited power.

TEAM TITANS: When the godlike son of Donna Troy, Lord Chaos, imposed his dictatorial rule on the world, the Team Titans sought to defeat him.

TIME AND TEMPEST: A corporate war between the Ray and Vandal Savage spilled out into a thousand-year world war.

THE TITANS OF TOMORROW: A great Crisis that wiped out many of Earth's heroes, leaving the Titans to adopt their mentors' identities; they ruled with a fascist grip until a splinter group tried to stop them.

WHATEVER HAPPENED TO THE MAN OF TOMORROW?: Superman's greatest foes teamed up for one final assault on the Man of Steel, exposing his identity and attacking his friends. Following the attack, Superman was never seen again.

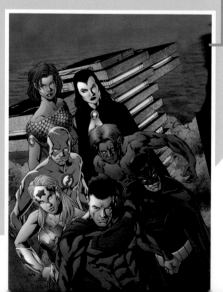

TYPES OF KRYPTONITE

When Krypton exploded, it blasted irradiated rocks from its core out into space. Many fell to Earth as meteorites and were used to wreak havoc on Superman.

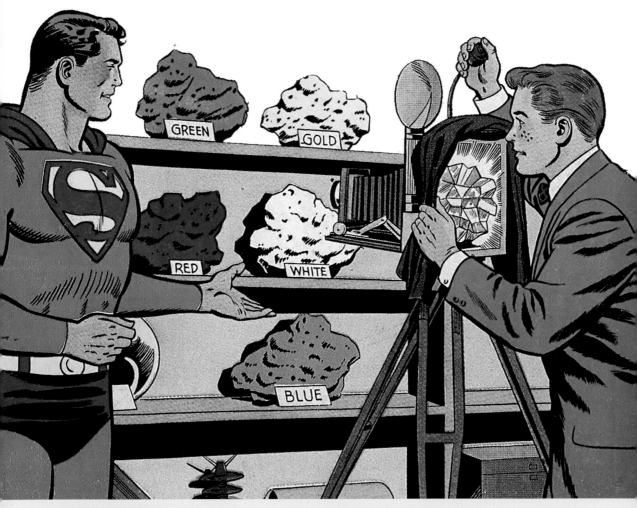

NATURAL KRYPTONITES: Unaltered Kryptonite that arrived on Earth.

ANTI-KRYPTONITE: Had no effect on Kryptonians powered by Earth's yellow sun, like Superman and Supergirl, but fatal to non-powered Kryptonians.

BLACK KRYPTONITE: Split Kryptonian individuals into two separate entities, one good and one evil. It could also send Kryptonians into a murderous frenzy.

BLUE KRYPTONITE: Possessed the same effect on Bizarros that Green K had on Kryptonians, but could also kill a Kryptonian's soul.

GOLD KRYPTONITE: Robbed Kryptonians of their powers, potentially permanently.

GREEN KRYPTONITE: The most common form of Kryptonite robbed Kryptonians of their powers and caused excruciating pain. Prolonged exposure resulted in death for Kryptonians and caused cancer in humans.

JEWEL KRYPTONITE: Remnants of Krypton's Jewel Mountains, which amplified Kryptonians' psychic powers.

PLATINUM KRYPTONITE: Granted humans Kryptonian powers.

RED KRYPTONITE: Exposure resulted in unexpected behavior and physical transformations that lasted twenty-four to seventy-two hours.

SILVER KRYPTONITE: Exposure caused a hallucinogenic effect, as well as increased paranoia and appetite. It also possessed unknown mystical properties.

WHITE KRYPTONITE: Killed all plant life.

ARTIFICIAL AND FAKE KRYPTONITES: Artificially synthesized, modified, or otherwise inauthentic forms of Kryptonite.

BIZARRO RED KRYPTONITE: Blue Kryptonite altered by Bizarro Luthor to affect humans the way Red Kryptonite affected Kryptonians.

BLOOD KRYPTONITE: A fake variation of Green Kryptonite created by Felix Faust to use in a resurrection ritual.

KRIMSON KRYPTONITE: A magical construct by Mr. Mxyzptlk that removed Superman's powers.

KRYPTONITE PLUS: Fake multicolored stones used as part of alien invaders' ruse.

KRYPTONITE-X: Green Kryptonite altered by the Eradicator's energy could restore Kryptonians' powers, but also increased solar radiation absorption at an accelerated rate, causing bodies to increase in mass and powers to become uncontrollable.

MAGNO-KRYPTONITE: A variation of Green Kryptonite created by Mr. Nero that was magnetically attracted to all Kryptonian matter. So once stuck to a Kryptonian, it was impossible to remove.

OPAL KRYPTONITE: Synthesized on Earth-Two by Terry Sloane to drive Kryptonians temporarily insane.

RED-GOLD KRYPTONITE: Caused temporary memory loss in Kryptonians.

RED-GREEN-BLUE-GOLD KRYPTONITE: A failed experiment that split Kryptonians into two separate beings; fortunately, neither was evil.

RED-GREEN-GOLD KRYPTONITE: A new element that robbed Kryptonians of their powers and memory.

RED-GREEN KRYPTONITE (VERSION 1): Synthesized by Brainiac to produce mutations, like growing a third eye.

RED-GREEN KRYPTONITE (VERSION 2): Exposure led to permanent power loss for Kryptonians.

SLOW KRYPTONITE: Created by Metallo, an artificial Green Kryptonite that affected humans the same way regular Green Kryptonite affected Kryptonians.

SYNTHETIC KRYPTONITE: Synthesized by gold, silver, lead, and bismuth, this artificial element had the same effect as the real Green Kryptonite.

X-KRYPTONITE: An attempted synthesized cure to Green Kryptonite, it instead gave any life-form superpowers.

YELLOW KRYPTONITE: A fake. If you find Lex Luthor selling some, don't buy it.

BATMAN'S CONTINGENCY PLANS

Batman was always prepared. From establishing bunkers throughout Gotham City to a packed Utility Belt containing anything he'd ever need, he was always prepared.

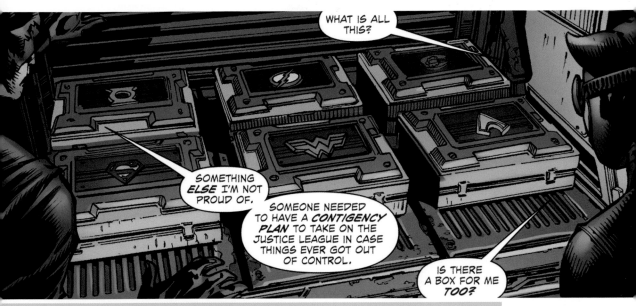

WHAT IS ALL THIS?

SOMETHING *ELSE* I'M NOT PROUD OF.

SOMEONE NEEDED TO HAVE A *CONTIGENCY PLAN* TO TAKE ON THE JUSTICE LEAGUE IN CASE THINGS EVER GOT OUT OF CONTROL.

IS THERE A BOX FOR ME *TOO?*

THE ALFRED PROTOCOL: Backup drives containing all of Batman's memories and trauma, meant to be used with a cloning machine to create a new Batman every twenty-seven years.

BROTHER EYE: Worried he couldn't trust the other Super Heroes, Batman created a satellite that collected data on all metahumans from an undetectable geo-synchronous orbit.

MOON BOMBS: In case the moon ever posed a danger to Earth, Batman planted bombs powerful enough to destroy it completely.

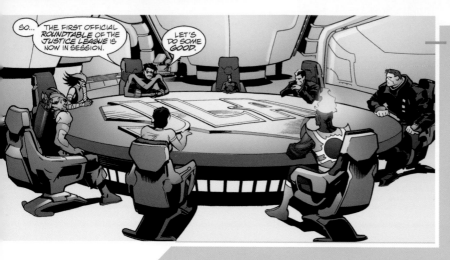

SO... THE FIRST OFFICIAL *ROUNDTABLE* OF THE JUSTICE LEAGUE IS NOW IN SESSION.

LET'S DO SOME GOOD.

REPLACEMENT JUSTICE LEAGUE:
In the event of a cataclysmic dissolution of the Justice League, drones based on Mister Terrific's T-Spheres would recruit an emergency League under Nightwing's leadership.

WAR GAMES:
An ambitious plan to create a power vacuum in Gotham City's underworld and unite all the crime syndicates under a single leader he could control—the vigilante Orpheus.

ZUR-EN-ARRH: A backup personality to take effect if Batman were ever psychologically compromised—meant only for short-term use.

JUSTICE LEAGUE COUNTERMEASURES
Batman put together plans to take down his teammates if ever necessary, which unfortunately fell into the hands of Rā's al Ghūl.

AQUAMAN: Induce hydrophobia with a modified version of Scarecrow's fear toxin, preventing Aquaman from replenishing himself in water.

THE ATOM: Compress him to sub-quantum size using his own white dwarf star belt.

BLACK CANARY AND ZATANNA: Constrict their larynxes with a muscle toxin, cutting off the source of their powers.

FIRESTORM: Induce fission with a particle accelerator to split Firestorm back into two beings.

THE FLASH: Paralyze his nervous system with counter-vibrational strikes.

GREEN ARROW: Bankrupt him as a distraction.

GREEN LANTERN: Diminish his willpower by inducing blindness via posthypnotic suggestion.

MARTIAN MANHUNTER: Cover his body in magnesium and set on fire.

PLASTIC MAN: Freeze and shatter his body, or liquify him with extreme heat and then decant.

STEEL: Intercept or disable his high-tech hammer.

SUPERMAN: Kryptonite. Green to kill; Red to incapacitate.

WONDER WOMAN: Lock her in a virtual reality battle with an unbeatable foe using nanite technology. (Batman later added that the only true means to stop Wonder Woman would be for Superman to subdue her.)

TROUBLE WITH GUY
When Guy Gardner got out of line, all Batman needed was one punch.

A HIERARCHY OF EXTRADIMENSIONAL BEINGS OUTSIDE THE MULTIVERSE

Even the Justice League looked like ants to these beings. Like Russian dolls, each level of existence revealed a new set of beings of unimaginable power.

-THE SOURCE-

Literally the source of all things, the Source spawned an omniverse.

THE JUDGES OF THE SOURCE: Unseen beings, tasked with preserving the omniverse.

CHRONICLER: A functionary of the Source, tasked with recording the last moments of dying multiverses within his Codex Omniversa.

THE COSMIC RAPTOR: Envoy of the Judges dispatched to carry out judgment and maintain harmony.

-THE SIXTH DIMENSION-

The control room where multiverses were designed and set in motion.

THE HANDS: A species tasked with creating their own multiverses.

PERPETUA: One of the Hands, who remained actively involved with her multiverse, whereas others either died or moved on to create others.

ALPHEUS (THE WORLD FORGER): Perpetua's firstborn son resided in the World Forge, where he created form from feelings and hammered new universes into existence from dark matter.

BARBATOS: Alpheus's monster slave destroyed unstable universes so their energies could return to the forge.

MAR NOVU (THE MONITOR): Perpetua's second son monitored and nurtured the development of all positive-matter universes in the multiverse and prevented any crises between them.

MOBIUS (THE ANTI-MONITOR): Perpetua's third son guarded the boundaries of creation, keeping them free of life through the use of antimatter.

-THE FIFTH DIMENSION-

The fifth dimension and its inhabitants existed outside the multiverse. It represented imagination—the blood of the multiverse and the energy that flowed between the dimensions beneath it.

BAT-MITE: An imp who idolized Batman and traveled to Earth to aid him, whether Batman liked it or not.

BRPXZ: The mourning king of Zrfff, the fivefold country, who couldn't smile until he encountered Mxyzptlk.

MR. MXYZPTLK: A troublesome imp who loved to bother Superman by visiting Earth every ninety days to cause chaos.

NYXLYGSPTLNZ: The princess daughter of Brpxz and lover of Mxyzptlk.

QWSP: This water sprite allied himself with Aquaman before transforming into a malevolent entity.

LKZ: A Bhadnisian djinn and rival to Yz.

VYNDKTVX: A sinister imp, envious of Mxyzptlk, who sought to destroy Superman across time.

YZ, THE THUNDERBOLT: The magical djinn who served human masters, such as Johnny Thunder.

-THE UNKNOWN-

Some beings existed outside the defined levels of existence.

DOCTOR MANHATTAN: This godlike figure from another Earth had the ability to reshape the multiverse on a whim.

THE EMPTY HAND: A powerful and mysterious entity that claimed to have destroyed at least one multiverse, with designs on destroying others.

THE GENTRY: Universe-corrupting monstrous beings who constructed the Oblivion Machine.

A HIERARCHY OF EXTRADIMENSIONAL BEINGS WITHIN THE MULTIVERSE

Perpetua's multiverse—encapsulating all time and space—contained multiple spheres. It was bordered on the outermost edge by the Source Wall.

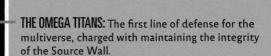

THE OMEGA TITANS: The first line of defense for the multiverse, charged with maintaining the integrity of the Source Wall.

-MONITOR SPHERE-

The outer level of the multiverse was home to the race of Monitors spawned from Mar Novu, each in charge of a universe. Unbeknownst to many of their own, they were celestial parasites feeding off the interdimensional Bleed between universes.

DAX NOVU: The firstborn Monitor, transformed into Mandrakk the Dark Monitor.

ZILLO VALLA: Dax Novu's lover, who led the charge to stop him from destroying existence.

NIX UOTAN: Son of Dax Novu and Zillo Valla, the last of the Monitor race.

ROX OGAMA: A follower of Dax Novu and his successor as Mandrakk the Dark Monitor.

-LIMBO-

Home to lost and forgotten beings from within the multiverse.

MERRYMAN: The former leader of the Inferior Five served as king of Limbo.

-THE SPHERE OF THE GODS-

Home to higher beings worshipped and celebrated throughout the multiverse. Each of the eight realms was mirrored with a twin, preserving a cosmic balance.

HECATE: The primal woman incarnate represented nature itself, born at the dawn of existence before the pantheons that followed.

HEAVEN:
 THE PRESENCE: The god of Abrahamic religions.
 MICHAEL DEMIURGOS: An archangel and Lucifer's twin brother.
 ECLIPSO: The embodiment of its wrath.
 THE RADIANT: The embodiment of its mercy.
 THE SPECTRE: The embodiment of its vengeance.
 THE WORD: The embodiment of its authority.
 THE DECREATOR: Its shadow.

HELL (see page 164 for details)**:**
 THE FIRST OF THE FALLEN
 LUCIFER MORNINGSTAR
 NERON
 LORD SATANUS AND LADY BLAZE

DREAM:
 THE ENDLESS: Seven siblings who each performed a function of life.
 DESTINY
 DEATH
 Death manifested in different forms, including:
 - THE BLACK FLASH
 - THE BLACK RACER
 - NEKRON
 DREAM
 DESTRUCTION
 DESIRE
 DESPAIR
 DELIRIUM (FORMERLY DELIGHT)

THE COURT OF FAERIE: A world of Faerie folk.
 QUEEN TITANIA AND KING AUBERON

GEMWORLD: A world of magical crystals ruled by twelve Royal Houses.
 HOUSE OF AMETHYST
 HOUSE OF AQUAMARINE
 HOUSE OF DIAMOND
 HOUSE OF EMERALD
 HOUSE OF GARNET
 HOUSE OF MOONSTONE
 HOUSE OF OPAL
 HOUSE OF RUBY
 HOUSE OF SAPPHIRE
 HOUSE OF SARDONYX
 HOUSE OF TOPAZ
 HOUSE OF TURQUOISE

NIGHTMARE:
 THE CORINTHIAN: The darkest reflection of humanity personified.
 THE THREE WITCHES: A trio known as the Kindly Ones.

SKYLAND:
 GAEA: The mother of the Titans, who created life out of chaos.
 THE PANTHEONS: The Gods of Olympus, Asgard, the Celts, the Mayans, and more.
 AHL: The God of Super Heroes.

 UNDERWORLD:
 GODS OF THE UNDERWORLD: From the various pantheons, including:
 HADES
 PLUTO
 ANNWN

NEW GENESIS:
 HIGHFATHER

APOKOLIPS:
 DARKSEID

-WONDERWORLD-

An ancient planet on the border of the Orrery of Worlds.

THE THEOCRACY: This team of godlike Super Heroes led by Adam One.

-TELOS-

Opposite Wonderworld on the border of the Orrery of Worlds, the planet containing domed cities from previous time lines.

BRAINIAC: An omnipotent incarnation of Brainiac.
TELOS: The servant to Brainiac and the planet's namesake.

THE QUINTESSENCE

A collective that watched over reality without intervening.

HIGHFATHER
HERA
THE PHANTOM STRANGER
GANTHET
THE GREAT WIZARD

LORDS OF ORDER AND CHAOS

Elemental forces at constant war with each other, manifesting themselves in many forms.

-KWYZZ-

A radio universe embedded in the Speed Force Wall.

KRAKKL THE DEFENDER: A light-speed protector of his world.

-THE ORRERY OF WORLDS-

The sphere containing the universes comprising the multiverse.

THE FUGINAUTS: Beings who protected the barrier between universes from incursions and healed holes in space and time.

-THE UNIVERSE OF EARTH-0-

The prime universe within the multiverse.

ORACLE: A stonelike being responsible for bearing witness to the destruction of worlds.

LIFE ENTITY: The embodiment of all living things in the universe.

THE PARLIAMENTS: Collective groups of totems that represented the interest of their respective elemental force and chose avatars to serve their purpose.

PARLIAMENT OF TREES (AND LATER PARLIAMENT OF FLOWERS): Plant life

PARLIAMENT OF LIMBS: Animal life

PARLIAMENT OF DECAY: Death

PARLIAMENT OF FLAMES: Fire

PARLIAMENT OF VAPORS: Air

PARLIAMENT OF WAVES: Water

PARLIAMENT OF STONES: Earth

PARLIAMENT OF WORLDS: Celestial bodies

THE DIVIDED: Bacteria

THE GREY: Fungi

THE RITHM: Artificial intelligence

ENTER THE FIRESTORM MATRIX

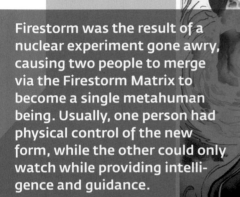

Firestorm was the result of a nuclear experiment gone awry, causing two people to merge via the Firestorm Matrix to become a single metahuman being. Usually, one person had physical control of the new form, while the other could only watch while providing intelligence and guidance.

WHO'S BEEN PAIRED WITH FIRESTORM?

RONNIE RAYMOND: The carefree high school athlete was one half of the original Firestorm pairing.

PROFESSOR MARTIN STEIN: The Nobel Prize–winning physicist.

MIKHAIL ARKADIN: The Russian Super Hero Pozhar, who received powers during the Chernobyl disaster.

SVAROZHICH: A soulless, inhuman Russian clone of Firestorm.

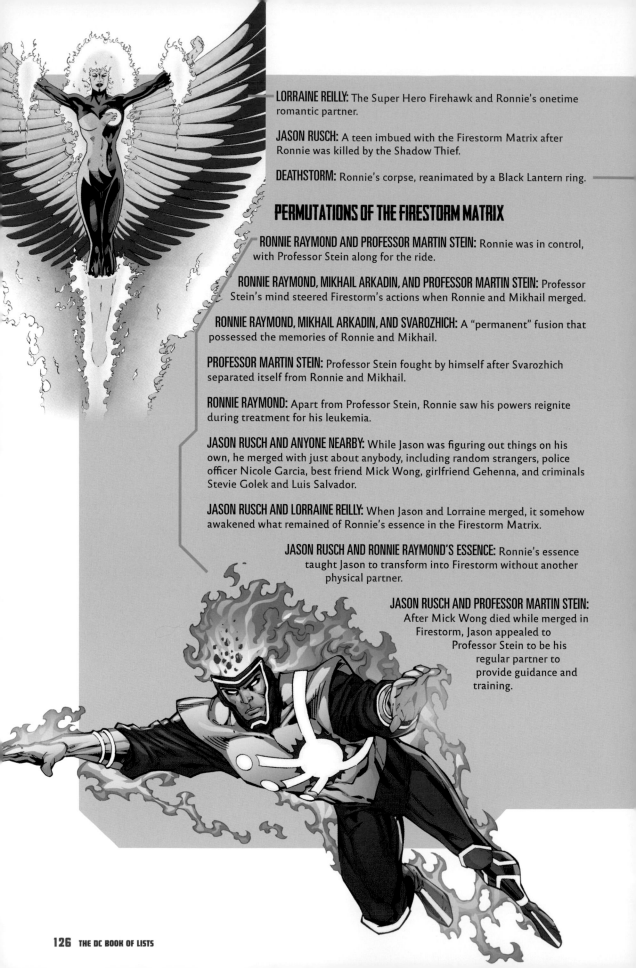

LORRAINE REILLY: The Super Hero Firehawk and Ronnie's onetime romantic partner.

JASON RUSCH: A teen imbued with the Firestorm Matrix after Ronnie was killed by the Shadow Thief.

DEATHSTORM: Ronnie's corpse, reanimated by a Black Lantern ring.

PERMUTATIONS OF THE FIRESTORM MATRIX

RONNIE RAYMOND AND PROFESSOR MARTIN STEIN: Ronnie was in control, with Professor Stein along for the ride.

RONNIE RAYMOND, MIKHAIL ARKADIN, AND PROFESSOR MARTIN STEIN: Professor Stein's mind steered Firestorm's actions when Ronnie and Mikhail merged.

RONNIE RAYMOND, MIKHAIL ARKADIN, AND SVAROZHICH: A "permanent" fusion that possessed the memories of Ronnie and Mikhail.

PROFESSOR MARTIN STEIN: Professor Stein fought by himself after Svarozhich separated itself from Ronnie and Mikhail.

RONNIE RAYMOND: Apart from Professor Stein, Ronnie saw his powers reignite during treatment for his leukemia.

JASON RUSCH AND ANYONE NEARBY: While Jason was figuring out things on his own, he merged with just about anybody, including random strangers, police officer Nicole Garcia, best friend Mick Wong, girlfriend Gehenna, and criminals Stevie Golek and Luis Salvador.

JASON RUSCH AND LORRAINE REILLY: When Jason and Lorraine merged, it somehow awakened what remained of Ronnie's essence in the Firestorm Matrix.

JASON RUSCH AND RONNIE RAYMOND'S ESSENCE: Ronnie's essence taught Jason to transform into Firestorm without another physical partner.

JASON RUSCH AND PROFESSOR MARTIN STEIN: After Mick Wong died while merged in Firestorm, Jason appealed to Professor Stein to be his regular partner to provide guidance and training.

JASON RUSCH AND DEATHSTORM: Deathstorm was in full control, forcing Jason to witness Gehenna's murder.

DEATHSTORM, PROFESSOR MARTIN STEIN, AND ALVIN RUSCH: Surviving Blackest Night via the Firestorm Matrix, Deathstorm merged with Professor Stein as well as Jason's father, Alvin, thereby making it difficult for Firestorm to attack without bringing harm to the men.

JASON RUSCH AND RONNIE RAYMOND: With Ronnie resurrected, both he and Jason could each turn into Firestorm on their own. However, when they merged, they became the powerhouse Fury.

THE MANY ORIGINS OF DONNA TROY

Changes in reality altered many people's lives, but none more extensively or repeatedly as Donna Troy.

SIMPLEST OF BEGINNINGS: Donna was Wonder Woman's younger sister and Queen Hippolyta's second child on the island of Themyscira. She left the island to join the Teen Titans.

BORN IN THE USA: Donna was a human child orphaned when a fire broke out in her family's apartment. Her parents perished, but she was rescued by Wonder Woman, who brought her to Themyscira to be raised by Queen Hippolyta. The island's chief scientist, Paula, used her Purple Ray technology to alter Donna's molecular structure and give her all the abilities of the Amazons.

GROWING TRAGEDY: Donna learned she was abandoned at an orphanage by her young, single mother, Dorothy Hinckley, who soon died of cancer. Donna was taken in by a couple, but after the husband died, the wife was forced to give up Donna. She wound up in the care of a group involved with a child-selling racket when a fire broke out and Donna was rescued by Wonder Woman.

A TITAN FROM THE START: Donna was rescued from the apartment fire by the goddess Rhea, one of the pre-Olympian gods known as the Titans, instead of Wonder Woman. She and eleven other orphans were brought to New Cronus and given great abilities. Donna returned to Earth with implanted memories of being rescued by a fireman and raised in an orphanage before becoming Wonder Girl and joining the Teen Titans.

REINCARNATION BLUES: Donna was a magical mirror duplicate of Wonder Woman, created by the sorceress Magala to serve as a companion for the twelve-year-old Amazonian princess. Mistaking Donna for Diana, Dark Angel kidnapped her. Donna was subjected to a series of torturous lives and reincarnations that culminated in becoming Dorothy Hinckley's daughter, who ultimately wound up in the burning apartment, where she was rescued by Rhea.

REMEMBERING A TITAN: Dark Angel wiped Donna from existence, and only a select few remembered her. Wonder Woman resurrected Donna from the memories of The Flash (Wally West) using her lasso and power granted by the goddess Hestia. Was Donna really herself after that or just how Wally perceived her? She had to answer that question for herself.

A WARRIOR REBORN: Amazonian sorceress Derinoe formed Donna from clay to destroy Wonder Woman and become the new queen of Themyscira. Wonder Woman stopped Donna's deadly revolt and banished her to Themyscira.

COMING FULL CIRCLE: Still conjured from clay as a weapon against Wonder Woman, Donna was defeated but then implanted with fake memories of being a human child rescued by Wonder Woman and raised on Themyscira. She then departed to join the Teen Titans.

THE LEGACY OF ROBIN

From the beginning, Robin was a beacon of hope in Batman's dark war on crime. The bearer of the Robin mantle changed over the years, but its significance never did.

DICK GRAYSON: The young circus acrobat traded the big top for high-flying adventures across the cityscape after he was taken in by Bruce Wayne. When Dick was ready to stand on his own, he hung up the Robin costume and assumed the identity Nightwing.

JASON TODD: Reckless and filled with anger, Jason Todd's tenure was cut tragically short when he was murdered by The Joker. Upon resurrection, he returned to crime fighting as the Red Hood.

TIM DRAKE: The child genius deduced Batman's identity and sought him out following Jason's death. He believed Batman needed a Robin and was ready to serve. He later went by Red Robin before settling on Drake.

STEPHANIE BROWN: When Tim Drake briefly quit being Robin, the hero Spoiler insisted Batman take her on as the next Robin. Her time as Robin was cut short when she was gravely injured and believed dead.

DAMIAN WAYNE: The headstrong son of Bruce Wayne and Talia al Ghūl saw the mantle of Robin as the stepping-stone to ultimately succeeding his father as Batman.

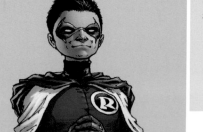

WE ARE ROBIN: A youth movement to inspire change in Gotham City, the group included Duke Thomas, Robina, R-iko, DaxAtax, and Dre-B-Robbin among their ranks.

ONCE AND FUTURE ROBINS

The legacy of Robin echoes out into the multiverse, turning up in surprising places in both the past and the future.

CARRIE KELLEY: Rescued by Batman the night of his return after a ten-year retirement, Carrie Kelley fashioned her own Robin costume and ventured out to join him.

MATT McGINNIS: Ever since Terry McGinnis took over as Batman from an elderly Bruce Wayne, his younger brother, Matt, was eager to join him. He finally did, becoming Robin.

RICKY: In the year 3000, Earth was enslaved by a warlord from Saturn. Young Ricky and his older companion Brane donned the identities of Batman and Robin to liberate the planet.

ROBIN REDBLADE: Street urchin Robin Redblade became a stowaway on the pirate ship belonging to Captain Leatherwing, the Batman of this reality.

BRUCE WAYNE: When young Bruce Wayne decided to shadow Detective Harvey Harris and learn his sleuthing skills, he crafted the fanciful Robin costume to hide his identity.

BRUCE WAYNE JR.: The son of Bruce Wayne and Kathy Kane, Bruce Jr. became Robin when Dick took over as Batman following Bruce and Kathy's retirement from crime fighting.

TOM WAYNE: In another version for the year 3000, Tom Wayne, a descendant of the original Batman, confronted alien conquerors, the Skulp, after his uncle—that era's Batman—was killed.

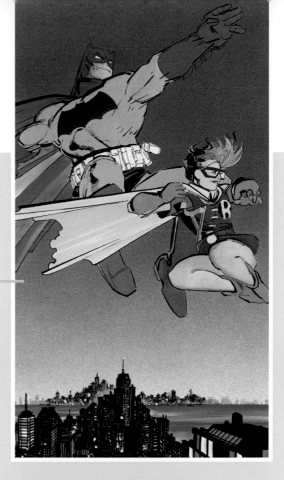

DICK GRAYSON'S CAREER CHANGES

When not venturing out into the night as a Super Hero, Dick Grayson tried his hand at many different careers upon reaching adulthood:

BARTENDER
BLACKJACK DEALER
CIRCUS OWNER
EXOTIC DANCER
GYM TEACHER
JOURNALIST
CONGRESSIONAL AIDE
MODEL
MUSEUM CURATOR
PERSONAL TRAINER
POLICE OFFICER
SOCIAL WORKER
TAXI DRIVER
TRAPEZE INSTRUCTOR
WAYNE INDUSTRIES EXECUTIVE

DC'S PRIMATES

The primates of the DC universe came in all shapes and sizes. Some smart, some dumb, some alien—all unforgettable.

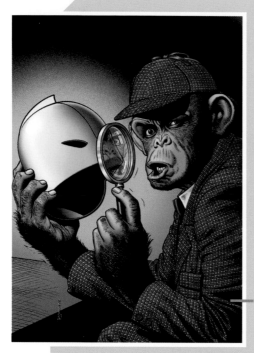

ORDINARY EARTH PRIMATES

ANDY: Wonder Woman's unlikely partner for a baseball game to save a school.

BONGO: This TV star was chimp-napped by a gang. Before Superboy could rescue him, he used his smarts to alert the police and stop the crooks.

BRUNA: A sacred gorilla who fell in love with Jimmy Olsen and married him.

LEOPOLD: A baboon, dressed in a Superman suit by Lex Luthor, whose sole purpose was to discredit Clark Kent's reporting.

MOGO: The Bat-Ape: A circus ape who donned a cape and cowl to clear his framed trainer.

PRIMATES WITH EXTRAORDINARY ABILITIES

BOBO THE DETECTIVE CHIMP: A carnival chimp who gained super-intelligence and the ability to speak after drinking from the Florida-based Fountain of Youth. His true name was "mostly an unpronounceable screech and three grunts" that translated to "Magnificent Finder of Tasty Grubs."

BONZO: A onetime recipient of the power of Shazam.

CHANDU: Water contaminated with Kryptonite gifted this gorilla with X-ray vision.

DJUBA: A red gorilla, residing on top of the snow-covered summit of Kilimanjaro, who guarded B'wana Beast's elixir and helmet.

THE GORILLA WONDERS OF THE DIAMOND: Nine super-intelligent gorillas who decided to pose as a baseball team to travel the United States and plant mind-control devices throughout the country.

JACKANAPES: Taken from his mother at a young age and raised by The Joker, Jackanapes never had a chance at a normal gorilla life.

KARMAK: A lab experiment gone wrong imbued a gorilla with the powers of mind control and absorbing the abilities of others, including Batman's fighting skills and intellect.

KILLA: Killa was a genetically modified gorilla from an uncharted island in the Pacific Ocean.

KING KRYPTON THE SUPER-GORILLA: A Kryptonian scientist whose evolution accelerator for space travel didn't quite work as planned.

KINGORILLA: A giant gorilla worshipped like a deity didn't at all resemble a certain cinematic ape who climbed the Empire State Building.

MR. STUBBS: The multiverse-faring adventurer Mr. Stubbs was partner to Nix Uotan, last of the Monitors, or just an inanimate plush monkey in Nix's room.

MONSIEUR MALLAH: The red-beret wearing, gun-toting gorilla with an IQ of 178 who founded the Brotherhood of Evil with his lover, a brain in a jar.

THE PRIMATE PLATOON: Nazi. Gorillas.

RALPH: Criminal Johnny Farrell devolved into a talking ape with his friend's Cosmiray Evolution Machine.

TITANO: A mutated giant chimpanzee with the ability to shoot Kryptonite radiation from his eyes.

UNNAMED MONKEY: Somewhere in the realm of Limbo resided a monkey, hard at work writing Shakespeare's *The Tempest* on a typewriter.

RESIDENTS OF GORILLA CITY

Contact with an alien spacecraft imbued a tribe of gorillas in Africa with superior intelligence that they used to build the technologically advanced kingdom, hidden away from humankind's world.

GORILLA GRODD: The most infamous and fiercest super-intelligent ape in the world, Gorilla Grodd received additional telepathic and telekinetic abilities from his exposure to the alien spacecraft.

SOLOVAR: The benevolent king who ruled until his murder by Grodd.

NNAMDI: Solovar's son and successor to the crown.

BIYO: The ape who gave birth to a holy child with healing powers, known as a Nzame.

BOKA: Solovar's fiancée, who left him for Grodd.

DR. CALOMAR: A scientist who left to work with the US government.

GORBUL MAMMIT: The son of Grodd and Boka, who attempted to create his own race of super-apes.

GORILLA KNIGHTS: Young gorillas led by Tolifhar, who were recruited by Grodd but later pledged their allegiance to Wonder Woman, moving into her apartment.

SAM SIMEON: Grodd's grandson, who relocated to New York City and became a comic book artist and a private detective.

SIMIAN SCARLET: A secret cabal, including Abu-Gita, Admiral Trafalgo, General Zolog, and Grimm, who attempted to start an ape-human war while under the influence of Gorilla Grodd.

ULGO: Nnamdi's cousin, Gorilla City's representative to the United Nations.

YOU MAY BE THE MAN WITH ANIMAL POWERS, *A-MAN*, BUT I'M THE *REAL McCOY!*

ANIMAL-MAN *BATTLES THE* MOD GORILLA BOSS!

ALIEN PRIMATES

BEPPO: A Kryptonian monkey who stowed away on the rocket that brought Superman to Earth.

GLEEK: A blue, alien monkey from the planet Exxor, whose tail could stretch to any length and was strong enough to lift a man.

THE INHABITANTS OF GORILLA LAND: Intelligent gorillas who communicated telepathically via stones native to their uncharted world in space sector XYG-46.

OCTI-APE: An eight-limbed ape from the menagerie of alien Kar Han and family.

SPACE APE: Prince Lorix, known to teammates as Space Ape, was a member of the Sinestro Corps before becoming a Green Lantern.

SUPER-APE: A Kryptonian ape used in a test rocket, who was raised by a pair of kind Earth apes until Superman one day helped reunite him with the other Kryptonian apes on their very own planet.

YANGO: An intelligent Kryptonian ape who led a tribe of Earth apes and protected all wildlife from poachers.

PRIMATES HOSTING A HUMAN BRAIN OR CONSCIOUSNESS

CONGORILLA: Adventurer William "Congo Bill" Glenmorgan received a magic ring that allowed him to transfer his consciousness into the body of the fabled Golden Gorilla.

GORILLA BOSS: Mobster George "Boss" Dyke arranged to have his brain transplanted into the body of a gorilla after his death sentence.

MOD GORILLA BOSS: A crook transformed into a stylishly dressed gorilla.

ULTRA-HUMANITE: A mad scientist with great mental abilities needed a body powerful enough to contain his mind.

XAVIER SIMON: A revenge-seeking criminal trapped in the body of an albino gorilla, who hoped to trade up for Batman's body.

AND GIGANTA...

Originally, a gorilla evolved into a towering strongwoman by a scientific experiment. Her later origin introduced her as Doris Zeul, a doctor dying of a rare blood disease, who attempted to transfer her consciousness into Wonder Woman's body but wound up in the body of a gorilla named Giganta. Dr. Zeul found a new human host in Olga, a circus performer who could enlarge her body, but kept the name Giganta.

THE MANY LOVES OF HARLEY QUINN, REQUITED OR OTHERWISE

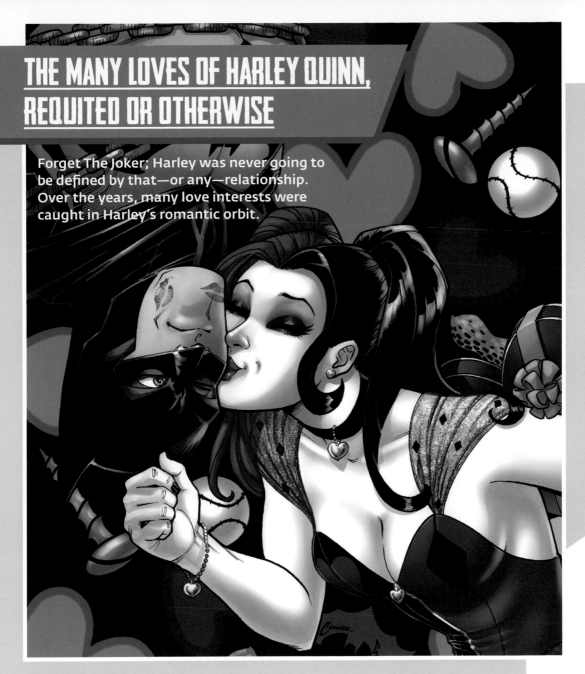

Forget The Joker; Harley was never going to be defined by that—or any—relationship. Over the years, many love interests were caught in Harley's romantic orbit.

BERNIE BASH: Harley's first crush showed his feelings by killing Harley's high school nemesis.

GUY KOPSKI: Harley's college boyfriend was also her unwitting psychology test subject.

JOSH THE HENCHMAN: Harley wasn't feeling the attention The Joker's new henchman gave her, and neither did The Joker, so he blew up Josh.

DETECTIVE JOHN BISHOP: Harley's brief fling with the detective was never meant to be, particularly when he didn't know her real identity.

TOMMY ELLIOT: Posing as Bruce Wayne, Tommy cozied up to Harley to get revenge on Catwoman, while Harley used the opportunity to make The Joker jealous.

DEADSHOT: Harley and Deadshot's fling came to an end when she made him wear The Joker's severed face and he proceeded to shoot her.

POISON IVY: Friends for years, Ivy and Harley shared a true love that brought them back into each other's arms again and again.

POWER GIRL: Harley's attempt to woo Power Girl got her stranded atop the Eiffel Tower.

BRUCE WAYNE: Harley paid $1,000,100 for a date with the real Wayne at a fundraiser.

GREEN LANTERN: Harley got a little frisky with Hal Jordan after their team-up, but he took off before she could get his number.

RED TOOL: The vigilante kidnapped Harley for their first date and tried to marry her on their second. Somehow, she remained friends with him.

LOBO: One thing led to another when Harley and Lobo went skinny-dipping on an alien planet.

RICK FLAG JR.: This Suicide Squad romance was cut short when Rick seemingly perished, leaving Harley heartbroken.

MASON MACABRE: The ex-con was murdered by one of Harley's rivals because of his "association" with her.

BOOSTER GOLD: After a couple of team-ups, Harley realized she was developing feelings for her "Big, Slobbery Booster Golden Retriever."

WEDDING DAZE

The post-apocalyptic wasteland world of Old Lady Harley revealed quite a lineup of failed marriages over the years.

BIG TONY DELFINI
CATWOMAN
FRANK FRANK
KILLER CROC
NIGHTWING
POISON IVY
RED TOOL

HIDDEN POPULATIONS OF EARTH

The Amazons of Themyscira and the Atlanteans throughout the oceans were well known even if their domains were inaccessible. Many other populations remained tucked away from the outside world, thriving in secret.

SECLUDED POPULATIONS

THE DZYAN: Tall, porcelain-skinned, shape-changing aliens who established a city in the Arctic.

THE FEITHERANS: Birdlike beings hailing from the hidden city of Feithera in Greenland.

THE H'V'LER'NI: Advanced beings from the city-state of A'r'ven in South America, who placed their minds into a giant robot when a plague destroyed their bodies.

THE HOMO MAGI: Magic-wielding humans who evolved alongside *Homo sapiens*, from which Zatanna descended.

THE IS BYGD: A clan of the Norwegian Romani people with ice powers, from which Ice (Tora Olafsdotter) hailed.

THE KINGDOM OF ICEBERG-LAND: A population of cold-blooded ice-people at the North Pole.

THE MEN OF SECRET CITY: A population, discovered by The Flash (Jay Garrick), capable of mind control and mental projection.

THE NETHERWORLDERS: Disaffected metahuman "phreaks" gathered in the old stockyards of South Side, Chicago.

THE SILICON MEN: Human-hating silicon-based "sand men" inhabiting a secret city in the Gobi Desert.

THE TERRORFORMS: Beings that emerged only to protect species going through a rapid evolutionary change from danger.

THE UNDERGROUND PEOPLE: A population of orange-skinned beings with pointy ears, noses, and chins, living in a city one hundred miles below the surface that began dying out from a noxious natural gas.

SUBTERRANEAN POPULATIONS

THE ABYSSIANS: A tribe of humans led by a telepathic monarchy beneath the Alps.

BASTO'S CAVE BEINGS: A tribe of blue-furred Neanderthal-like beings who obeyed the command of rogue explorer Emile Basto.

THE CENTAURS: The mythic human-horse beings, who established a city within a dormant volcano.

THE CLOUD CREATURES: Weather-controlling cloud beings who came to the surface to wipe out mankind.

THE DAUGHTERS OF VENUS: Women from Venus, chosen by the goddess Aphrodite to inhabit the Garden of Eden, which sank below the South Pole.

THE LANSINARIANS: A highly advanced race of blind humans living beneath of the frozen surface of Antarctica.

THE KERNUGIANS: A race of aliens who posed as Mesopotamian deities and dwelled in caverns beneath the Syrian desert.

THE MIROS: Winged reptilian beings whose city beneath the North Pole was sustained by an artificial sun.

THE MOLE MEN: A blind race whose women were enslaved until Wonder Woman intervened.

THE MULDROOGANS: The inhabitants of a lush sanctuary sustained by irradiated God Stones, whose interactions with the surface led to them worshipping Batman as a folkloric hero.

THE SEAL MEN: Hostile, blue-skinned beings living in the South Pole caverns of Bitterland.

THE STRATANS: An advanced civilization made up a variety of species with geomorphic powers that evolved within the corpse of a giant alien that crashed on Earth centuries ago.

THE SUBTERRANEANS: An imperial matriarchy seven miles beneath the surface of Venezuela, who produced a powerful source of renewable energy from the life force of adorable monkey creatures.

THE UNDERWORLDERS: A homeless population beneath the streets of Metropolis, largely composed of mutant clones from Project Cadmus.

MINIATURE POPULATIONS

THE ELVARANS: Six-inch, bat-riding humanoids who retreated to caves as mankind dominated the planet.

THE KATARTHANS: A yellow-skinned, miniature alien race, inhabiting the colony of New Morlaidh in the Amazon jungle.

THE NORTUIIANS: A microscopic race from a planet orbiting a single nucleus, invisible to humans and possessing the proportional strength of Superman.

THE WAITING: A warmongering miniature race that rode insects and lived in cities nestled in dogs' fur.

RUNS IN THE FAMILY

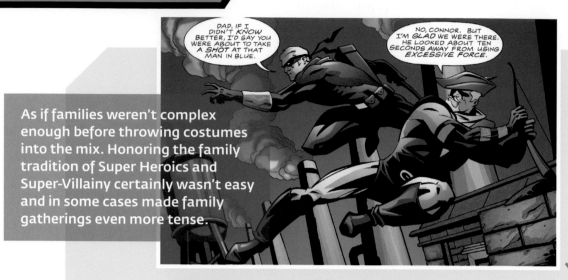

As if families weren't complex enough before throwing costumes into the mix. Honoring the family tradition of Super Heroics and Super-Villainy certainly wasn't easy and in some cases made family gatherings even more tense.

SUPER HERO PARENTS, SUPER HERO OFFSPRING

THE ATOM (Al Pratt) ⟶ DAMAGE (Grant Emerson)
BLACK CANARY (Dinah Drake Lance) ⟶ BLACK CANARY (Dinah Lance)
BLACK LIGHTNING (Jefferson Pierce) ⟶ THUNDER (Anissa Pierce)
 AND LIGHTNING (Jennifer Pierce)
THE FLASH (Barry Allen) ⟶ THE TORNADO TWINS (Don and Dawn Allen) ⟶
 KID FLASH (Bart Allen; son of Don) AND XS (Jenni Ognats; daughter of Dawn)
THE FLASH (Wally West) ⟶ IMPULSE (Iris West [II])
GIOVANNI ZATARA ⟶ ZATANNA ZATARA
GREEN ARROW (Oliver Queen) ⟶ GREEN ARROW (Connor Hawke)
GREEN LANTERN (Fentara Rrab) ⟶ GREEN LANTERN (Arisia Rrab)
GREEN LANTERN (Tomar-Re) ⟶ GREEN LANTERN (Tomar-Tu)
HAWKMAN (Carter Hall) AND HAWKGIRL (Shiera Hall) ⟶ SILVER SCARAB /
 DOCTOR FATE (Hector Hall)
HOURMAN (Rex Tyler) ⟶ HOURMAN (Rick Tyler)
JOHNNY QUICK (Johnny Chambers) ⟶ JESSE QUICK (Jesse Chambers)
STARMAN (Ted Knight) ⟶ STARMAN (David and Jack Knight)
SUPERMAN (Clark Kent) ⟶ SUPERBOY (Jon Kent)
SWAMP THING (Alec Holland) ⟶ SPROUT (Tefé Holland)
WILDCAT (Ted Grant) ⟶ TOMCAT (Tommy Bronson)
WONDER WOMAN (Diana Trevor) ⟶ FURY (Lyta Trevor; Pre-Crisis only)

SUPER HERO PARENTS, SUPER-VILLAIN OFFSPRING

DONNA TROY ⟶ LORD CHAOS (Robert Long)
GREEN LANTERN (Abin Sur) ⟶ YELLOW LANTERN (Amon Sur)
LIGHTNING LAD (Garth Ranzz) AND SATURN GIRL (Imra Ardeen) ⟶ VALIDUS
 (Garridan Ranzz)

SUPER-VILLAIN PARENTS, SUPER-VILLAIN OFFSPRING

GENERAL DRU-ZOD AND URSA ⟶ LOR-ZOD
HENRI DUCARD ⟶ NOBODY (MORGAN DUCARD)
ICICLE (Joar Mahkent) ⟶ ICICLE (Cameron Mahkent)

THE MIST (Kyle Nimbus) ⟶ THE MIST (Nash Nimbus)
RÄ'S AL GHÜL ⟶ TALIA AL GHÜL

SUPER-VILLAIN PARENTS, SUPER HERO OFFSPRING

BLACK MANTA (David Hyde) ⟶ AQUALAD (Jackson Hyde)
BRAIN WAVE (Henry King Sr.) ⟶ BRAIN WAVE (Henry King Jr.)
CLUEMASTER (Arthur Brown) ⟶ SPOILER (Stephanie Brown)
DAVID CAIN AND LADY SHIVA ⟶ ORPHAN (Cassandra Cain)
NOBODY (Morgan Ducard) ⟶ NOBODY (Maya Ducard)
THAAL SINESTRO ⟶ GREEN LANTERN (Soranik Natu)
TRIGON ⟶ RAVEN (Rachel Roth)

SUPER-VILLAIN PARENTS, MORALLY AMBIGUOUS OFFSPRING

CAPTAIN BOOMERANG (Digger Harkness) ⟶ CAPTAIN BOOMERANG (Owen Mercer)
DEATHSTROKE (Slade Wilson) ⟶ RAVAGER (Grant Wilson; villain only),
 JERICHO (Joseph Wilson; hero turned villain), AND RAVAGER (Rose Wilson;
 villain turned hero)

SUPER HERO AND SUPER-VILLAIN PARENTS, SUPER HERO OFFSPRING

BATMAN (Bruce Wayne) AND TALIA AL GHÜL ⟶ ROBIN (Damian Wayne)
GREEN LANTERN (Alan Scott) AND THORN (Rose Canton) ⟶
 JADE (Jennifer-Lynn Hayden) AND OBSIDIAN (Todd Rice)
POWER GIRL (Kara Zor-El) AND SCARABUS ⟶ EQUINOX
SUPERMAN (Clark Kent) AND LEX LUTHOR ⟶ SUPERBOY
 (Conner Kent; cloned from their DNA)

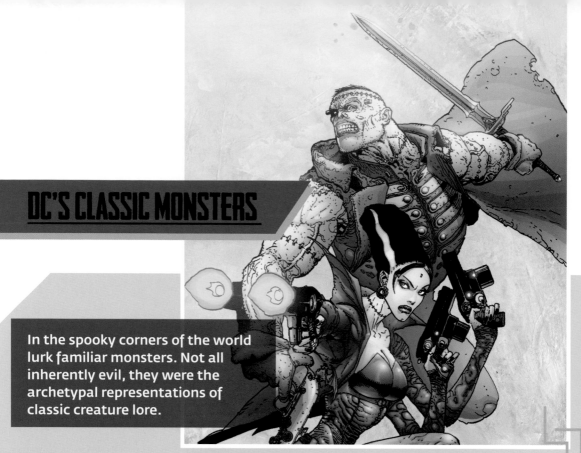

DC'S CLASSIC MONSTERS

In the spooky corners of the world lurk familiar monsters. Not all inherently evil, they were the archetypal representations of classic creature lore.

AMPHIBIAN CREATURES

BOGMAN: Member of the Creature Commandos.

LAGOON BOY: Atlantean Super Hero and member of the Teen Titans.

NINA MAZURSKY: Member of the Creature Commandos.

FRANKENSTEIN'S MONSTER

FRANKENSTEIN: Created by Doctor Frankenstein using stolen body parts and the blood of Melmoth.

THE BRIDE: Estranged wife of Frankenstein and fellow agent of S.H.A.D.E.

PATCHWORK (Private Elliot "Lucky" Taylor): Member of the Creature Commandos.

SPAWN OF FRANKENSTEIN: The unstable son of Frankenstein and the Bride, who forced his parents to kill him.

YOUNG FRANKENSTEIN: Onetime member of the Teen Titans.

GORGONS

ANDONIS BAL: Member of Mento's team, the Hybrid.

GORGONUS: Resident of the Tower of the Dead.

MEDUSA: The actual Greek legend.

MEDUSA (DR. MYRRA RHODES): Member of the Creature Commandos.

MUMMIES

ATEN: Member of the Creature Commandos.

HASSAN: Guardian of Zatanna's home, Shadowcrest.

KHALIS: Ancient Egyptian priest and member of the Creature Commandos.

SONS OF ANUBIS: Warrior team working with Mordru.

VAMPIRES

ALLEN BARR: Scientist whose serum cured cancer but made humans poisonous to vampires.

ANDREW BENNETT: Vampire who hunted his own kind.

AZZARENE: Protector of the Holy Grail.

BABE TANAKA: Friend of Jimmy Olsen turned by Baron Ruthven.

BARON NIGHTBLOOD: Alcoholic member of the League of Annoyance.

COUNTESS BELZEBETH: Alien from Vorr, the planet of the vampires.

BARON RUTHVEN: Vampire who nearly turned Superman.

BLOODY MARY: Member of the Female Furies.

CARNIVORE: The first vampire, who attempted to conquer heaven.

COLONEL YURI RASHNIKOV: High-ranking KGB leader of vampire soldiers.

COUNT BERLIN: Nazi vampire member of the Fourth Reich.

THE CULT OF THE BLOOD RED MOON: One of the oldest vampire groups in existence. It was responsible for many vampires, including:

BILLY KESSLER
DUNYA MISHKIN
EMIL VELDT
JONATHAN GUNNARSON
MAGGIE CARLE

DALA AND LOUIS DUBOIS: Sibling vampires from New Orleans.

DRACULA: The evil count of legend.

DRAGORIN: A clone from Transilvane.

EDWARD TRANE: Assistant to Andrew Bennett.

ELLIE MAE SKAGGS: Notably turned into a vampire three days after President Lincoln was assassinated.

GUSTAV DECOBRA: Scientist turned vampire who encountered Batman.

HEMO-GOBLIN: A white supremacist.

JONATHAN ROMERO: Lead singer for the popular band the Dead Romeos.

LA SANGRE: Spanish crime fighter.

LOOKER (EMILY BRIGGS): Super Hero member of the Outsiders.

LORD CRUCIFER: Leader of the Tenth Circle cult.

THE MAD MONK (NICCOLAI TEPES): Leader of the Brotherhood cult.

MARIUS DIMETER: Reluctant ally of Batman.

MARY, QUEEN OF BLOOD (MARY SEWARD): Leader of the Cult of the Blood Red Moon and nemesis of Andrew Bennett.

NIGHTRIDER (DAGON): Member of the Team Titans.

NOCTURNA (NATALIA MITTERNACHT): Gotham City–based thief.

NOSFERATA: Inhabitant of the Wild Lands.

PRINCE RODERICK: Nemesis of the Outsiders.

PYRA: Member of the Corpse Corps.

PRYEMAUL: Vampire. Nazi. Gorilla.

REVEREND EDGAR WARNOCK: Leader of the American Crusade, a radical political movement.

SCHREK: Agent of Soviet military group Red Shadows.

SCREAM QUEEN (NINA SKORZENY): Lead singer for Scare Tactics.

SERGEANT VINCENT VELCORO: Member of the Creature Commandos.

STAKE: Vampire who became a vampire hunter.

STARBREAKER: Alien vampire who fed on energy.

TIG RAFELSON: Teen vampire hunter turned vampire.

VICTOR CHRISTIANSON: Longtime ally of Madame Xanadu.

VRYKOS: Servant of Mordru.

WEREWOLVES

ANTHONY LUPUS: Former athlete turned werewolf by rogue scientist Professor Milo.

BIG BAD WOLF (DOLPH MARROCK): Carrier of the Lukos virus.

COACH HUMPHREYS: Coach at Gotham Academy.

EL LOBIZON: Member of the Argentinian super-team Súper-Malón.

FANG (JAKE KETCHUM): Guitar player for Scare Tactics.

HARRY FORCE: Wandering do-gooder.

THE HOWLERS: Infernal lycanthropes from hell.

KYLE ABBOT: Founder of the True Believers cult.

LAR-ON: Kryptonian lycanthrope.

LUPEK: A clone from Transilvane.

MIKOLA ROSTOV: A swordsman in Skartaris.

MRS. DANIELS: Leader of the Wolf Cult.

ROVER: Companion to Lucien the Librarian at Ghost Castle.

SCRATCH (ZACK): Deformed teen runaway.

SEA WOLF (I): Aquatic Nazi werewolf member of Axis Amerika.

SEA WOLF (II): Aquatic eater of souls.

TURK: Archer rival of Arrowette.

WOLFPACK (PRIVATE WARREN GRIFFITH): Member of the Creature Commandos.

SUPERGIRL GOES BAD

The S-shield adorning the outfit may stand for hope, but for each of the women carrying the mantle of Supergirl, a darkness lurked beneath the surface.

BLACK MAGIC: Cursed by a demonic ring, Kara grew red horns and had the uncontrollable urge to commit evil acts, such as giving a bank robber demonic wings so he could fly away from the police. While she struggled to cure herself, she used her new abilities to turn Superman blind so he couldn't see her horns.

BRAIN ON FIRE: The flaming-sword-wielding Nightflame grew from the darkest recesses of Kara's subconscious. She desired to purge the goodness from Kara's body and possess it for herself.

BAD HAIR DAY: Now cursed by Medusa's ghost, Kara watched as her blond locks transformed into a headful of snakes. After she accidentally turned a pair of robbers to stone, the Justice League attempted to intervene. They too were turned to stone as Kara insisted on finding a cure on her own.

IDENTITY CRISIS: After a breakdown, Matrix Supergirl thought she was Superman. Since there could be only one Superman, she tried to kill the real deal before coming to her senses.

BETRAYED BY LOVE: Matrix rightfully flipped out when she learned her lover, Lex Luthor, was attempting to make clones of her. The berserker look returned when Matrix was possessed by Raven and forced to fight the New Teen Titans.

MONKEY'S PAWN: Under the mind control influence of Gorilla Grodd, Linda Danvers became an errand girl for robbing and kidnapping.

MATRIX RETURNS: Matrix had merged with Linda Danvers—long story—but something got left behind. That something manifested in a monstrous new form. Insane and homicidal, Matrix wanted to reclaim her Supergirl identity.

WELCOME TO THE DARK SIDE: Kara Zor-El was back! Once more a new arrival on Earth, Kara was promptly abducted and brainwashed by Darkseid. Kara battled her cousin Superman and could only be subdued by a Kryptonite punch.

SUPERGIRL BLACK, SUPERGIRL BLUE: Exposed to Black Kryptonite by Lex Luthor, Kara was split into two separate beings—one good and one evil. Dark Kara briefly resurfaced again during a Justice League battle with the Omega Man.

EXECUTIVE MISTAKE: After the Amazons attacked Washington, DC, Wonder Girl and Kara attempted to help broker peace talks . . . by kidnapping the president of the United States while he was aboard Air Force One. Amazons attacked the plane, but Supergirl managed to bring it down safely.

SUPERGIRL AT THE END OF THE WORLD: Kara went along with the crazed H'El's plan to resurrect Krypton, even fighting the Justice League to make it happen. Unbeknownst to her, if carried out, H'El's plan would've destroyed Earth and everyone on it.

RAGING OUT: Kara had a lot of pent-up anger when she was recruited to the ranks of the rage-fueled Red Lantern Corps. The red power ring transformed her into a near-unconquerable powerhouse.

SUPERGIRL THE INFECTED: The wicked Batman Who Laughs had designs on corrupting Superman, but Kara intervened by catching a poisoned Batarang meant for her cousin. She transformed into her devilish new persona, free of inhibitions with a maniacal laugh and a newfound loyalty to the evil Batman.

THE LEGION OF SUPER-HEROES TIME LINES

A group of teens from the future, each hailing from a different planet and possessing a different set of powers, united to protect the universe from harm. Largely inspired by heroes of the past, they adopted monikers and costumes as they served as bright, shining examples of all the future has to offer.

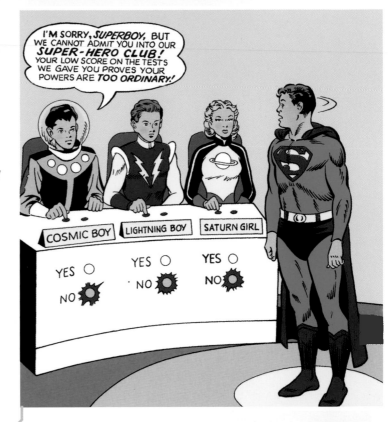

ORIGINAL TIME LINE: Lightning Boy, Saturn Girl, and Cosmic Boy traveled from the thirtieth century to meet their inspiration, Superboy, and invited him to the future for adventures with the Legion.

POCKET UNIVERSE TIME LINE: In the wake of the *Crisis on Infinite Earths*, which wiped out Clark Kent's time as Superboy, the Time Trapper created a pocket universe where Clark still was Superboy. All the Legion's previous adventures occurred in this pocket universe, not the Post-*Crisis* time line. Problem. Solved.

FIVE YEARS LATER / GLORITHVERSE TIME LINE: Five years after the Magic Wars, the Time Trapper was killed and the Legion was wiped from existence, allowing the Mordru to conquer the universe. One of his wives, Glorith, remembered the old time line and used the Time Trapper's powers to restore it . . . mostly. The Legion was now inspired by the twentieth-century hero Mon-El. This time line also included duplicates of the entire Legion, known as the Batch SW6 Legion, but let's not get into that.

THE POST-*ZERO HOUR* REBOOT TIME LINE: After *Zero Hour*, a new Legion was born, which wasn't inspired by the original Superboy or Mon-El. However, the new Superboy, Conner Kent, eventually made his way to the future for some adventures. A team-up with the Teen Titans against the Fatal Five results in the space-time continuum being torn apart, causing this Legion to vanish.

THE "RETROBOOT" TIME LINE: If the "Threeboot" team was the future, who were these Legionnaires showing up in the twenty-first century on a secret mission, looking like grown-up versions of the original time line team? After Superman's history as Superboy was restored in the present day, the original Legion was back with their own future.

THE "THREEBOOT" TIME LINE: The Legion formed anew in an oppressive society that looked down on any form of youthful expression. Though they did not meet Superboy, this Legion welcomed Supergirl to the team.

THE LEGION OF 3 WORLDS

With the "Retroboot" and "Threeboot" teams existing simultaneously, it was as good a time as any to see where the Post–*Zero Hour* "Reboot" team had been. All three Legions worked together to stop the Superboy-Prime. The "Threeboot" Legion was revealed to be from another Earth and the "Reboot" Legion, without a universe to call their own, headed out to explore the multiverse.

THE *NEW 52* TIME LINE: *Flashpoint* changed the time line again, with all present-day heroes losing much of their history. In the future, the Legion was seemingly unaffected. However, Clark Kent once again lost his time as Superboy, so it was quite possible this Legion belonged to the future of another Earth.

THE SECOND *NEW 52* TIME LINE: I know, things are getting complicated. Clark Kent was never Superboy but, at least once, he was met by three teens from the future and, years later, they returned to join him in a fight against the Anti-Superman Army. This Legion willingly erased their own future by helping to prevent Superman's death at the hands of Vyndktvx.

THE *REBIRTH* LEGION TIME LINE: The time-alternating machinations of Doctor Manhattan upon his entry into the DC Universe once again restarted the Legion with a clean slate. These teenagers drew inspiration from Superboy, but in this case, it was Superman's son, Jon Kent, whom they then invited to join them in the future.

Long Live the Legions!

CITIZENS OF THE OLD WEST

From the saloons to the range, these eighteenth- and nineteenth-century men and women were the epitome of grit and determination.

BAT LASH: The handsome gambler Bartholomew Lash survived by his charm and his fast draw.

CINNAMON & NIGHTHAWK: Orphan-turned-bounty-hunter Katherine Manser partnered with legendary gunslinger Hannibal Hawkes, forming the most formidable duo in the west.

EL DIABLO: A bolt of lightning split bank teller Lazarus Lane's life in half; at night, he became a masked phantom of justice.

JOHNNY THUNDER: Schoolteacher John Tane resorted to violence when necessary under a gunfighter guise.

MADAME .44: Jeanne Walker moonlighted as a vigilante, stealing from thieves and giving to the poor.

MATT SAVAGE: The former army scout made his humble way as a trail boss, facing trouble when necessary.

POW-WOW SMITH: Sioux tribesman Ohiyesa Smith grudgingly accepted his nickname as he served as sheriff of the town of Elkhorn.

THE ROUGH BUNCH: The greatest heroes of the era.

SCALPHUNTER: Brian Savage, raised by a Kiowa tribe, maintained his adopted traditions, even as he settled in as sheriff of Opal City.

STRONG BOW: Hailing from beyond the Misty Mountains, the last of his tribe crossed the lands keeping the peace.

THE BEST OF THE WEST

AHWEHOTA (WINDRUNNER): A scout of the US Cavalry, gifted with super-speed by a dying Blackfoot shaman.

BARBARY GHOST: The vigilante Yanmei Tsen used her expert knowledge of gunpowder and explosives to gain an upper hand.

BEAR BOY: Half-human, half-bear child Jonah Hex, rescued from Buffalo Will's Wild West Show.

TALLULAH BLACK: The one-eyed gunfighter hunting down the people who killed her family.

DON CABALLERO: Spanish sword fighter who defended Hawk Hill, California, from all manner of threats.

EL CASTIGO: The Spanish nobleman Fernando Suarez protected Seguro, New Mexico, with just his whip.

COWBOY MARSHAL: James Sawyer was the US marshal called when a job needed to be done right.

CHUCK DAWSON: Revenge-seeking cowboy out to take down his father's killers.

FIREHAIR: A white child raised by the Blackfoot tribe to protect the Plains.

JENNY FREEDOM: The spirit of the nineteenth century personified.

HAWK: This Plains hero was the son of Apache princess Moon Fawn and frontiersman Thomas Hawk.

JONAH HEX: The famed disfigured bounty hunter who lived by a strict yet bloody moral code.

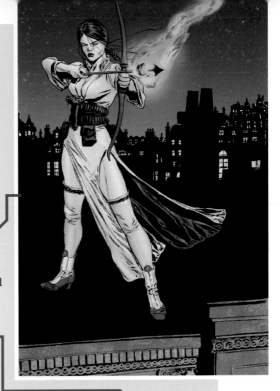

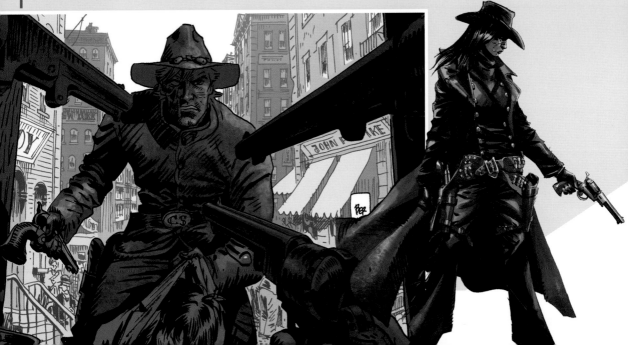

DAN HUNTER: A time traveler who remained in the past to assist Thomas Hawk.

JEBEDIAH AND NATHANIEL KENT: Brothers divided by the Civil War and ancestors of the Kents of Smallville.

BUCK MARSHALL: Honorable range detective going where he needed to to solve crimes.

MASTER GUNFIGHTER: Rodeo performer turned vigilante and vampire hunter Cody Barrow.

THE MINSTREL MAVERICK: Henry "Harmony" Hayes cracked heads with his guitar when he wasn't crooning with it.

RODEO RICK: Professional rodeo performer who put his skills to use fighting crime with his horse, Comet.

THE ROVING RANGER: Confederate Army captain Jeff Graham returned to Texas to pursue both criminals and vigilantes.

ADRIAN STERLING: A well-off New Orleans woman whose love of Jonah Hex left her an amnesiac barmaid.

TEJANO: The proud, Spanish-speaking ranger of the Lone Star Republic, Antonio Ramirez.

TOMAHAWK (I): The leader of Tomahawk's Rangers, Thomas Hawk earned his nickname for his choice of weapon.

TOMAHAWK (II): The mightiest of warriors among the Native American nations.

THE TRIGGER TWINS: Sheriff Walt Trigger's secret weapon was his identical twin brother, Wayne.

WISE OWL: This Apache mystic wielded the power of a plant elemental.

THE WYOMING KID: Son of a sheepherder, William Polk traveled the West as a freelance deputy.

CROOKS, THIEVES, AND KILLERS

GEORGE BARROW: Wyoming bank robber who murdered Jonah Hex.

THE GRAY GHOST: A masked Confederate out to avenge the South's loss.

LUCAS "MAD DOG" McGILL: The first criminal Jonah Hex killed.

OUTLAW: Rick Wilson wanted to grow up to be a Texas marshal but instead wound up a criminal.

EL PAPAGAYO: The leader of a gang of bandits whose family was killed by Jonah Hex's father.

PIG-TAILS: Stagecoach robber Emmylou Hartley's signature hairstyle made her easy to spot.

QUENTIN TURNBULL: Virginia plantation owner who blamed Jonah Hex for the death of his son.

DOC "CROSS" WILLIAMS: Snake-oil salesman and voodoo practitioner, capable of resurrecting the dead.

BY THE BOOK

The biographies, secret histories, and best sellers found on book-shelves on Earth and beyond.

∞LSEN: MY LIFE IN THE INFINITE METROPOLIS: Jimmy Olsen's book of photography.

THE ATLANTIS CHRONICLES: The chronicled history of Atlantis, scribed by Albart-Son-of-Yarrow of Ancinor before Atlantis sank and by Britton, Illya, Regin, and Atlanna afterward.

THE ATOM'S FAREWELL: A biography of the Atom, written by Norman Brawler based on the personal accounts of Ray Palmer and Jean Loring.

THE BLACK CASEBOOK: Batman's personal records of cases that defied explanation.

THE BOOK OF BLOOD: Also known as the Bible of Blood, the history of the Church of Blood.

THE BOOK OF DESTINY: Destiny carried this tome containing all knowledge of the past, present, and future, also known as the Book of Souls.

THE BOOK OF OA: The complete history of the Guardians of the Universe and the Green Lantern Corps.

THE BOOK OF OLD GOTHAM: Handwritten by Alienor Frych, the biography of her friend Amity Arkham, who was burned as a witch.

JASON BLOOD TRIES TO GATHER HIS THOUGHTS! THEY *RACE!* THEY *WHIRL!* THEY *FILL* HIS HEAD WITH THROBBING PAIN!

WHY DO YOU STARE AT THIS TOMB? *WHO* LIES BURIED HERE!?

MERLIN! I-ITS *MERLIN'S* TOMB···AND MORE THAN *THAT~!*

THE JANUS CONTRACT: Clark Kent's debut novel, a thriller featuring the character David Guthrie.

THE LIBRARY OF LIMBO'S BOOK: A single book with infinite pages, all occupying the same space, contained every book ever written.

THE LIFE STORY OF THE FLASH: The biography of Barry Allen, penned by Iris Allen.

MASK OF THE MANHUNTER: A biography of Paul Kirk by former Interpol agent Christine St. Clair.

ORQWITH: An encyclopedia for a world that did not exist, which manifested itself upon being written.

REFLECTIONS: A COLLECTION OF ESSAYS AND SPEECHES: Penned by Wonder Woman to share her beliefs and worldview.

SHORT AND SNAPPY TALES OF DEATH: Lobo's favorite book, even if it was a bit wordy for him.

SIMPLY BRILLIANT: Lex Luthor's sensationalized autobiography.

UNDER A YELLOW SUN: Clark Kent's sequel to *The Janus Contract*, continuing the adventures of David Guthrie.

UNITY: Lois Lane's investigative exploration into parallel universes and divergent time lines.

BOOKS OF THE ARCANE
Ancient texts of incantations, rites, and spells.

THE BOOK OF THOTH
THE EBONTOME
THE GRIMORIUM VERUM
THE MAGDALENE GRIMOIRE
THE NECRONOMICON
WARLY'S WIZARDRY

THE BOOK OF PARALLAX: The complete history of the Sinestro Corps.

THE BOOK OF THE BLACK: Written in preparation for the *Blackest Night*, this book contained all who glowed with the invisible light of sentient emotion.

THE BOOKS OF MAGIC: Ancient books that contained the source of all magic, each volume representing the opposing forces of reality—life, death, chaos, and order.

THE CASE-BOOK OF GREEN LANTERN: Tom Kalmaku's chronicling of Hal Jordan's adventures as Green Lantern.

THE CHRONICLES OF CHOLOH: Ancient texts that pertained to the history of Atlantis.

THE CRIME BIBLE: The holy text of the Religion of Crime.

THE DIARY OF MILLIE JANE COBBLEPOT: A nineteenth-century autobiography, taught in Gotham Academy history classes.

THE ENCYCLOPEDIA OF MAGICAL MONSTERS: An ancient text in the possession of Doctor Sivana, containing knowledge on all manner of extraordinary creatures.

THE ETERNITY BOOK: A powerful book of spells and prophecies that the demon Belial gave to his son Merlin.

HISTORAMA: An all-knowing book, found at the Rock of Eternity, with insight into all time and space.

GONE IN A *FLASHPOINT*

In the aftermath of *Flashpoint*, years of history—and people themselves—vanished. People like Superman and Cyborg had key moments in their lives changed or removed. Others, however, might as well have been other people entirely. These snapshots of radical *Flashpoint* changes started to become undone over time.

BLACK CANARY: Neither World War II Super Hero Dinah Drake nor her daughter, Dinah Lance, escaped *Flashpoint*. In their place was Dinah Drake Lance, a covert government operative turned vigilante turned rock star.

CYBORG SUPERMAN: Astronaut Hank Henshaw never donned the visage of a cybernetically enhanced Superman. Instead, Supergirl's father, Zor-El, did, rebuilt by Brainiac and forced to do the villain's bidding. The Hank Henshaw version soon returned as well.

THE CREEPER: TV newscaster Jack Ryder was injected with a serum that gave him advanced abilities and a device that could make his thrown-together, flamboyant costume appear at will. After *Flashpoint*, he was killed while on assignment and had his body possessed by a Japanese oni demon.

KID FLASH (BART ALLEN): Born in the thirtieth century, the grandson of Barry Allen and Iris West after *Flashpoint*. Now, there was Bar Torr, a thirtieth-century thief turned revolutionary, sent back in time with his memories erased as a part of a witness protection program.

KID FLASH (WALLACE WEST): Iris West's young, wholesome nephew Wally idolized The Flash and followed in his hero's footsteps. The post-*Flashpoint* Wallace "Wally" West disliked The Flash but changed his tune once he received speed powers. The multiverse had to make room for more than one Wally when the pre–*Flashpoint* Wally was freed by the Speed Force.

LOBO: The grungy and profane space biker who wiped out his entire species was still around after *Flashpoint*, until he was revealed to be an imposter. The "true" Lobo, once an officer in the Czarnian Empire, was haunted by his role in his planet's destruction and cauterized his own brain stem to treat his anguish. But reality couldn't keep the original "Main Man" down and the old-school Lobo once again became the official *and only* Lobo.

THE QUESTION: Investigative journalist Vic Sage tackled crime and corruption in Hub City with a faceless mask. After *Flashpoint*, he was an unknown man brought before the Council of Eternity for committing a great sin, who saw his memories and face erased as punishment.

REVERSE-FLASH: No longer was Hunter Zolomon the successor to the mantle of The Reverse-Flash. In his place came Daniel West, black sheep of the West family and father of Wallace West, who was imbued with speed powers after an accident while fleeing the Rogues.

SUPERBOY: The clone of Superman and Lex Luthor, Conner Kent, created by Project Cadmus in the wake of Superman's death was no more. The new Kon-El was a clone of Jon Lane Kent, the son of Superman and Lois Lane in an alternate future time line, created by the ruthless time traveler Harvest.

TEEN TITANS: Led by Robin (Dick Grayson), the sidekicks of the World's Greatest Super Heroes banded together as the Teen Titans, a group that expanded and evolved over the years. That legacy vanished, and the Teen Titans formed for the first time under the leadership of Red Robin (Tim Drake) after he uncovered a plot by N.O.W.H.E.R.E. to abduct young metahumans.

THE ANIMAL KINGDOM

Throughout the universe, a force known as the Red connected all animal life, from the largest behemoths down to the tiniest microorganisms. Most people with animalistic abilities derived their power from the Red.

AKANDO: The onetime Suicide Squad member could channel the ferocity of a bear.

THE ANI-MEN: Human/animal hybrids led by the lionlike Maximus Rex, who participated in gladiatorial combat for the rich and elite.

ANIMAL MAN: Bernhard "Buddy" Baker was the avatar of the Red and protector of all animal life, gifted with the means to replicate the abilities of any animal.

BEAST BOY: The combination of the deadly Sakutia virus and an untested cure permanently altered young Gar Logan's DNA, turning him green and allowing him to transform into any animal.

FREEDOM BEAST: With a helmet that allowed communion with animals and an elixir that provided enhanced strength and the ability to merge life-forms into chimeras, Dominic Mndawe was the latest hero to bear the responsibility as Freedom Beast.

THE HORSEWOMAN: Atop a saddle of invention and magic, Clytemnestra felt everything her steed felt.

LADY VIPER: This sideshow performer obsessed with snakes could transform into one via an ancient totem.

MAN-BAT: An unintended side effect of Dr. Kirk Langstrom's transformative Man-Bat Serum was a connection to the Red.

MAXINE BAKER: Animal Man's daughter was destined to be the true avatar of the Red, but her father was chosen because she was not yet born when an avatar was needed.

MONSTER MASTER: A teen rejected by the Legion of Super-Heroes who sought revenge by using his ability to control animals by forming the Legion of Super-Monsters.

MOTHER BLOOD: After feasting on the Source energy, the newest leader of the Church of Blood had the power to make the Red serve her and control others who maintained a connection to it.

THE PARLIAMENT OF LIMBS: The governing party of the Red, monstrous in appearance, that represented the interests of all animal life and chose the new avatar to serve. Members, all former avatars, included Shepherd, Ignatius, the Tailors, and formerly the Hunters Three.

SAC: This member of the Council of Spiders commanded thousands of arachnids at a time.

TABU: A warrior and blood relative of Vixen who channeled her animal abilities via tribal masks.

TIAMAT: Cancer-afflicted witch Katie Randles placed her soul inside a gargoyle, establishing her connection to the Red via magic.

TRISTESS: The young shaman was a kindred spirit to Animal Man.

VIXEN: Connecting to the Red via her fox-shaped Tantu Totem, Mari McCabe could draw from any animal's abilities.

PECKING ORDER

They might not have a connection to the Red, but these Super Heroes and Super-Villains went all-in on bird identities.

BLACK CANARY
BLACK CONDOR
BLACKBIRD
BLUE JAY
BLUEBIRD
CONDOR
THE COURT OF OWLS
DOVE
DRAKE
THE FLAMINGO
GOLDEN EAGLE
HAWK
HAWKGIRL
HAWKMAN
HUMMINGBIRD
IBIS THE INVINCIBLE
LADY BLACKHAWK
LARK
MADAME CROW
MANITOU RAVEN
OWLMAN
EL PAPAGAYO (PARROT)
THE PENGUIN
RAVEN
ROBIN
SILVER SWAN
SPARROW
STARLING
WHITE CANARY

THE BATMEN OF ALL NATIONS

Batman's influence extended far beyond Gotham City. He inspired—and sometimes even trained—heroes across the globe. These heroes first banded together as the International Club of Heroes and later many joined Batman Incorporated, a worldwide network of crime fighters deputized by Batman.

THE BATMAN OF JAPAN: Jiro Osamu was the apprentice of Japanese hero Mr. Unknown until his mentor was murdered.

THE BATMAN OF MOSCOW: Little was known about Ravil, who aided Batman Incorporated before he was murdered by Nobody.

BATWING: Operating out of the Democratic Republic of the Congo, David Zavimbe fought corruption and warlords before hanging up the mantle of Batwing, which was taken over by Luke Fox.

BLACK BAT: Longtime ally Cassandra Cain adopted a new identity when she represented Batman Incorporated in Hong Kong.

DARK RANGER AND SCOUT: Dark Ranger (formerly the Ranger) and his sidekick, Scout (John Riley), protected Australia for years. After Dark Ranger—whose identity was never revealed—was killed, John Riley took over the mantle.

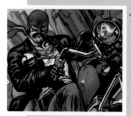

EL GAUCHO: Santiago Vargas was an Argentinian crime fighter in addition to having a history with the covert spy agency Spyral.

THE HOOD: George Cross was an English vigilante who joined up with Spyral, in addition to serving with Batman.

THE KNIGHT AND THE SQUIRE: Percy Sheldrake, the Earl of Wordenshire, and his son, Cyril, modeled themselves after Batman and Robin to protect England. Percy was killed by his nemesis, Springheeled Jack. Years later, after assuming his father's mantle, Cyril died fighting Leviathan. Beryl Hutchinson, a child taken in by Cyril, was the second Squire before becoming the new Knight.

THE LEGIONARY: Wielding ancient Roman armor and a spear, Alphonso Giovanni, served as the protector of Rome until he let fame and gluttony consume him.

MAN-OF-BATS AND RAVEN RED: Operating out of a Sioux reservation in South Dakota, Dr. William Great Eagle and his son, Charles, fought crime and protected their community.

THE MUSKETEER: The Musketeer was the guardian of Paris until he accidentally killed a criminal and was confined to an asylum.

NIGHTRUNNER: The parkour-trained Bilal Asselah succeeded the Musketeer as Batman's French representative.

WINGMAN: Consumed by his jealousy of Batman, the Swedish vigilante Benedict Rundstrom ultimately joined the villainous Black Glove and killed his former teammates, the Legionary and Dark Ranger. Jason Todd later adopted his identity.

THE DOCTOR IS IN

Not every Super Hero and Super-Villain calling themselves doctors had completed the necessary schoolwork to earn the title.

DOCTORS WITH DEGREES

THE CRIME DOCTOR: Medicine, catered exclusively to the Gotham City underworld.

DOCTOR CANUS: Post–Great Disaster programs might not be accredited, but we'll allow it.

DOCTOR CYBER: Cybernetics.

DR. CYCLOPS: An evil scientist was a scientist nonetheless.

DOCTOR DEATH: Chemistry and toxicology.

DOCTOR DEDALUS: An unrepentant Nazi master criminal and scientist.

DOCTOR DESTINY: Identity, and thus credentials, unknown.

DR. DOUBLE X: Another evil scientist.

DR. DREEMO: A stage performer and blackmailer who had a doctorate in psychology.

DOCTOR FATE (KENT NELSON): Archaeology.

DOCTOR HERCULES: Robotics.

DR. KRYPTONITE: Medicine, but should've had his license revoked for injecting himself with Kryptonite.

DOCTOR LEVITICUS: Medicine . . . and resurrection.

DOCTOR LIGHT (ARTHUR LIGHT): Physics.

DOCTOR LIGHT (KIMIYO HOSHI): Astronomy.

DOCTOR MANHATTAN: Atomic physics.

DOCTOR MID-NITE: Medicine.

DR. MOON: Neurosurgery.

DOCTOR NEMO: Quantum physics.

DR. OMEN: China's director of the Ministry of Self-Reliance.

DR. PHOSPHORUS: Unknown, but it entailed a successful Park Avenue practice in Gotham City.

DR. POISON: Toxicology.

DOCTOR POLARIS: Medicine and physics.

DR. PSYCHO: Psionics.

DOCTOR REGULUS: Nuclear science.

DOCTOR SIVANA: Brilliant mad scientist.

DOCTOR THIRTEEN: Parapsychology.

DOCTOR TYME: Horology.

DR. VIRUS: Virology.

DOCTOR IN NAME ONLY

DR. 7: No schools offered coursework in evil sorcery.

DR. ALCHEMY: Criminal chemistry aficionado.

DOCTOR BEDLAM: Unlikely that Apokolips had any doctoral programs.

DR. CHAOS: Guardian of the Realm of Chaos.

DR. CLEVER: Gave himself too much credit for both parts of his criminal identity.

DOCTOR DIEHARD: Terrorist from Earth-Eight.

DOCTOR DOMINO: Unlikely, given that his head was a giant domino.

DR. ECHO: Meta-terrorist who dabbled in quantum vacuum fluctuations and magic.

DOCTOR EXCESS: His familiarity with performance-enhancement drugs points to some study, but unconfirmed.

DOCTOR FANG: Crime boss and former boxer.

DOCTOR FATE (INZA CRAMER NELSON, ERIC STRAUSS, LINDA STRAUSS, HECTOR HALL, KENT V. NELSON, KHALID NASSOUR, KHALID BEN-HASSIN): Bearers of the mantle, though Khalid Nassour was in med school.

DOCTOR FAUSTUS: Gotham City lunatic who thought he made a pact with the devil.

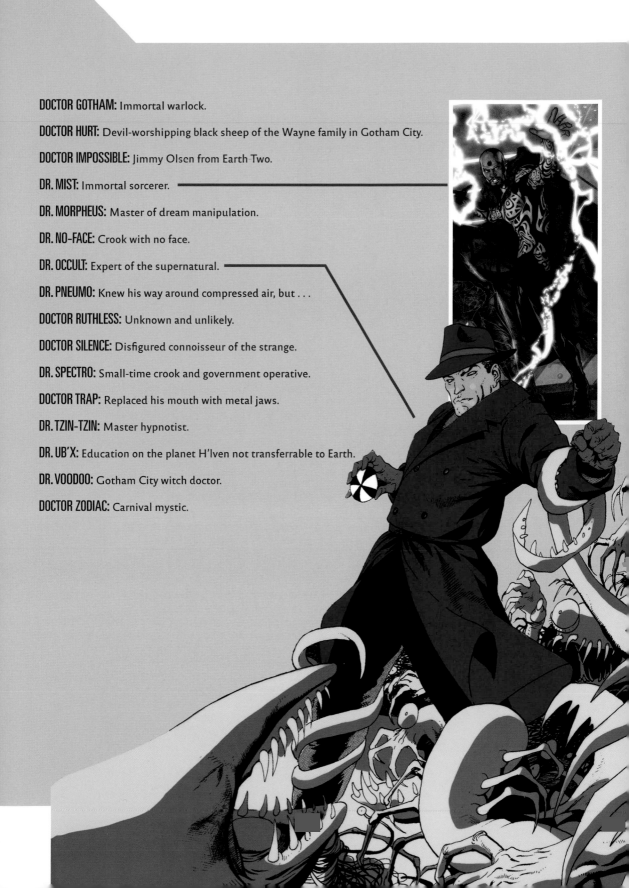

DOCTOR GOTHAM: Immortal warlock.

DOCTOR HURT: Devil-worshipping black sheep of the Wayne family in Gotham City.

DOCTOR IMPOSSIBLE: Jimmy Olsen from Earth-Two.

DR. MIST: Immortal sorcerer.

DR. MORPHEUS: Master of dream manipulation.

DR. NO-FACE: Crook with no face.

DR. OCCULT: Expert of the supernatural.

DR. PNEUMO: Knew his way around compressed air, but . . .

DOCTOR RUTHLESS: Unknown and unlikely.

DOCTOR SILENCE: Disfigured connoisseur of the strange.

DR. SPECTRO: Small-time crook and government operative.

DOCTOR TRAP: Replaced his mouth with metal jaws.

DR. TZIN-TZIN: Master hypnotist.

DR. UB'X: Education on the planet H'lven not transferrable to Earth.

DR. VOODOO: Gotham City witch doctor.

DOCTOR ZODIAC: Carnival mystic.

THE RULERS OF HELL

The realm of hell saw countless numbers of sufferers. Its near-limitless expanse required a feudal system of ruling demons of varying status.

THE FIRST OF THE FALLEN: God's first creation, cast out to what would become hell and established the ruling Satanic Triumvirate over the domain.

LUCIFER MORNINGSTAR: The first and longest king until he abdicated the throne.

THE SATANIC TRIUMVIRATE

The ruling council, including Lucifer and two other members at a time. Demons who served on the council included:

ABADDON: A fallen angel and guardian of Masak Mavdil, the Pit of Hell.

AZAZEL: His failed attempt to rule hell on his own caused him to be trapped in a glass jar by Morpheus.

BEELZEBUB: The Lord of the Flies and an entity of decay and decomposition.

BELIAL: The Prince of Lies and the father of the demon Etrigan and the mage Merlin.

ETRIGAN: This demon staged a coup to overthrow the Triumvirate.

RAN VA DAATH: The Serpent Queen, Etrigan's mother, who joined her son's coup.

THE SECOND AND THIRD OF THE FALLEN: Demons deceived into believing they were fallen angels.

SUBSEQUENT RULERS

REMIEL AND DUMA: A pair of angels assigned to run hell when it came under heaven's control.

NERON: A fallen angel who bartered for the souls of superheroes and villains in exchange for power.

LORD SATANUS AND LADY BLAZE: Siblings and rulers of purgatory, who wrestled control from Neron.

THE RULERS OF THE NINE CIRCLES OF HELL

MINOS: The judge in the First Circle, who sentenced souls to the other circles.

CERBERUS: This three-headed hound guarded the Bronze Gates of hell and inhabited the Third Circle.

PLUTUS: The God of Wealth ruled the Fourth Circle.

PHLEGIAS: Ferryman to the dead on the River Styx in the Fifth Circle.

LILITH: The mother of all atrocities devoted herself to Neron's rule and oversaw the Sixth Circle.

CHAR'RAH: The violent master of the Seventh Circle.

GERYON: The deceitful master of the Eighth Circle.

THE NAMES OF RULERS OF THE SECOND AND NINTH CIRCLES REMAINED UNKNOWN.

KEY DENIZENS OF HELL

AGONY AND ECSTASY: Hell's enforcers and inquisitional police.

ASMODEL: Heaven's Bull Host attempted his own rebellion and became an archfiend under Neron.

ASTEROTH: An ambitious archfiend, keen to upset the power of the Triumvirate.

BAYTOR: The belligerent Lord of Insanity.

BLATHOXI: The Lord of Flatulence.

MORAX: The bull-beast ruler of Stygia, who seized Asteroth's domain.

MORDECAI SMYT: Satanus's supreme field commander.

NERGAL: The demoted former Archduke of Mendacity.

PRINCE RA-MAN: Satanus's primary counsel.

SHAMMA: Satanus's intelligence resource.

SUPER-CHEMISTRY

From laboratories on Earth to Apokolips, doctors and mad scientists developed many unique and troubling substances that produced surprising changes in their human users.

A39: A super-steroid derived from Venom by the Terrible Trio that turned its users into zombielike soldiers but also gave Doctor Mid-Nite the ability to see in the dark.

APOCRITIC: Derived from Starro's DNA, when this serum was injected into the bloodstream, it allowed its users to share a telepathic link.

BARR CANCER SERUM: A cure for cancer developed by Dr. Allen Barr had an unexpected side effect—it turned humans' blood poisonous for vampires.

BIO-RESTORATIVE FORMULA: Developed by Alec and Linda Holland to accelerate plant growth, this formula led to the creation of Swamp Thing.

BZRK: A drug created by DeSaad that increased size and strength, sending its users into a frenzy before they burst into flames.

ELASTI-FORMULA: A concoction created by Professor Phineas Potter that increased a body's elasticity and could easily be confused for soda pop.

FEAR TOXIN: A gas developed by Jonathan Crane, which he used as the Scarecrow, that unlocked people's phobias and induced hallucinations and paranoia.

GINGOLD: An extract of the rare gingo fruit that increased the body's elasticity in some—like Elongated Man—but was deadly to many.

JOKER VENOM: The Joker's home-brewed concoction—typically used in gas form—ranged in severity from facial nerve paralysis, causing a permanent smile, to fits of hysterical laughter that resulted in death. The Joker produced at least fifty different strains over time.

MAN-BAT SERUM: Derived from a bat-gland extract, this serum was intended to replicate bats' natural sonar hearing in humans but instead transformed Dr. Kirk Langstrom into a monstrous human-bat hybrid.

MARU VIRUS: A biochemical agent based on Soviet-era combat drugs that induced a murderous rage before ultimately killing its victims.

MIRACLO: Developed by Rex Tyler, this pill increased strength, speed, and stamina, lasting one hour.

NEUROTROL: This intended cure for dementia and violent urges unlocked dormant psychic abilities in some people.

NUVAFED: Dr. Bruce Bonwit intended to create a potent antihistamine, but instead, it transformed test subject Fred Delmar into the allergy-producing, vegetative creature Goldenrod.

PARANOID PILL: Doctor Bedlam's chemical creation unleashed a powerful gas that induced temporary but violent insanity.

PROFESSOR IVO'S IMMORTALITY SERUM: This immortality serum had an unfortunate side effect—it caused disfigurement in the form of hard, scaly skin.

RASHNIKOV FORMULA: KGB agent and vampire Colonel Yuri Rashnikov developed a formula to turn humans into vampires without any of the weaknesses like bloodlust and aversion to sunlight. It was fatal to anyone already a vampire.

SOLUTION Z: Created by villain Mr. Who from adaptive animals and insects, this miracle solution allowed users to change size, turn invisible, regenerate limbs, and more.

SOUL: A street drug designed to induce bliss but instead incited violent rage in many of its users.

TAR: This strength-enhancing street narcotic known to temporarily increase size and muscle mass was originally developed for military use.

VELOCITY 9: A highly addictive drug developed by Vandal Savage that produced superspeed abilities in its users, resulting in premature aging and death.

VENOM: Dr. Randolph Porter invented the addictive super-steroid Venom, used by Batman and later by Bane.

VITAMIN 2-X: Dr. Franz's chemical compound provided Dan Garrett, the first Blue Beetle, with super-strength and invulnerability.

MOST POISONOUS
Never cross these venomous villains.

CHESHIRE
DOCTOR POISON
THE JOKER
MIDAS
POISON IVY
SCARECROW
THORN

THE MANY TRANSFORMATIONS OF JIMMY OLSEN

Jimmy's hijinks led to a variety of temporary changes in his appearance and abilities. Each day of the week was a new opportunity for Jimmy to be someone else entirely as he accidentally ingested the wrong potion or upset the wrong person.

ANT OLSEN: Dressed to take down the Bug Bandits.

THE BIRDBOY OF METROPOLIS: Soaring through the sky with thunderbird wings.

BIZARRO JIMMY: A backward version of himself.

BONZO OLSEN: A brain swap left him with a new primate body.

THE BOY OF STEEL: A completely indestructible Jimmy.

CHAMELEON-HEAD OLSEN: Chameleon Boy's shape-changing power on loan.

COMPUTER-BRAIN JIMMY: This upgrade forced Jimmy to obey Brainiac.

COSMIC BRAIN JIMMY: A bigger brain meant a bigger, balder head.

DENSE JIMMY: Same Jimmy, greater density.

DOOMSDAY JIMMY: Superman's best friend, now his worst enemy.

ELASTIC LAD: Jimmy's most famous transformation by any stretch of the imagination.

FLAMEBIRD: A Super Hero persona in the Bottle City of Kandor.

THE GIANT TURTLE MAN: A towering turtle-human hybrid.

GRAVEDIGGER LAD: Great at digging graves and tending to the Graveyard of Solitude.

HIPPIE OLSEN: Shaggy hair and a Kryptonite necklace were a deadly combo.

THEN, AS JIMMY PREPARES HIS BREAKFAST...

LOOK, *SUPERMAN!* AT FIRST, WHEN I SUMMONED YOU TO HELP ME, I WAS SHOCKED AND WORRIED! NOT *NOW*, *THOUGH!* I SEE THAT HAVING SIX ARMS CAN BE A *PLEASURE!* I'M BEGINNING TO WONDER HOW I EVER GOT ALONG WITH JUST TWO MEASLY HANDS!

THE HUMAN ATOM BOMB: Radioactive Jimmy disintegrated everything nearby.

THE HUMAN FLAME-THROWER: A true fire-breather.

THE HUMAN METAL-EATER: Jimmy truly expanded his taste palate.

THE HUMAN OCTOPUS: Four extra arms helped get a lot done.

THE HUMAN PORCUPINE: A prickly appearance, same charming demeanor.

THE HUMAN SKYSCRAPER: A colossal presence in Metropolis.

INVISIBLE JIMMY: Not even Superman could see him.

THE JIMMY FROM JUPITER: A green, scaly, and telepathic Jovian alien.

JIMMY OF ALL AGES: Baby, middle-aged, old man—Jimmy aged all over.

JIMMY THE BEARDED BOY: More facial hair than he could ever ask for.

JIMMY THE FREAK: A human balloon with floppy eyes, messy hair, and a foot-long tongue.

JIMMY THE GENIE: A genie forced to obey an evil master.

JIMMY THE IMP: Along with Mr. Mxyzptlk's powers came his penchant for mischief.

THE KID WITH THE GOLDEN TOUCH: Anything he touched turned to gold.

KRYPTONITE JIMMY: Eating Kryptonite-infused fruit was not a smart way to turn one's skin green.

MAGIC GLOVED JIMMY: Anything was possible—playing piano, flying a plane, performing surgery—with this pair of gloves.

MR. ACTION: Limitless, but uncontrollable new superpowers.

OLSEN THE TEEN WONDER: Jimmy Olsen was Robin for one brief shining moment.

ONE-MAN LEGION: The powers—and costumes—of the Legion of Super-Heroes.

OVERWEIGHT JIMMY: The bottle of weight-increaser should have been more clearly marked.

PINOCCHIO OLSEN: The wrong nasal spray gave Jimmy a very long nose.

SHRUNKEN JIMMY: For fitting in at Kandor and elsewhere.

SPEED DEMON: He didn't break a sweat keeping up with Superman.

STEEL-MAN: A costumed mashup of Superman and Batman on a parallel world.

SUPER-APPETITE JIMMY: A bottomless stomach gave him an advantage in an eating contest.

SUPER-LAD/SUPER-YOUTH/ULTRA-OLSEN: Superstrength can come from unexpected places like chemically treated costumes, Dyna-Combs, and Mayan medallions.

THE WOLF-MAN OF METROPOLIS: A potion turned him into a werewolf; only a kiss could change him back.

The vast expanse of space provided more than enough room for additional protection from groups other than the Green Lantern Corps. Some were driven by duty, others by profit. Not all left the universe safer.

THE BLACKSTARS: Founded by Controller Mu, this offshoot of the Darkstars was a ruthless but effective militia for hire. Their goals reached beyond universal peace; Mu strived for total domination.

THE DARKSTARS: The Maltusian race known as the Controllers formed the Network for the Establishment and Maintenance of Order (NEMO) to protect their own interests from threats. But after a thousand years, the Controllers realized that a more proactive police force was needed to root out evil. So the Darkstars were born, rivaling the Green Lantern Corps in reach and prominence.

GALACTIC PATROL: The esteemed Galactic Patrol was responsible for protecting all of Earth's vast space empire in the twenty-second century.

INTERDIMENSIONAL COOPERATIVE ENFORCEMENT POLICE TEAM (INTERC.E.P.T.): Hailing from different realms, this group enforced dimensional laws and sealed any breaches that arose.

KNIGHTS OF THE GALAXY: The twenty-fifth-century commandos who protected Earth as well as planets colonized or allied with Earth. From a round table, inspired by knights of legend, aboard space station Gala, the Knights were poised to leap into action at a moment's notice.

LICENSED EXTRA-GOVERNMENTAL INTERSTELLAR OPERATIVES NETWORK (L.E.G.I.O.N.):
L.E.G.I.O.N. was a vast and powerful for-hire police force created by Vril Dox II, the brilliant son of Brainiac. Renowned for its effectiveness, L.E.G.I.O.N. was ultimately corrupted by Vril's son Lyrl, inspiring acronym-aficionado Vril to form Revolutionary Elite Brigade to Eradicate L.E.G.I.O.N. Supremacy, or R.E.B.E.L.S.

THE MANHUNTERS: Before creating the Green Lantern Corps, the Guardians of the Universe built an android army to patrol space. The Manhunters were effective until rogue scientist Krona exploited their lack of emotion and reprogrammed them, which led to the massacre of all living beings in Space Sector 666.

OMEGA MEN: From the perspective of the Citadel, the tyrannical rulers of the Vega star system, the Omega Men were terrorists. To others, they were rebel freedom fighters, all hailing from oppressed planets within Vega.

THE PLANETEERS: Rising through the ranks of this future police force, Tommy Tomorrow protected the universe with his partner Brent Wood, traveling across the galaxies in their ship, Space Ace.

SPACE CANINE PATROL AGENTS (SPCA): Alien dogs with high intelligence, each with unique superpowers, that looked adorable in their blue uniforms and little white capes. Krypto joined their ranks as Canine Secret Agent #1.

SPACE RANGER: Rick Starr served as protector of Earth's solar system in the twenty-second century, thanks to his father's great wealth, and operated out of an asteroid orbiting between Mars and Jupiter.

THE VANGUARD: An assembly of superpowered aliens who served as cosmic emissaries, traveling the universe in their sentient starship, Drone, and visiting planets that had need of their powers.

THE WINGMEN: The protectors of the once-great Thanagarian empire patrolled the skies with their Nth Metal wings and served as the frontline defense against any threat.

Beginning with a gift from the gods, the means to travel through time have followed humanity over the centuries, with each great advancement leading to another.

TIME ENGINE: Humankind's first means of time travel, built by the descendants of Aurakles—a Neanderthal gifted with great intellect and power by the New Gods in 40,000 BCE.

TIME KNIFE: An ancient Egyptian knife of unknown origin that possessed the ability to open portals in time.

THE RINGS OF KUR-ALET: A pair of ancient Egyptian rings were gifted to Pharaoh Kur-Alet by the high priest of Anubis. When worn by two people who chant, "Pelogri Etea Telen," the rings would transport the wearers in time.

DR. DOOME'S TIME MACHINE: An early time travel machine, created by evil scientist Dr. Doome to recruit great conquerors from the past to commit crimes.

THE TIME TRUST'S TIME RAY: A group of American scientists known as the Time Trust developed this ray to send the Justice Society of America far into the future and back.

THE PANZER-SHIP: An invisible rocket ship, designed by the Nazi Red Panzer in 1943 on Earth-Two, that could also travel between parallel worlds.

PROFESSOR ZEE'S TIME MACHINE: Time Trust member Professor Malachi Zee invented his own time machine, which Per Degaton attempted to steal for his time crimes.

PROFESSOR CARTER NICHOLS'S INVENTIONS: Professor Nichols discovered a method of time hypnosis that could send people's minds into the past where they'd rematerialize in new bodies. He later built a machine that could transmit matter throughout time without hypnosis.

DOCTOR SIVANA'S TIME PILLS: A chemical formula synthesized in pill form—a single dose to travel through time and a second dose to return.

THE TIME SPHERE: Rip Hunter was generally regarded as one of the pioneering inventors of time machines with his Time Sphere. He later refined the technology, producing wearable Time Packs.

THE COSMIC TREADMILL: Barry Allen's invention complemented his natural speed-ability to travel through time, affording him pinpoint precision for his destinations.

THE TIME POOL: Retired Ivy Town University professor Alpheus Hyatt's invention could open small portals in time. Too small for any average size human, the portal was perfect for the Atom.

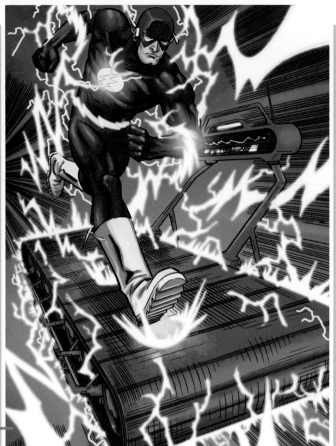

HOURMAN'S TIMESHIP: Build by Hourman in the 853rd century, this tachyon-powered vessel with a steampunk aesthetic could sail through both time and space.

CASTLE REVOLVING: One billion years in the future, the Sheeda's flying time-ship was home to their monarch and used to travel to the past to plunder civilizations for their resources. It was reverse-engineered from the Time Engine, serving as a bookend to all of human-kind's time travel.

THE LINEAR MEN'S TIME BANDS: Based out of the Vanishing Point, the fortress existing outside of time, the Linear Men used wristbands to travel wherever necessary as they protected the timestream. These Time Bands were also an essential component in Monarch's time travel suit, transforming him into Extant.

THE TIME COMMANDER'S HOURGLASS: Constructed while in prison, the hourglass created by rogue scientist John Starr allowed him to manipulate time at will.

ANGLE MAN'S ANGLER: Forged in laboratories on Apokolips, the Angler found its ways to earth where Angelo Bend wielded it to warp time.

THE TIME BUBBLE: Invented by Brainiac 5, this thirty-first century machine drew its inspiration from Rip Hunter's Time Sphere but was by far one of the most durable.

THE TIME CUBE: Honorary Legion of Super-Heroes member Rond Vidar created the Time Cube to transport people through time, but if they wanted to transport back, they had to be in the exact spot in which they arrived twenty-four hours later, or else they'd be stuck.

THE INVENTIONS OF EPOCH: The Lord of Time invented a variety of time travel devices in the thirty-eighth century, starting with a watch-like device on his wrist and later the sentient AI known as the Eternity Brain, and the Chrono-Cube.

M-METAL: A radioactive meteorite from the year 6363 used to power the Time-Vehicle, which Abra Kadabra stole to travel to the present day.

GREEN ARROW'S 50 MOST PECULIAR SPECIALTY ARROWS

With a quiver full of custom-made arrows—most notably a boxing glove arrow—the Emerald Archer came prepared for any occasion. The planning sessions for these arrows must have been wild.

AIRBAG ARROW: An inflatable cushion.

ANTI-GRAVITY ARROW: Sent targets to the sky.

ANTLER ARROW: Could stop a charging antlered animal.

AQUA ARROW: Mimicked the abilities of electric eels, octopuses, glowfish, and jellyfish.

AQUA-LUNG ARROW: For breathing underwater.

ARROW-BOMB: Deployed multiple arrows that could be used for Morse code.

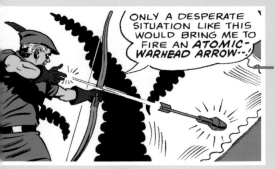

ARROW-KITE: For Ben Franklin maneuvers.

ATOM ARROW: Literally the Atom riding on the arrowhead.

ATOMIC WARHEAD ARROW: For truly desperate circumstances.

AURORA BOREALIS ARROW: Emulated the natural phenomenon.

BABY-RATTLE ARROW: Calmed frightened babies.

BAIT ARROW: Looked like a duck or a fish for luring animals.

BALL-AND-CHAIN ARROW: Used when needing to shoot a large, heavy ball on a chain.

BALLOON ARROW: A fun distraction.

BENT ARROW: Used for a non-straight trajectory.

BLEACH BOTTLE / SODA CAN ARROW: When nothing else was available.

BUBBLE-GUM ARROW: Made fleeing foes stick around.

CHIMNEY SWEEP ARROW: Cleaned out the soot.

CLOUD-SEEDING ARROW: Created thunderstorms.

DDT/INSECTICIDE ARROW: Eliminated pesky insects.

DUMMY CAT ARROW: Cured phobias of cats.

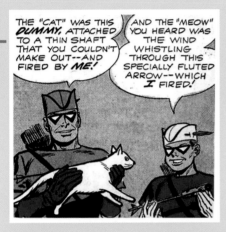

FAKE-URANIUM ARROW: Produced false radiation readings.

FIRECRACKER/INDEPENDENCE ARROW: For loud noise and celebrations.

FOUNTAIN PEN ARROW: Left a trail of ink.

GELATIN ARROW: Rendered dangerous rays inert.

GREEK FIRE ARROW: Covered a target in a flaming liquid.

GUN ARROW: Fired real bullets.

HANDCUFF ARROW: For quick arrests.

HELI-SPOTTER ARROW: Surveillance via large, rotating mirrors.

HOOP ARROW: Sometimes a Hula-Hoop was needed.

HYPNOTIC ARROW: Hypnotized onlookers.

INVISIBILITY ARROW: Turned the target area invisible.

ITCHING POWDER ARROW: When there was no other way to subdue an enemy.

JACK-IN-THE-BOX ARROW: Provided unexpected bops on the nose.

MIDNIGHT ARROW: Launched a deluge of black liquid.

MIND-READING ARROW: Read minds.

MOP ARROW: Cleaned up the streets.

MUMMY ARROW: Wrapped targets like mummies.

OIL SPRAY ARROW: Made getaways slipperier.

PHANTOM ZONE ARROW: Sent someone to the Phantom Zone quickly.

PLUNGER ARROW: For suction . . . and the unexpected clogged toilet.

RAIN ARROW: Extinguished small fires and got crooks wet.

RAINBOW ARROW: Misleadingly produced blinding colorful lights and not rainbows.

SMOG-ALERT ARROW: Blinded and asphyxiated enemies.

SUN-ARROW: For creating a blinding luminescence in the sky.

SUPERSTITION ARROWS: Included a ladder to walk under, a black cat, spilled salt, the number thirteen, and the ace of spades.

TUMBLEWEED ARROW: Stirred up dust.

TUNING-FORK ARROW: Produced ultra-frequency sound waves.

UMBRELLA-ARROW: For unexpected showers.

VACUUM ARROW: Sucked up small items.

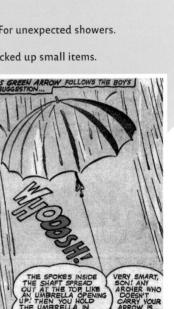

SLEUTHS, GUMSHOES & PRIVATE EYES

Batman wasn't the only detective to call when a mystery needed solving.

ACCOMPLISHED PERFECT PHYSICIAN: Yao Fei served the role of resident sleuth for Chinese Super Hero team the Great Ten.

JASON BARD: An unassuming private investigator as comfortable under deep cover as he was working with the police or aiding Batgirl.

BLOODHOUND: With his uncanny tracking skills, Travis Clevenger hunted down rogue metahumans for the FBI.

SAMUEL "SLAM" BRADLEY: Gotham City's finest—and toughest—private detective, who used his fists as much as his brain.

DETECTIVE CHIMP: After a traditional detective career didn't pan out, Detective Chimp applied his brilliant mind to supernatural mysteries.

JONNY DOUBLE: The former police detective turned private investigator, fielding small-time crooks and major threats like Kobra.

NATHANIEL DUSK: Fed up with police brutality and corruption, Nathaniel Dusk went solo as a private investigator in New York City.

THE ELONGATED MAN AND SUE DIBNY: Whenever Ralph Dibny's nose started to twitch, a mystery was underfoot, which he and his wife, Sue, set out to uncover.

THE GOTHAM ACADEMY DETECTIVE CLUB: Also known as the Pizza Club, this group of Gotham Academy students represented the next generation of detectives.

HARVEY HARRIS: Batman considered this famed Southern private detective one of the best in the world.

HAWKMAN AND HAWKGIRL: From exploring the unknown on Earth to Thanagarian police work, the winged pair solved mysteries throughout their lives.

SHERLOCK HOLMES: The famed nineteenth-century detective lived well past one hundred years old, aiding Hawkman, Batman, Elongated Man, and Slam Bradley.

THE HUMAN TARGET: Private investigator and bodyguard Christopher Chance could impersonate anyone to a frighteningly indistinguishable degree.

MARTIAN MANHUNTER: Under the guise of Detective John Jones, Martian Manhunter transferred his alien manhunting skills to Earth detective work.

MYSTO, MAGICIAN DETECTIVE: Using sleight of hand and illusionary powers, Rich Carter aided investigations when he wasn't entertaining children.

O'DAY AND SIMEON PRIVATE INVESTIGATIONS: The unlikeliest pair of private investigators—Angel O'Day, a non-metahuman from a family of Super Heroes, and Sam Simeon, grandson of Gorilla Grodd.

ODD MAN: With gags and gimmicks, Clay Stoner operated as a private investigator and protector of River City, wearing garish, mixed-pattern garb.

JOHNNY PERIL: This solider of fortune, sometimes known as Mr. Nobody, settled in as a private detective drawn to the weird and supernatural.

JOE POTATO: Armed with his fake "Joe Potato Peeler" knife, Joe Potato became a private investigator to sate his endless curiosity.

JASON PRAXIS: The reluctant recipient of telepathic and telekinetic powers he'd rather be rid of, Praxis aided the Conglomerate and the FBI.

THE QUESTION: Both investigative reporter Vic Sage and former Gotham City detective Renee Montoya sought answers as the faceless Question.

EDOGAWA SANGAKU: Little is known about the mystic detective adorned with sigil face tattoos, but he was part of the esteemed detective group the Croatoans.

TIM TRENCH: A no-nonsense, classic-film-loving private investigator from St. Louis.

THE LEGACY OF MANHUNTER

Alien androids. Cults. Clones. Mental reprogramming. The Manhunters had it all.

THE MANHUNTERS: For millennia, Manhunter androids doled out justice on behalf of the Guardians of the Universe until they turned evil and were nearly all destroyed. A few escaped to Earth, where they formed the Cult of the Manhunters under the leadership of the Grandmaster and began recruiting human agents.

DONALD "DAN" RICHARDS: In a costume provided by the Grandmaster, the 1940s rookie police officer turned vigilante when justice required more than the law could provide, joined by his trusty companion, Thor the Thunder Dog.

PAUL KIRK: The big game hunter allowed himself to be recruited to the Manhunters in the 1940s when his friend Inspector Donovan was murdered, unaware that Grandmaster orchestrated the death to lure him in. After a near-fatal injury, Kirk was seized by a shadow organization, the Council, who began cloning him to form their own army of Manhunters.

PAUL KIRK (CLONE): Proving virtue was in the original Kirk's blood, one of his clones rebelled against the Council. Learning of a coming threat from Darkseid, he infiltrated the Secret Society of Super-Villains to stop the wicked tyrant.

MARK SHAW: Informed of the Cult of the Manhunters from his uncle—a Manhunter himself—this public defender joined their ranks. Experimentation and manipulation from the US government later damaged Shaw's psyche. He took over the terrorist group Leviathan, which he used to destroy the world's intelligence agencies.

CHASE LAWLER: A small-time musician was the government's next attempt at their own Manhunter. Lawler was programmed to believe he was compelled to hunt by the demonic Wild Huntsman.

KIRK DEPAUL: The last surviving clone of Paul Kirk continued the heroic legacy of his progenitor. He adopted the name Manhunter as he worked with superhero-for-hire team the Power Company.

KATE SPENCER: The granddaughter of Super Heroes Iron Munro and the Phantom Lady, Spencer worked as a federal prosecutor until she felt the courts couldn't uphold justice. With equipment she pilfered from an evidence room, Spencer set out to hunt criminals.

The Amazon race settled on the paradise island of Themyscira—hidden away from hostile "Patriarch's World"—where they flourished in a utopian society.

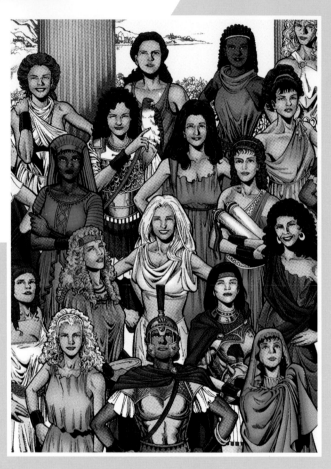

ACANTHA: Senator cautious of the Amazon's interactions with Patriarch's World.

AELLA: Aggressive separatist general deceived by Ariadne into starting an Amazonian civil war.

ALCIPPE: The queen until she was killed by the Spartans.

ALEKA: Rival to Diana who always looked down on the princess as inferior.

ALKISTIS: One of the five Amazons that Ares impregnated to birth a new generation of children.

ALKYONE: Captain of the royal guard, who attempted to overthrow the queen.

ANTIOPE: Hippolyta's sister and general of the Amazons.

ARETO: Scholar and member of the queen's council.

ASCLEPIA: A doctor who worked in both science and magics.

ASTARTE: Sister of the queen.

CARRISA: A lead healer, not known for her bedside manner.

CASTALIA: An oracle and member of the queen's council.

CHARIS: Former keeper of the royal menagerie who joined Alkyone.

CLIO: A scribe.

CYDIPPE: A handmaiden to the queen.

DALMA: Driven by jealousy of Diana, she left Themyscira for the United States.

DESSA: Longtime friend and counsel of Hippolyta.

EGERIA: First captain of the royal guard, who sacrificed her life preventing monsters from invading the island.

EPIONE: Chief healer and member of the queen's council.

EUBOEA: One of the royal guardians who helped raise Diana.

MAGALA: Mystic who chose a life of hermitage.

MAGGIE: A human made honorary Amazon after discovering Antiope's sword.

MALA: Friend of Diana's who competed in both contests held to decide who became the Amazons' ambassador.

MELIA: Battalion leader.

MENALIPPE: Chief priestess and oracle.

MESOPEE: One of the earliest Amazons created by the gods.

MNEMOSYNE: Chief librarian who oversaw all records on Themyscira.

MYRINA: The Amazons' chosen assassin, who conceived Darkseid's daughter to use against him.

MYRRHA: A handmaiden to the queen, killed during the Imperiex War.

NIOBE: Priestess and aide to Menalippe.

NUBIA: Esteemed warrior and Hippolyta's successor as queen.

EUDIA: A priestess in service of Athena.

GENNES: Scribe of theatrical epics.

GRAIL: Darkseid's daughter and attempted conqueror of Themyscira.

HELLENE: Senator who argued against any relations with Patriarch's World.

HESSIA: A general and confidante of Diana who chose to leave behind the Amazon way of life.

HIPPOLYTA: Queen of the Amazons and mother of Diana.

IO: Blacksmith who forged Diana's breastplate.

IPHTHIME: Chief sculptress.

JANESTRA: Destroyer of a demonic Icarus.

JASON: Wonder Woman's long-lost twin brother, banished from the island.

KASIA: One of Diana's closest friends and companions.

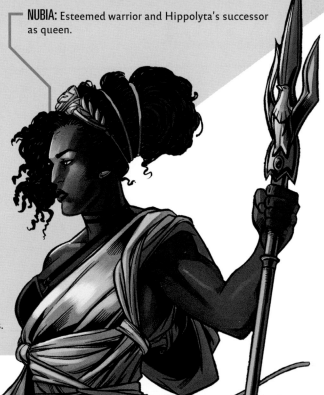

OENONE: Chief botanist.

ORANA: Challenged Diana for the title of Wonder Woman and won, only to die stopping a neutron bomb.

OSIA: Oracle and keeper of the hawk Zephyrus.

PALLAS: Artisan who constructed Diana's golden armor.

PANTHEA: Rogue scientist unhappy with the lack of scientific progress on the island.

PENELOPE: Priestess and Menalippe's lover.

PENTHISELEA: Key warrior in the Trojan War.

PHILIPPUS: High-ranking general and the queen's chief counsel.

PHILOMELA: Greatest markswoman on Themyscira.

PYTHIA: Missionary to Patriarch's World.

SEENA: An Amazon eager to leave Themyscira until she saw the cost of losing her immortality.

SOFIA: Finalist in the first contest to become the Amazons' ambassador.

TIMANDRA: Chief architect.

TONIA: One of Themyscira's most accomplished scientists.

VENELIA: Diver who competed to replace Diana as Wonder Woman.

VERONA: Master equestrian.

THE AMAZONS OF BANA-MIGHDALL

This splinter group of Amazons known for their violent ways settled in Egypt before later returning to Themyscira.

ALIAZA: Guardian of the Golden Girdle of Gaea.

ANAHID: Queen who promoted the tribe as mercenaries.

ANAYA: A peace-loving outlier of the tribe.

ARTEMIS: Onetime successor to the Wonder Woman mantle.

ATALANTA: Ruler who abdicated the throne to wander the planet.

FALIZIA: Warrior whose friendship with Donna Troy help bond the two groups of Amazons.

FARUKA: Merciless warmonger with designs on ruling the tribe.

JASMINE: A knife-wielding assassin.

KADESHA BANU: High priestess and alchemist.

KAHIRI: Accomplished bomb maker.

NEHEBKA: The queen's aide-de-camp.

PHTHIA: Founder and first queen of the tribe.

SHIM'TAR: The tribe's warrior chief, chosen through the rite of combat.

COSTUME CHANGE

Just because these Super Heroes had iconic outfits, it didn't mean they couldn't change things up from time to time, with inspiring and eye-catching new styles.

BATMAN

Needing to draw attention away from Robin's injured arm, Batman donned an array of bold new outfits. After single-color variations, he debuted the ultimate rainbow look.

Struck by a machine that caused him to emanate an uncontrollable magnetic force of energy, Batman had an unexpected new look. The energy force manifested itself in zebralike lines across his body!

His mind under assault by Doctor Hurt, Batman assembled a new red, yellow, and purple costume out of rags, manifesting the Batman of Zur-En-Arrh, which was either an alien or a psychotic hallucination.

SUPERMAN

Superman returned from the dead in style with long hair, a solid black regeneration suit with a silver S shield, and matching gauntlets. A pair of rocket boots courtesy of Lex Luthor completed the ensemble.

FANTASTIC!

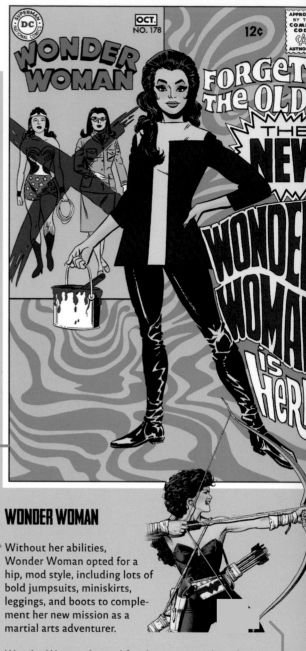

WONDER WOMAN

Without her abilities, Wonder Woman opted for a hip, mod style, including lots of bold jumpsuits, miniskirts, leggings, and boots to complement her new mission as a martial arts adventurer.

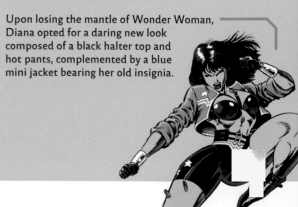

Wonder Woman dressed for the occasion when she served as a space pirate, disrupting an intergalactic slave trade dressed in black with a jacket that was easily removable during hand-to-hand combat.

Upon losing the mantle of Wonder Woman, Diana opted for a daring new look composed of a black halter top and hot pants, complemented by a blue mini jacket bearing her old insignia.

Superman came prepared for his rematch with Doomsday, armed with a Mother Box that transformed his clothing to include head protection, a gladiator-inspired arm guard, a sword, and a lot of pouches.

Superman required something to contain himself as his body converted to pure energy. Professor Hamilton constructed a suit using Kryptonian tech and an advanced polymer fabric.

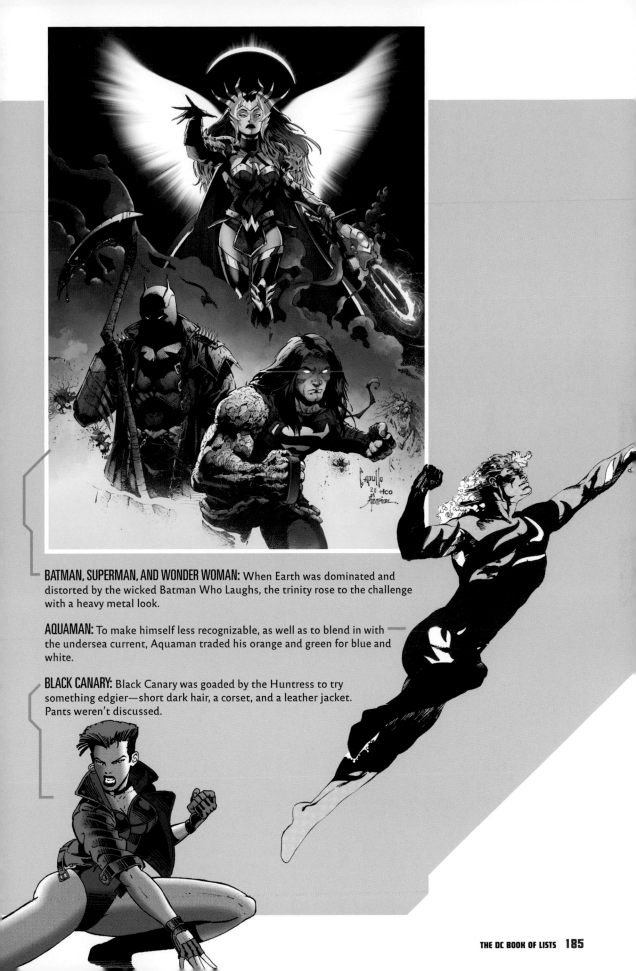

BATMAN, SUPERMAN, AND WONDER WOMAN: When Earth was dominated and distorted by the wicked Batman Who Laughs, the trinity rose to the challenge with a heavy metal look.

AQUAMAN: To make himself less recognizable, as well as to blend in with the undersea current, Aquaman traded his orange and green for blue and white.

BLACK CANARY: Black Canary was goaded by the Huntress to try something edgier—short dark hair, a corset, and a leather jacket. Pants weren't discussed.

BOOSTER GOLD: After his high-tech suit from the future was trashed, Booster turned to best bud Blue Beetle for something new: a bulky, Tin Man–like suit of armor.

COSMIC BOY: Cosmic Boy adopted a less-is-more look for his new uniform, which comprised a revealing black bustier, with matching gloves and boots, and little else.

GUY GARDNER: Having drunk from the Warrior Waters, Guy Gardner activated newfound powers to connect to his then-unknown alien heritage, which covered his body in traditional Vuldarian markings.

SANDMAN: Around the time he adopted young orphan Sandy Hawkins, Sandman swapped his gas mask, fedora, suit, and caped ensemble for a more traditional, albeit ordinary, look with gold-and-purple tights.

EARTH-ADJACENT DIMENSIONS

Occupying the same space as Earth, these dimensions overlapped and intersected, creating a web of realities just outside our doorsteps.

AZARATH: A peaceful utopia until it was ravaged by Trigon.

BARTER'S SHOP: A pocket dimension pawnshop.

BEYOND REGION: Merlin's personal dungeon dimension for wicked supernatural beings.

BGZTL: A phantom dimension, whose inhabitants could turn immaterial.

DARKWORLD: The birthplace of the Atlantean gods and demons, and source of Atlantis's magics.

DIMENSION CHI: A dark reflection of Themyscira, created and monitored by Queen Hippolyta.

DIMENSION X: A realm containing reptilian conquerors as well as an evil Wonder Woman.

DIMENSION ZERO: A realm of giants, protected by Xeen Arrow.

FLORIA: A dimension of miniature plant beings, only accessible via plants on Earth.

THE HIDDEN CITY: Home to the Homo Magi.

THE LAND OF THE GHOST FOX WOMEN: A twilight realm between life and death, sustained by the harvested souls of evil men.

THE META-ZONE: A technologically advanced, authoritarian society, and home to Rac Shade and Loma Shade.

THE MICROVERSE: The subatomic universe that served as the foundation of all reality.

MIRROR WORLD: A dimension inhabited by the telepathic warrior women, known as the Orinocas, which was accessible via mirrors.

MYRRA: A nightmarish realm of wild magic, located outside of time.

THE NIGHTSHADE DIMENSION: A magical realm whose inhabitants harnessed the power of shadows.

NETHERSPACE: A purgatory dimension where discorporate beings must wait until their keepers, the Others, allow them to return to the corporeal world.

OBLIVION BAR: A pocket dimension hot spot for mystics and magical beings.

THE OTHER SIDE OF THE WORLD: A timeless dimension whose sole, lonely inhabitant was the Warlock of Ys.

THE PARADISE DIMENSION: The pocket dimension to which Superman and Lois Lane of Earth-Two escaped, alongside Alexander Luthor and Superboy-Prime, following the Crisis.

PYTHARIA: Of fifteen worlds in an alien dimension—seven worlds of light and seven worlds of shadow—the barbaric Pytharia hung in the balance.

RA-REALM: A realm resembling ancient Egypt, beneath a green hexagonal sun.

SAVOTH: A technologically advanced civilization, accessible via the Speed Force.

SHADOWLANDS: A realm of conscious, primordial darkness that served as the source of power for people like the Shade and Obsidian.

SKARTARIS: A savage land of eternal sunlight—and dinosaurs—first colonized by early Atlanteans, originally believed to be located within Earth's core.

"SPEEDY" DIMENSION: An unnamed dimension whose sole inhabitant was an energy being who took the form of Speedy to help the Teen Titans.

TEALL: A dimension whose inhabitants are composed of pure energy.

THULE: A haven for Atlantean sorcerers to practice their dark arts.

ULTRA-REALM: The collective subconscious of Earth, giving form to the extreme contrasts of humanity's hopes and fears.

THE VOID: A purple-sky, digital dimension; home to sentient computer code M1dn1ght.

XARAPION: An alien world where scientist Thar Dan made advancements to shadow technology.

XRO: A male-dominated society where the physically stronger women are enslaved. Transferring to and from this dimension caused a reversal of a person's emotional responses.

WATER REALMS
Water flows beyond the confines of Earth's oceans into these other dimensions.

OCEANID
THE SECRET SEA
XEBEL

MAGIC USERS OF ALL SHAPES AND SIZES

Pure magic wove itself through all existence. To tap into it required both knowledge and skill. Those who could belonged to one of seven schools of occult arts.

MAGICIAN

Magic users of all levels and proficiencies, from beginners casting their first spell to the most advanced and dangerous spell casters.

ALCHEMASTER
ALI-KA ZOOM
BLACK ALICE
BLACKBRIAR THORN
GREGORIO DE LA VEGA
EMPRESS
SEBASTIAN FAUST
THE FLYING FOX
GRACEFUL MOON
JINX
KADAVER
MONTGOMERY KELLY
KING INFERNO
ELPHIUS LEVI
MAP
MISTER E
NICK NECRO
ROSE PSYCHIC
SINDELLA
SLIZZATH
SPELLBINDER
TOR, THE MAGIC MASTER
TRACI 13
WITCHFIRE
THE WIZARD (WILLIAM ZARD)
GIOVANNI ZATARA
ZATANNA ZATARA

SORCERER

Magicians who used enchanted artifacts to enhance their abilities and serve as protection from the riskier aspects of spell casting.

ARION
CALCULHA
CIRCE
CORUM RATH
DOCTOR FATE
DR. MIST
DR. OCCULT
EFFRON
FELIX FAUST
GARN DAANUTH
THE GRAY MAN
HOUNGUN
TIM HUNTER
IBIS THE INVINCIBLE
KLARION
KRAKLOW
KULAK
MADAME XANADU
MAJISTRA
MANITOU DAWN
MANITOU RAVEN
MORDRU
MORGAINE LE FEY
JENNIFER MORGAN
PAPA MIDNITE
QUESTING QUEEN

SARGON
SILVER SORCERESS
TANNARAK
TEMPEST
BARON WINTERS
WOTAN

BLOOD MAGIC

Living beings who carried the blood of fully magical beings in their veins, either by birth or intervention.

AMETHYST
BROTHER BLOOD
JOHN CONSTANTINE
DECEMBER GRAYSTONE
MERLIN
NIGHTSHADE
RAVEN
TIAMAT

CHAMPION

Magical beings of celestial origin who were bonded to human souls.

ENCHANTRESS: Bonded to June Moone.
ETRIGAN: Bonded to Jason Blood.
PRINCE RA-MAN: Bonded to Mark Merlin.

GUARDIAN

Chosen protectors of the elemental forces of Earth.

ABIGAIL ARCANE: Avatar of the Rot.
ANIMAL MAN: Avatar of the Red.
FLORONIC MAN: Avatar of the Green.
MIKI: Avatar of the Grey.
SWAMP THING: Avatar of the Green.

ARCHMAGE

Sorcerers who ascended past the need for enchanted objects and have become enchanted themselves, and higher beings of magic that fell to our plane of existence.

THE KINGBUTCHER
THE PHANTOM STRANGER
QUEEN OF FABLES
ZOR

JUDGE

Magical beings given power by the Divine Presence itself, tasked with specific roles. They were virtually unstoppable unless bound to a human soul.

ECLIPSO
THE RADIANT
THE SPECTRE
THE WORD

PHANTOM ZONE PRISONERS

When Krypton exploded, many of its survivors happened to be the criminals locked away in the Phantom Zone, the inter-dimensional realm—formed by the crystalline mind of its sole original inhabitant, Aethyr the Oversoul—that was discovered by Jor-El.

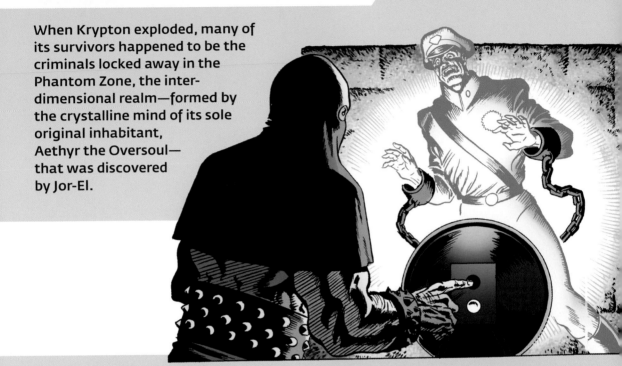

AK-VAR: Stole a rare Sun-Stone as a prank.

AR-UAL: Destroyed an alien probe, depriving Krypton of its knowledge.

AZ-REL AND NADIRA VA-DIM: Robbery.

CAR-VEX: Found guilty of lethal negligence while operating her gravity wave projector.

CHA-MEL: Caught impersonating Jor-El to rob his house.

DEV-EM: Sentenced for crimes of perversion and murder.

GENERAL DRU-ZOD: Attempted to overthrow the government.

FAORA HU-UL: Caused twenty-three deaths at her farm camp of male slaves.

GANN ARTAR: Invented a de-evolutionary ray that created large monsters.

GAZOR: Used an earthquake machine in an attempt to destroy the planet.

GOR-NU: Conducted reckless experiments that caused multiple deaths.

JAX-UR: The first criminal sent to the Phantom Zone; sentenced for blowing up the inhabited moon Wegthor in an unauthorized nuclear missile experiment.

JER-EM: Caused the destruction of Argo City.

KRU-EL: Built an arsenal of forbidden weapons.

LAR-ON: Sent to the Phantom Zone until a cure for his lycanthropy could be found.

NON: Lobotomized and sentenced for participating in Zod's attempted coup.

ORN-ZU: Kidnapped children.

PY-RON: Turned people into weird, birdlike monsters.

QUEX-UL: Poached the endangered Rondors for their healing horns. (He was framed.)

RAL-EN: Used Hyper-Hypnosis on the population of Krypton.

SHYLA KOR-ONN: Convicted of manslaughter.

THUL-KAR: Transported himself into the Phantom Zone to survive Krypton's destruction.

TOR-AN: Convicted of transferring the minds of a family into the bodies of round, one-eyed monsters.

TRA-GOB: Robbed the Science Archives.

URSA: Convicted as the main conspirator of Zod's attempted coup.

PROFESSOR VA-KOX: Mutated the marine life and polluted the waters of the Great Krypton Lake.

VORB-UN: Conducted unauthorized experiments with forbidden elements.

DR. XA-DU AND ERNDINE ZE-DA: Conducted illegal experiments in suspended animation that resulted in the deaths of test subjects.

ZAN-EM: Performed unauthorized mind-control experiments.

ZAN-ZOLL: Created a forbidden evolutionary machine.

ADDITIONAL PRISONERS
The records of these criminals' crimes were left unrecorded.

BAL-GRA
BLAK-DU
THE INVENTOR
KUR-DUL
MAROK
MURKK
RAN-ZO
RAS-KROM
TYB-OL
VAL-TY
VAX-NOR
VOR-KIL
ZAN-AR

NEW INMATES
Since learning of the Phantom Zone, Superman and company also used it to house dangerous threats, as well as to save the lives of Mon-El and Kryptonian astronauts Bar-El and Lilo.

CYBORG SUPERMAN
DOOMSDAY
THE ERADICATOR
GRA-MO AND HIS GANG
MONGUL
NAM-EK
NUCLEAR MAN
ROGOL ZAAR
ROZ-EM
TAL-VAR
WHITE MARTIANS
ZO-MAR
ZORA VI-LAR

THE SCHEMING MINDS
OF BOOSTER GOLD AND BLUE BEETLE

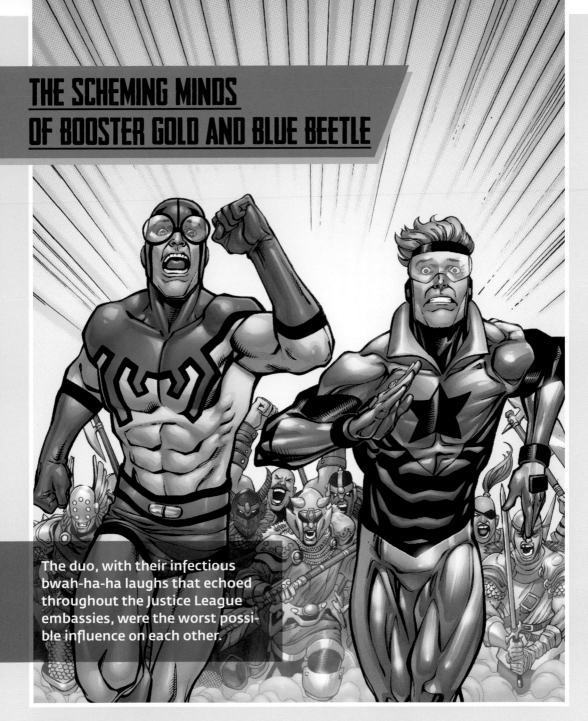

The duo, with their infectious bwah-ha-ha laughs that echoed throughout the Justice League embassies, were the worst possible influence on each other.

REPO MEN: Using their Super Hero celebrity status as a draw, Booster and Beetle got into the repossession business. Their first gig involved a high-tech tank they were wildly unqualified to drive, causing property damage.

CLUB JLI: On Kooey Kooey Kooey Island, they created Club JLI, a casino and resort with the promise that guests could "do all the things you ever wanted to do—and do it all legally." The sentient island upon with they built the resort proved to be structurally unsound, and the whole thing fell to ruins when the island started moving.

THE FIRE CALENDAR: This solo scheme of Booster's involved creating a dummy corporation that hired his teammate Fire to pose in scantily clad outfits for a wall calendar. Upon discovering that Booster was behind it, Fire burned all the copies.

BLUE & GOLD EXPRESS: Using teleporter technology they "borrowed" from the Justice League, Booster and Beetle tried a delivery service with the motto: "When it absolutely, positively has to be there in ten seconds." With a cash-accepted, no-questions-asked policy, they were easily exploited by criminals.

THE COOKIE PRANK: Booster and Beetle stashed away all Martian Manhunter's favorite cookies, buying out every package within a mile radius. They didn't anticipate the major consequences of cookie withdrawal on Martian physiology, which sent their teammate on an uncontrollable rampage throughout the city.

BLUE & GOLD BACK IN ACTION: Booster's heart was in the right place when he decided to rescue Ted moments before he was killed by Maxwell Lord. Unfortunately, the rescue created a dystopian time line in which Lord conquered the planet with his OMACs. Ted had to sacrifice himself to restore the time line.

A THOUSAND-YEAR SLUMBER: Booster and Beetle wound up in a cryochamber after throwing a party for the Elongated Man, where they remained for nearly a millennium, until the chamber was unearthed. Without any time travel equipment to use, they were stranded in the future.

THE BOOSTER BRAND

Booster Gold would put his name on just about anything if it meant a paycheck. In addition to licensing and sponsoring action figures, beer, board games, candy, comic books, deodorant, exercise machines, fire alarms, lunch boxes, plush toys, soft drinks, sunglasses, and T-shirts, he endorsed the following products:

B.G.I. MOBILE CELL SERVICE
BIG BELLY BURGER
BOOSTER BATTERIES
BOOSTER BITS, BOOSTER PUFFS, FLAKIES, AND SUGAR-PACKED BOOSTEROS CEREALS
BOOSTER BLASTER WATER GUN
BOOSTER BUBBLE GUM
BOOSTER CREAM AND BOOSTERPASTE TOOTHPASTES
BOOSTER GEAR APPAREL
BOOSTER GOLD CARD CREDIT CARD
THE BOOSTER GOLD FAN CLUB
BOOSTER GOLDEN NUGGET CASINO
BOOSTER'S BEST COFFEE
BOOSTER-BLAST ENERGY DRINK
THE BOOSTERMOBILE, THE BRYSLER-BOOSTER MARK IV
COLOGNE DE GOLD
HERO BRITCHES ADULT DIAPERS
PERFUME DU BOOSTER
PLANET KRYPTON SUPER HERO-THEMED RESTAURANT

ASSASSINS A-Z

Hired killers were always in demand. Deciding who to hire was another story.

DEADSHOT: When not locked up with the Suicide Squad, Floyd Lawton was the one to call.

DEATHSTROKE: Slade Wilson was the world's best assassin, and you pay for that kind of quality.

HENRI DUCARD: The legendary French mercenary could find and kill just about anyone.

KANTO: The master assassin of Apokolips carried out Darkseid's lethal orders.

KILLING IT AT WORK

When a hit is needed, these assassins would get the job done.

BOLT: Larry Bolatinsky was a special-effects artist turned elite, teleporting killer with shocking powers.

CHESHIRE: Jade Nguyen's weapon of choice was an array of poisons. Her only weakness? Roy Harper.

CHILLER: This killer's shape-changing ability let him get up close to his targets without them realizing it.

DEADLINE: His metagene activated by the Dominator's Gene Bomb, Deadline went from working for crime families to the big leagues as a member of the super-powered assassin team the Killer Elite.

LADY VIC: British aristocrat turned martial arts master, Elaine Marsh-Morton was more ruthless than most.

NOBODY: Following in his father's footsteps, Morgan Ducard added a costumed flair to his career.

RAGDOLL: Peter Merkel Jr.'s fully rotating, prosthetic joints allowed him to contort into any configuration while strangling targets.

RAPTOR: Hired by the Parliament of Owls, the mysterious Richard felt no pain, thanks to his leprosy-scarred skin.

THE RAVAGER: A legacy code name used by Slade Wilson's son Grant, his daughter, Rose, and his half brother Wade DeFarge.

LEAGUE OF ASSASSINS

This ancient army of killers founded by Rã's al Ghūl served as the elite training ground for scores of assassins, most notably:

ONYX ADAMS: A rare member who turned her back on the League . . . and survived to fight for good.

BRONZE TIGER: The hero Ben Turner was brainwashed into serving the League until he was deprogrammed by Amanda Waller.

DAVID CAIN: Methodical and precise, Cain passed his knowledge down to Batman, Deadshot, and his daughter Cassandra.

THE DARK ARCHER: Malcolm Merlyn was one of the greatest archers in the world.

DOCTOR DARRK: The first known leader of the League appointed by Rã's al Ghūl, Dr. Ebenezer Darrk relied on manipulation and traps, rather than physical conflict for his kills.

LADY SHIVA: Master martial artist Sandra Wu-San aligned herself with the League when necessary to achieve her own objectives.

THE SENSEI: The immortal father of Rã's al Ghūl and a former leader of the League.

TALIA AL GHŪL: Daughter of Rã's al Ghūl and his successor as the League's head.

REQUIEM INC.

An East Coast killer-for-hire organization, founded by Richter and Mrs. Waverly, commanded top dollar, though most of their hires wound up dead.

"SLIPPERY" GINO TRASK
BODY DOUBLES (THE DUO BONNY HOFFMAN AND CARMEN LENO)
LADY-KILLER
NICK HOFFMAN
THE PARDNERS (PECO AND COLT)

YOUR MILEAGE MAY VARY

Be sure to check the reviews before hiring any of these assassins.

ALPHA
CAMOROUGE
HENRY CANNON
CONSTANTINE DRAKON
THE EEL
EXECUTRIX
FYREWYRE
GOODE OLE BERNIE
GUNSMITH
HEADHUNTER
KILLSHOT
THE KISS OF DEATH
KUDZU
THE LEAGUE OF LIMOUSINE ASSASSINS
MA MURDER
THE MORRIS MEN
MR. TEETH
THE ORDER OF ASSASSINS
MARSCHALL SABER
SHRAPNEL
THE SILENT SAMURAI

THE COURT OF OWLS

The secret cabal that controlled Gotham City from the shadows possessed their own army of assassins, known as Talons, who they kept in stasis until needed, including:

HENRY BALLARD
URIAH BOONE
ALTON CARVER
WILLIAM COBB
MEI LING
EPHRAIM NEWHOUSE
CALVIN ROSE
ALEXANDER STAUNTON
MARY TURNER

HAMMER ORGANIZATION

The feared covert KGB group that trained the Soviet Union's premier assassins.

KGBEAST
NKVDEMON

LEVIATHAN

When Talia al Ghūl and, later, Quietus ran Leviathan, they turned to these killers to carry out their dirty work. Among other places, they turned to St. Hadrian's Finishing School for Girls for talented new prospects.

BLOODVESSEL
BREACHER
CRADLE
GRAVE
RAZE
THE SILENCER

NOONAN'S SLEAZY BAR

Retired assassin Sean Noonan catered to like-minded individuals at his Gotham City dive bar.

HITMAN (TOMMY MONAGHAN)
HACKEN
NATT THE HAT (NATT WALLS)
PAT NOONAN
RINGO CHEN

THE DARKEST REFLECTIONS

A trip to Earth-3 wasn't necessary for finding rogue doppelgängers of Super Heroes. Rogue doppelgängers were ever-present, lurking in the shadows, and ready to ruin the good names of Super Heroes.

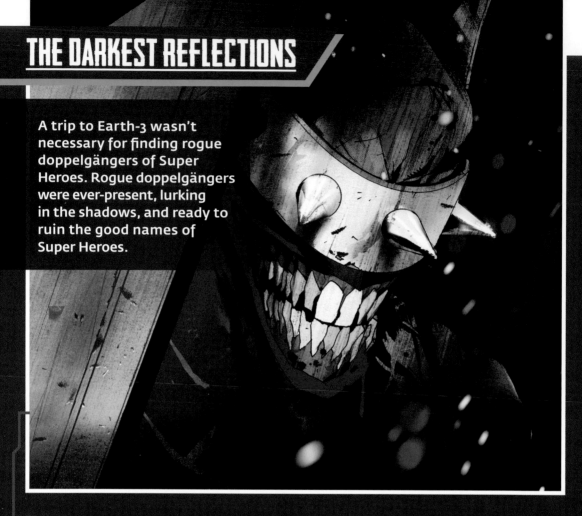

BATMAN

THE BATMAN WHO LAUGHS: A Joker-ized Batman from the depths of the Dark Multiverse.

THE THREE GHOSTS OF BATMAN: Three Gotham City cops, recruited, trained, and costumed by Doctor Hurt.

ADDITIONAL DOUBLE TAKES

JASON TODD: Jason insisted he was Bruce's worthy successor, as a gun-toting, armored Batman.

JEAN-PAUL VALLEY: Mentally unfit to take over, Jean-Paul resorted to ruthless tactics.

THOMAS WAYNE: Bruce's father, the Batman of the *Flashpoint* time line.

THE WRATH: Orphaned as a child, The Wrath dedicated his life to hunting—and killing—police.

SUPERMAN

BIZARRO: Bizarro am the worst true Superman.

CYBORG SUPERMAN: Blaming Superman for the death of his wife, Hank Henshaw sought to destroy Superman's legacy.

THE NEGATIVE SUPERMAN: A negative duplicate was created by molecular-rearranging and neutron-splitting rays.

SAND SUPERMAN: A sentient sand being that drained Superman's powers anytime they were near each other.

SUPER-MENACE: An energy-based life-form created when baby Kal-El's rocket was struck by a duplicator ray. He landed on Earth, only to be found and raced by crooks.

SUPERBOY-PRIME: After his own Earth was destroyed during the *Crisis on Infinite Earths*, Superboy-Prime was willing to destroy everything to get it back.

THE FLASH

THE RIVAL: Jay Garrick's jealous rival Edward Clariss became, well, the Rival with his own less-effective speed formula.

PROFESSOR ZOOM, THE REVERSE-FLASH: Obsessed with The Flash, Eobard Thawne traveled from the twenty-fifth century to ruin Barry Allen's life.

ZOOM: When Wally West wouldn't help him undo a personal tragedy, Hunter Zolomon set out to cause one for Wally.

INERTIA: Bart Allen's evil clone, Thaddeus Thawne, manipulated relative time rather than harnessing the Speed Force.

WONDER WOMAN

ROBOT WOMAN: A duplicate built by Elektro, head of the science division of an apparently very well-organized criminal gang—not to be confused with the Robot Wonder Woman from the parallel Robot Earth.

WONDER WOMAN'S EVIL TWIN: Not an actual twin, just a villainous counterpart from a parallel world who crossed dimensions to woo Steve Trevor.

AQUAMAN

AQUABEAST: Attempting to become Aquaman to steal away Mera, Peter Dudley instead became a deformed, hulking monster.

THANATOS: Aquaman's dark reflection, hailing from the Netherspace dimension.

NIGHTWING

DEATHWING (I): Hailing from an alternate time line, this Dick Grayson was corrupted by Raven.

DEATHWING (II): A victim of Professor Pyg and Doctor Hurt, brainwashed into believing he was Nightwing.

JASON TODD: Jason really needed to stop trying to follow in Dick's footsteps.

ADDITIONAL DOUBLE TAKES

BLACK ADAM: The Great Wizard's chosen champion, whose defiance led to Billy Batson receiving the wizard's power.

BLACK BEETLE: Blue Beetle's counterpart set out to build a new future by altering the past.

BLACKFIRE: Starfire's older sister, who cruelly sold her sibling into slavery.

DARK ARCHER: Master archer Malcolm Merlyn was determined to best Green Arrow.

GRID: Cyborg's artificial intelligence operating system, given sentience and its own body to wreak havoc.

LEGION OF SUPER-VILLAINS: The thirty-first-century rogue triumvirate of Lightning Lord, Saturn Queen, and Cosmic King.

MA'ALEFA'AK: Martian Manhunter's twin eradicated nearly their entire species.

SINESTRO AND THE SINESTRO CORPS: Sinestro and his fear-based Corps were on the opposite end of the Emotional Spectrum from the Green Lanterns.

WHITE CANARY: A martial artist seeking to avenge the defeat of her brothers, the Twelve Brothers in Silk, at the hand of Black Canary and the Birds of Prey.

THIS IS THE TIME FOR *CASTING AWAY* YOUR SHACKLES, YOUR OLD BONDS!

FOLLOW ME AND LET THE WORLD BE *REBORN AS I HAVE BEEN!*

LET LIFE ON EARTH BE A *BLESSING OF BLOOD!*

Somehow there's no such thing as a benevolent cult; they always varied from misguided to world-threatening evil.

BLOOD! BLOOD! BLOOD! BLOOD! BLO

THE BETI-MA: Worshippers of the cat goddess Bast's children, Beti and Maahes.

THE BROTHERHOOD OF THE MONKEY FIST: A caste-based cult where enlightenment was attained through the murder of martial arts masters.

THE BRUJERÍA: A secret order of South American male witches desiring to destroy heaven.

THE CHURCH OF BLOOD: A Trigon-worshipping cult that ruled the European nation of Zandia.

THE CHURCH OF THE MIDNIGHT DAWN: A Satanist group, conquered by sorceress Morgaine le Fey.

THE CULT OF CONNER: A cult hoping to resurrect the recently deceased Superboy (Conner Kent) via Kryptonian rituals.

THE CULT OF THE BAT: A group led by Jason Todd in an alternate future, who rallied against the Gotham City government.

THE CULT OF THE BLOOD RED MOON: An order of vampires ruled by Mary Seward.

THE CULT OF THE COLD FLAME: Sargon the Sorcerer, Zatara, Mister E, and Tannarak founded this group, only to be corrupted by the power they possessed.

THE CULT OF THE MANHUNTERS: An android organization for recruiting and training human Manhunter minions.

THE CULT OF THE UNWRITTEN BOOK: A religious order, led by the Archons of Nürnheim, intent on summoning God's shadow, the Decreator, to wipe out all existence.

THE CULT OF YUGA KHAN: An Apokoliptian church led by Lord Aagog, who claimed to be Darkseid's father, Yuga Khan, reborn.

THE DARK CIRCLE: A worldwide network of evil sorcerers and wizards led by the mystical Tala, who wished to either rule the world or destroy it.

THE FIRST CELESTIAL CHURCH OF THE TRIPLE FISH-GOD: A pacifist, fish-worshipping church that somehow appointed Lobo as archbishop.

THE FIRST CHURCH OF ANTI-TECHNOCRACY: A radical church led by Ron Evers, who preached against all technology and science.

THE GREEN DRAGON SOCIETY: A doomsday cult led by Guru Chud, devoted to summoning a Great Destroyer of the world.

THE KOBRA CULT: A terrorist religious organization determined to bring about Kali Yuga, the Age of Chaos.

THE ORDER OF ANCIENT MYSTERIES: An occult fraternity who sought to conjure and capture Death but ensnared her brother Dream instead.

THE ORDER OF ST. DUMAS: An offshoot of the Knights Templar, who conditioned and trained a champion enforcer, Azrael.

THE ORDER OF THE VAN HELSINGS: A cult of vampire hunters dating back to ancient Egypt.

THE RELIGION OF CRIME: Worshippers of the Crime Bible and its five Lessons of Blood.

THE RESURRECTION CRUSADE: Christian fanatics led by Elder Martin, who wanted his daughter to birth a new messiah.

LA SALIGIA: Worshippers of the seven deadly sins, plotting to restore the lost eighth deadly sin.

THE TEMPLE OF THE DIVINE LIGHT: A church of false hope, orchestrated by Eclipso.

THE TRUE BELIEVERS: A faction of the Religion of Crime, led by Kyle Abbot.

THE UNDERWORLD EMPIRE: A cult army composed of Gotham City's homeless, brainwashed, and drugged by Deacon Blackfire.

TRIGON'S UNNAMED CULT: The group that summoned Trigon and offered Angela Roth as a bride, leading to the birth of Raven.

GOTHAM CITY POLICE DEPARTMENT

The finest—and sometimes not-so-finest—current and former members of the GCPD, according to their rank.

Key:
DECEASED
CORRUPT

COMMISSIONER
McKEEVER (FIRST NAME UNKNOWN)
GILLIAN B. LOEB
JACK GROGAN
JAMES GORDON
VANE (FIRST NAME UNKNOWN)
PETER PAULING
SARAH ESSEN-GORDON
ANDY HOWE
MICHAEL AKINS
JACK FORBES
JASON BARD
MAGGIE SAWYER
HARVEY BULLOCK

DEPUTY COMMISSIONER
MAURICE "MOBY" DICK

CHIEF OF POLICE
CLANCY O'HARA

CHIEF OF DETECTIVES
MacKENZIE "HARDBACK" BOCK
KARL ESTERHAUS

COUNTY SHERIFF
STEVEN "SHOTGUN" SMITH

SHERIFF DEPUTY
CISSY CHAMBERS

WATCH COMMANDER
STAN MERKEL

COMMANDER
HOWARD BRANDEN (SWAT)

INSPECTOR
MATT CONWAY (INTERNAL AFFAIRS)
MANNY ESPERANZA (INTERNAL AFFAIRS)

CAPTAIN
J. T. BURNS (INTERNAL AFFAIRS)
DAVID KING
WEIR (FIRST NAME UNKNOWN)

LIEUTENANT
HARVEY BULLOCK (MAJOR CRIMES UNIT)
DAVID CORNWELL (MAJOR CRIMES UNIT)
HUGH DANZIZEN (ROBBERIES)
RICHARD DRAKE
ELLISON (FIRST NAME UNKNOWN)
HUGH FOLEY
JACK FORBES (INTERNAL AFFAIRS)
JERRY HENNELLY (QUICK RESPONSE TEAM)
STAN KITCH (MAJOR CRIMES UNIT)
NICKY LINCOLN
MATTHEWS (FIRST NAME UNKNOWN)
RON PROBSON (MAJOR CRIMES UNIT)
SAM WEAVER (MIDNIGHT SHIFT)

SERGEANT
MAXWELL CORT
FRANK IVERS
HARVEY HAINER
MacNAULTY (FIRST NAME UNKNOWN)
McCARTHY (FIRST NAME UNKNOWN)
BILLY PETTIT (SWAT)
ROOK (FIRST NAME UNKNOWN;
 INTERNAL AFFAIRS)

DETECTIVE SERGEANT
VINCENT DEL ARRAZIO
 (MAJOR CRIMES UNIT)
JACKSON "SARGE" DAVIES
 (MAJOR CRIMES UNIT)

DETECTIVE
ALEX AISI
CRISPUS ALLEN (MAJOR CRIMES UNIT)
CARLOS ALVAREZ (ROBBERIES)
JOSEPH ARNO
JOSH AZEVEDA (MAJOR CRIMES UNIT)
JOELY BARTLETT (MAJOR CRIMES UNIT)
JOHN BISHOP
SAMUEL BRADLEY JR.
TOMMY BURKE (MAJOR CRIMES UNIT)
TOMMY CARMA (DRIVEN INSANE)
ROMAN CAVALLO (MAJOR CRIMES UNIT)
ROMY CHANDLER (MAJOR CRIMES UNIT)
APRIL CLARKSON
ERIC COHEN (MAJOR CRIMES UNIT)
DANIEL CORRIGAN
JIM CORRIGAN (MIDNIGHT SHIFT)
NELSON CROWE (MAJOR CRIMES UNIT)

EVAN DOUGLAS
LISA DRAKE (MIDNIGHT SHIFT)
MARCUS DRIVER (MAJOR CRIMES UNIT)
PETER FARELLI
FARRUCCI (FIRST NAME UNKNOWN)
GEORGE FLANNERY
ARNOLD FLASS
CLARENCE FOLEY
NICHOLAS "ST. NICK" GAGE
 (MAJOR CRIMES UNIT)
DANA HANRAHAN (HOMICIDE)
TREY HARTLEY (MAJOR CRIMES UNIT)
TIMOTHY HOPKINS
ANDI KASINSKY (MAJOR CRIMES UNIT)
BILL KENZIE (NARCOTICS)
TAMMY KEYES
SANDRA KINCAID
TOM KIRK (UNDEAD)
LARRY LANCE
JIM LENAHAN
ELLIOT LYNCH
JOSEPHINE "JOSIE MAC" MacDONALD
 (MAJOR CRIMES UNIT)
McGONIGLE (FIRST NAME UNKNOWN)
MELODY McKENNA
GARY MINELLI
RENEE MONTOYA (MAJOR CRIMES UNIT)
MOSES (FIRST NAME UNKNOWN)
MURPHY (FIRST NAME UNKNOWN)
NATE PATTON (MAJOR CRIMES UNIT)
DAGMAR "DAG" PROCJNOW
 (MAJOR CRIMES UNIT)
CAZ SALLUCCI
KEVIN "SURVIVOR" SOONG
 (MAJOR CRIMES UNIT)
"TAKA" TAKAHATA (FIRST NAME
 UNKNOWN; MAJOR CRIMES UNIT)
DEBORAH TIEGEL
PAT TRAYCE
MARCUS WISE (MAJOR CRIMES UNIT)
RAYMOND WILLS (INTERNAL AFFAIRS)
CARL WORTH
NANCY YIP

DETECTIVE SPECIALIST
JAMIE HARPER

OFFICER
BRANCA (FIRST NAME UNKNOWN)
JACK CRANE (DRIVEN INSANE)
ROGER DeCARLO
FARLEY (FIRST NAME UNKNOWN)
HENDRICKS (FIRST NAME UNKNOWN)
ANDY KELLY

MICHAEL LANE
STEVE LONG
VERONICA LOPEZ
LOWE (FIRST NAME UNKNOWN;
 ROBBERIES)
KELVIN MAO (SWAT)
BECKY MULCAHEY
JOSEF MULLER
TIM MUNROE
DONALD PEAK
JORDAN RICH
RICKETT (FIRST NAME UNKNOWN)
NANCY STRODE
XUE (FIRST NAME UNKNOWN)

CRIME SCENE INVESTIGATOR
JIMMY CORRIGAN
 (MAJOR CRIMES UNIT)

FORENSICS
SAMUEL AERONS
CLEM ROBINS
SZANDOR TARR (MIDNIGHT SHIFT)

CORONER
NORA FIELDS

HELICOPTER PILOT
CURTIS EISENMANN

WEAPONS MASTER
LOUGHRIDGE (FIRST NAME UNKNOWN)

RECEPTIONIST
STACY (LAST NAME UNKNOWN;
 MAJOR CRIMES UNIT)

JANITOR
BARNEY BARROWS

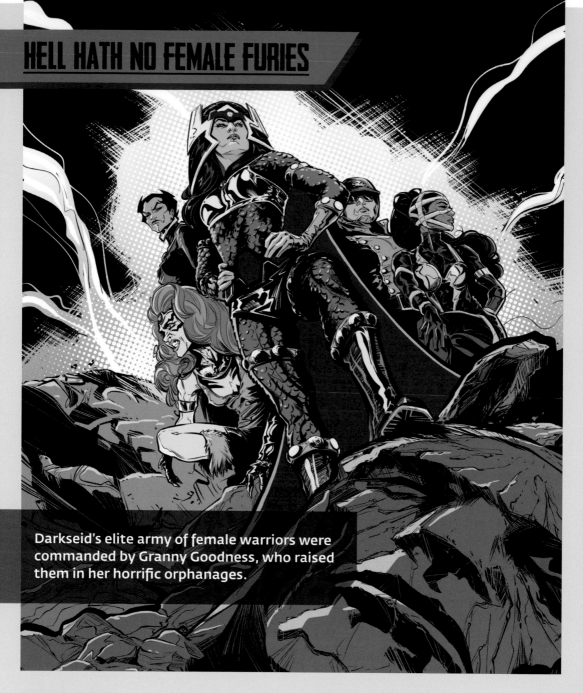

Darkseid's elite army of female warriors were commanded by Granny Goodness, who raised them in her horrific orphanages.

FOUNDING FURIES

AURELIE: The Furies' first leader died in defiance of the treatment to which she and her teammates were subjected.

BERNADETH: The scheming leader who burned her enemies from the inside out with her Fahren-knife.

BIG BARDA: Wielding her Mega-Rod, Big Barda led the group until she fled to Earth with Mister Miracle.

LASHINA: Armed with her deadly steel lashes, Lashina was the most powerful member of the Furies and was also a member of the Suicide Squad under the name Duchess.

MAD HARRIET: The psychopathic Mad Harriet cackled as she slashed her foes with razor-sharp claws.

STOMPA: With boots made of antimatter, Stompa could crush anything.

RECRUITS

ARTEMIZ: A master archer who hunted with a pack of cybernetically enhanced wolves.

BLOODY MARY: The vampiric Bloody Mary possessed the ability to control people with her gaze.

GILOTINA: A younger member who could chop through anything with her hands.

KNOCKOUT: This powerhouse took a cue from Big Barda and fled the Furies for Earth.

MALICE VUNDABAR: The youngest of the Furies could summon the demonic shadow monster Chessure.

PETITE TINA: A giant who rejected Granny and managed to escape the Furies.

SPEED QUEEN: A thrill seeker equipped with propulsive roller skates and zip gloves.

WUNDA: A newer recruit who could dazzle and disorient with her light-based powers.

THE FEMMES FATALES
This quartet of Furies defected to join the Cult of Yuga Khan, only to be recaptured and reconditioned by Granny.

ENCHANTHRAX
KILLSANDRA
SWEET LEILANI
THUMPA

EARTHBORN FURIES

ALIANNA HUBBARD: Showing extraordinary physical potential and a mastery of pain, Alianna was the first human recruited by Granny to join the Furies.

LOIS LANE: Lois impressed Granny with her mettle, earning a temporary spot on the Furies as she aided Superman and Superboy.

HARLEY QUINN: Granny recruited Harley to track down the escaped Petite Tina, christening her Hammer Harleen.

FINAL CRISIS FURIES
When Darkseid unleashed the Anti-Life Equation on Earth, a new group of Furies came under his control.

WONDER WOMAN
BATWOMAN
GIGANTA
CATWOMAN

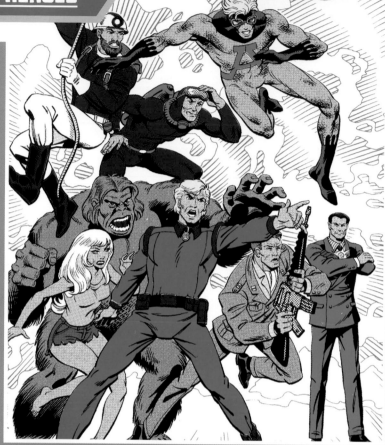

Even heroes who had largely fallen out of the spotlight could come together to save the world. Dubbed the Forgotten Heroes by the press, they kept the name as a reminder that any man or woman could be a hero.

WHO WERE THEY?

ANIMAL MAN: Hollywood stuntman Buddy Baker could tap into the Red and mimic the abilities of any animal in his vicinity.

CAVE CARSON: An internationally renowned geologist known for his adventures beneath the planet's surface with his Cave Crew team.

CONGO BILL: With a talisman, naturalist William Glenmorgan transferred his consciousness into the body of the enchanted Golden Gorilla, Congorilla.

DANE DORRANCE: The renowned deep diver led a group of adventurers, known as the Sea Devils, to explore the ocean and face watery threats.

DOLPHIN: A human abducted as a child by aquatic aliens and mutated to survive underwater.

RICK FLAG: A war hero and leader of the US government's Task Force X program.

RIP HUNTER: The legendary time traveler and protector of the timestream.

THE IMMORTAL MAN: Klarn Arg was a heroic member of a prehistoric tribe gifted with the power of reincarnation.

WHY WERE THEY ASSEMBLED?

Individually, each person encountered a mysterious golden pyramid somewhere on the Earth—or in the timestream, in the case of Rip Hunter. Save for Rip, each found themselves in the crosshairs of the US government. For Rick Flag, however, it was a cover story assigned by the government to infiltrate the group. With no one else to turn to, they were recruited by the Immortal Man to stop Vandal Savage from harnessing the pyramids' energies to turn Earth into a prehistoric jungle.

WHERE ARE THEY NOW?

ANIMAL MAN: Buddy settled down with his family and pursued an acting career while serving as the avatar of the Red until his daughter—the true avatar—was of age.

CAVE CARSON: Cave continued with his underground explorations, now with his daughter at his side. Having lost an eye, he replaced it with a cybernetic one.

CONGO BILL: After Congo Bill's human body died, he was permanently trapped in the body of Congorilla. That didn't prevent him from joining the Justice League.

DANE DORRANCE: Dane remained with the Sea Devils, though they fell on the wrong side of the law as ecoterrorists, until Aquaman hired him as surface liaison for Atlantis.

DOLPHIN: Prior to *Flashpoint*, Dolphin married Tempest, had a child, and died when the Spectre destroyed Atlantis. Post-*Flashpoint*, Dolphin was alive, single, and helped Aquaman liberate Atlantis from Corum Rath.

RICK FLAG: Rick Flag continued to work with Amanda Waller and lead most iterations of the Suicide Squad as field commander.

RIP HUNTER: After joining the Linear Men in their studies of the timestream, Rip Hunter went solo, other than partnering with his father, Booster Gold, to protect the whole of existence from time villains.

THE IMMORTAL MAN: Still alive, the Immortal Man recruited an entire team of Immortal Men, gifting them with a small piece of his immortality to combat his sister, the Infinite Woman.

NEWLY FORGOTTEN HEROES

The team expanded their ranks years after they formed to include:

BALLISTIC
FETISH
THE RAY (RAY TERRILL)
VIGILANTE (PAT TRAYCE)

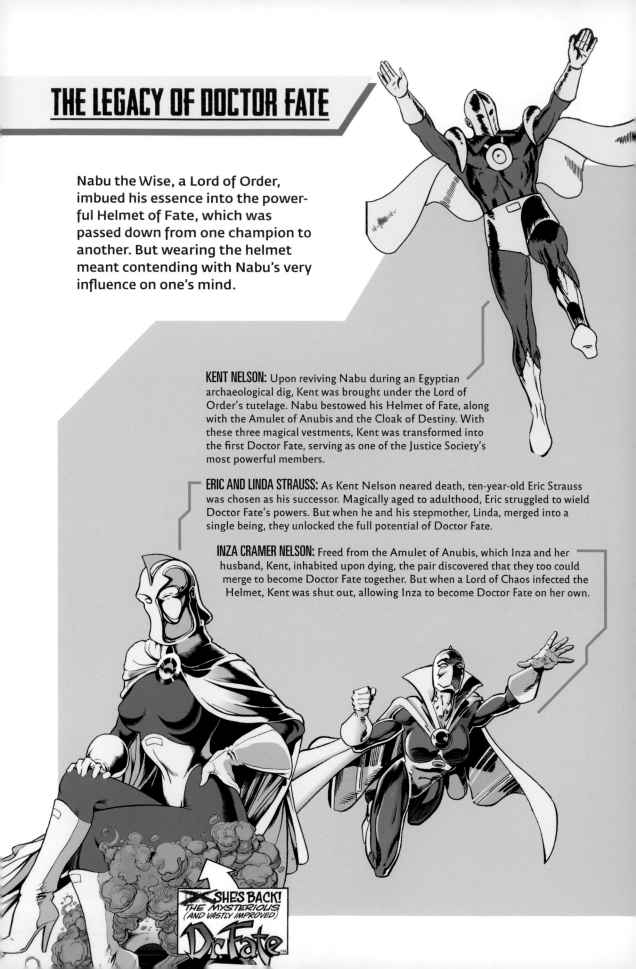

THE LEGACY OF DOCTOR FATE

Nabu the Wise, a Lord of Order, imbued his essence into the powerful Helmet of Fate, which was passed down from one champion to another. But wearing the helmet meant contending with Nabu's very influence on one's mind.

KENT NELSON: Upon reviving Nabu during an Egyptian archaeological dig, Kent was brought under the Lord of Order's tutelage. Nabu bestowed his Helmet of Fate, along with the Amulet of Anubis and the Cloak of Destiny. With these three magical vestments, Kent was transformed into the first Doctor Fate, serving as one of the Justice Society's most powerful members.

ERIC AND LINDA STRAUSS: As Kent Nelson neared death, ten-year-old Eric Strauss was chosen as his successor. Magically aged to adulthood, Eric struggled to wield Doctor Fate's powers. But when he and his stepmother, Linda, merged into a single being, they unlocked the full potential of Doctor Fate.

INZA CRAMER NELSON: Freed from the Amulet of Anubis, which Inza and her husband, Kent, inhabited upon dying, the pair discovered that they too could merge to become Doctor Fate together. But when a Lord of Chaos infected the Helmet, Kent was shut out, allowing Inza to become Doctor Fate on her own.

SHE'S BACK!
THE MYSTERIOUS
(AND VASTLY IMPROVED)
Dr. Fate™

JARED STEVENS: Separated from Inza and Kent, the Helmet of Fate, the Amulet of Anubis, and the Cloak of Destiny came into the possession of antiques smuggler Jared Stevens. A battle with demons destroyed the amulet, but its magics were imbued in Jared. He used the cloak to bandage an injury he sustained in the battle. But rather than wear the helmet, he melted it down to forge a dagger and ankh-shaped throwing darts.

HECTOR HALL: The son of Hawkman and Hawkgirl inherited their cycle of reincarnation. Having previously lived and died as the Super Hero Silver Scarab, Hector was reborn as Doctor Fate, adorned in the traditional vestments of Nabu, reconstructed after Jared Stevens's death.

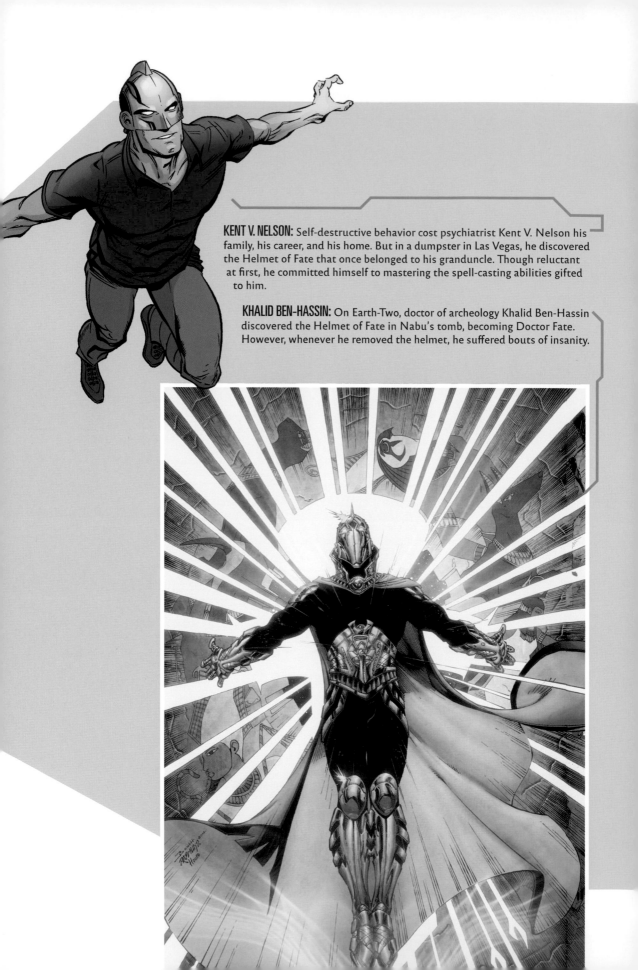

KENT V. NELSON: Self-destructive behavior cost psychiatrist Kent V. Nelson his family, his career, and his home. But in a dumpster in Las Vegas, he discovered the Helmet of Fate that once belonged to his granduncle. Though reluctant at first, he committed himself to mastering the spell-casting abilities gifted to him.

KHALID BEN-HASSIN: On Earth-Two, doctor of archeology Khalid Ben-Hassin discovered the Helmet of Fate in Nabu's tomb, becoming Doctor Fate. However, whenever he removed the helmet, he suffered bouts of insanity.

KHALID NASSOUR: Brooklyn med student Khalid Nassour—also a grandnephew of Kent Nelson—became the next wearer of the Helmet of Fate when a champion was needed to stop Egyptian god Anubis from flooding the city. He soon found a mentor in the newly returned Kent.

DOCTOR FATE OF THE THIRTY-THIRD CENTURY: Venturing back to the thirty-first century, this six-armed Doctor Fate joined the Legion of Super-Heroes, knowing the important role they would play in the future.

CITIZEN SERVICE

Not all heroes wore capes or costumes. Some were just ordinary folks who answered the call of duty, serving in critical roles aiding superheroes.

LUCAS "SNAPPER" CARR: Known for his finger-snapping habit, young Snapper served as the original Justice League of America's mascot, hanging around their Happy Harbor base and performing handyman duties when necessary.

LUCIUS FOX: With great business savvy, Lucius successfully ran Wayne Industries while still finding time to invent new crime-fighting technology and equipment for Batman.

HAROLD ALLNUT: The mute engineering wizard was homeless until Batman took him in. From the Batcave, Harold created much of Batman's impressive arsenal and technology.

CHARLES "DOIBY" DICKLES: This Brooklyn cab driver, nicknamed for the derby hat he always wore, acted as Green Lantern's sidekick in the 1940s and could handle himself well in any fight that ensued.

TOM KALMAKU: This airplane engineer chronicled Hal Jordan's adventures as Green Lantern. When offered the chance to become a Green Lantern himself, he declined with a simple "naw," having more interest in his family.

OBERON KURTZBERG: The lovable curmudgeon didn't just manage Mister Miracle's escape artist career, he also was a father figure to the hero. Oberon also operated as Maxwell Lord's second-in-command, running Justice League International.

JIMMY OLSEN: Photojournalist Jimmy expertly navigated troubling situations, which was good because he often got himself stuck in them. When in doubt, Superman bailed him out.

ALFRED PENNYWORTH: Alfred dedicated his life to raising Bruce Wayne after Bruce's parents' death and tending to his many injuries sustained in his war on crime. When Bruce needed help, Alfred was there. The butler truly did it . . . all.

PERCIVAL POPP: The bubbling, self-appointed "Super Cop" was going to be the Spectre's sidekick whether the hero liked it or not.

ARISTOTLE "TOT" RODOR: The retired inventor was a friend and mentor to Vic Sage in Hub City. His greatest creation was Pseudoderm, the artificial skin that Vic used for his faceless mask as the Question.

LESLIE THOMPKINS: Dr. Thompkins didn't just help look after Bruce Wayne; she tended to the sick and impoverished of Gotham City by running the Thomas Wayne Memorial Clinic, which was free to all who needed its services.

HIRAM "STRETCH" SKINNER: Stretch might not have been the brightest—his private eye degree came from a phony university—but he was a loyal ally and friend to Wildcat.

WOLFGANG "WOOZY" WINKS: How did a small-time crook wind up working for the FBI? By becoming Plastic Man's inseparable sidekick. The brawler was clumsy and dim-witted, but knew virtually everyone in the criminal underworld, making him an indispensable source of information.

There was no single secret to immortality. From Amazons to vampires, many beings inhabited the planet for centuries or more.

THE COUNCIL OF IMMORTALS

An assembly of immortals brought together by Hawkman and Hawkgirl in their pursuit of hidden truths extending back to the dawn of humankind.

CAIN AND ABEL: The biblical brothers never quite escaped the cycle of violence that defined them.

THE GREAT WIZARD: Once known as Mamaragan, this wizard safeguarded the powers of Shazam.

THE HANGMAN: Nothing is known about this masked member of the Council.

HAWKMAN AND HAWKGIRL: The couple achieved immortality through reincarnation, living many lives throughout time and space.

IMMORTAL MAN: Caveman Klarn Arg and his four siblings in the Bear Clan were exposed to radiation from a meteorite and used their gift of immortality to protect and guide mankind.

JASON BLOOD: With the demon Etrigan bound to his soul, Jason Blood at least had company for his eternal life.

MARY, QUEEN OF BLOOD: The vampiric leader of the Cult of the Blood Red Moon lived forever undead.

MORGAINE LE FEY: The Arthurian sorceress was one of the immortals who relied on magic to keep her youth over centuries.

THE PARLIAMENT OF TREES: According to Hawkman, at least one member of the governing party of the Green belonged to the Council.

THE PHANTOM STRANGER: Once known as Judas Iscariot, the Phantom Stranger was forced to walk the Earth as an unknown mystic being for the sin he committed.

RĀ'S AL GHŪL: The powerful waters of the Lazarus Pit kept the leader of the League of Assassins alive.

THE SHINING KNIGHT: Drinking from the Holy Grail allowed Ystin to live for centuries as they righted wrongs in the world.

UNCLE SAM: The spirit of America personified in human form.

VANDAL SAVAGE: The most infamous of immortals was granted his eternal life from a meteorite, which he used to kill his father and others.

MORE LIVES TO LIVE

Not everyone with everlasting life was invited to join the Council.

ALADDIN: This thief used his long life to amass a great collection of historical artifacts.

BLACK ADAM: The Great Wizard's first champion held on to his power even after he fell from grace.

BUZZ: A deal with the demon lord Beelzebub allowed Buzz to sow chaos for centuries.

DAVY TENZER: Not everyone believed this harp-playing teen had been alive for centuries, battling an organization bent on world domination.

DOCTOR HURT: Bruce Wayne's devil-worshipping ancestor gained immortality when he encountered Darkseid's Hyper-Adapter.

DR. MIST: Exposure to the Pillar of Life gave this African wizard-king an unending lifetime of magic.

DUCRA: The leader of the All Caste, a group of warrior monks, kept secret how she lived for three thousand years.

EL ESPECTRO: Thanks to the Fountain of Youth, this conquistador achieved immortality.

THE IMMORTAL MEN: Ghost Fist, Reload, Stray, Timber, and Caden Park represented the latest group of humans gifted with a piece of the Immortal Man's immortality.

KID KARNEVIL: This murderous teen claimed to have been kicked out of hell for being too much trouble.

LA DAMA: To some she was an urban legend, to others a crime boss. Regardless, La Dama might be one of the oldest living beings.

PLASTIC MAN: The chemicals that made Eel O'Brian all rubbery also made him eternal.

PROFESSOR IVO: A serum granted the mad scientist immortality, even as it riddled him with disease.

RESURRECTION MAN: Injected with a solution that gave him regenerative powers, Mitch Shelley came back to life with a new superpower every time he was killed.

SOLOMON GRUNDY: After he was murdered in the Slaughter Swamp, Grundy would always be born again no matter how many more times he died.

FREEDOM OF THE PRESS

The virtues of journalism went hand in hand with superheroics. It was no surprise that some journalists led double lives as heroes and others were closely aligned with them.

SUPER HERO JOURNALISTS

Both in costume and out, they were well known in the public eye.

CAPTAIN X: Richard "Buck" Dare, print, the *Tribune*

THE CREEPER: Jack Ryder, television, GNN News, and host of *Life After Death* and *You Don't Know Jack*

THE CRIMSON AVENGER: Lee Travis, print, the *Globe-Leader*

JOHNNY QUICK: Jonathan Chambers, newsreel photographer, *See All / Tell All News*

LIBERTY BELLE: Elizabeth "Libby" Lawrence, radio, the Green Network

OWLMAN: Roy Raymond Jr., television, *Roy Raymond Jr.: Manstalker*

THE QUESTION: Vic Sage, television, *KBEL News*

PHANTOM LADY: Jennifer Knight, print, the *Daily Planet*

THE RAY: Langford "Happy" Terrill, print, the *Star* and the *Globe*

SUPERMAN: Clark Kent, print, the *Daily Planet*; formerly television, WGBS-TV News

DAILY PLANET

One of America's oldest and most respected news sources, which was located in downtown Metropolis. Staff of note included:

ROBINSON GOODE, City Beat

CAT GRANT, Entertainment and Gossip Columnist

CONNIE HATCH, Puzzle Editor

HERCULES (AS ROGER TATE), Reporter

LOIS LANE, Pulitzer Prize–winning Investigative Reporter

LANA LANG, Business Editor

STEVE LOMBARD, Sports

RYAN LOWELL, Obituary Editor

JIMMY OLSEN, Staff Photojournalist

TRISH Q, Gossip Columnist

HARLEY QUINN (AS HOLLY CHANCE), Love Columnist

RON TROUPE, Political Analyst

PERRY WHITE, Editor in Chief

GOTHAM CITY GAZETTE

The nationally syndicated newspaper based out of Gotham City. Staff of note included:

THOMAS BLACKCROW, former Foreign Correspondent

ALEXANDRA BRACKETT, Reporter

DON CLEMENS, Reporter (deceased)

JOEY DAY, Photographer

JOHN HALL, Editor

MARIO ITO, Editor-in-Chief

MARTIN MAYNE, former Editor-in-Chief

JULIA REMARQUE, Reporter

ART SADDOWS, Crime Reporter

WARREN SPACEY, Crime Editor

JACK "FIVE STAR" THORPE, former Editor

VICKI VALE, Reporter and Photojournalist

ADDITIONAL KEY JOURNALISTS

ANGELA CHEN, television, *Impossible . . . But True!*

MYRA CONNELLY, television, *KBEL News*

JACK GOLD, print, the *National Chronicle*

MELBA MANTON, television, *WGBS-TV News*

ESTHER MARIS, print, the *San Diego Union Tribune*

MAXINE MICHAELS, print, Pulitzer Prize–winning, freelance

TANA MOON, television, *GBS News* and *Kona-TV News*

LINDA PARK, television, *Central City Tonight with Linda Park*; formerly *WKEY-TV Channel 4 News*

EDWARD RAYMOND, print, the *Daily Express*

ROY RAYMOND SR., television, *Impossible . . . But True!*

TOBY RAYNES, print, the *Metropolis Star*

BETHANY SNOW, television, *The Bethany Snow Show*

CHLOE SULLIVAN, print and online, the *Metropolitan*

MARA TALBOT, print, *Newstime*

GEORGE TAYLOR, print, the *Daily Star*

WALLY TORTOLINI, print, freelance

LIZ TREMAYNE, print and television, *In-Depth Magazine*

IRIS WEST, print, *Central City Citizen*

DANITA "DANI" WRIGHT, print, the *Weekly World Star*, television, *KLAQ-TV*

CRIME IS NO LAUGHING MATTER IN GOTHAM CITY

But no one managed to tell The Joker that. Primarily known for use of his Joker Venom, which caused a laughing death, The Joker clowned around with many other crazy capers, including:

- Dressed as police, firefighters, postal workers, and sailors to commit crimes.
- Based crimes on phrases, like dumping paint from an airplane to "paint the town red" and trapping Batman in a giant gyroscope to "take him for a spin."
- Made people cry.

- Took over a flower shop to sell chloroform-emitting flowers that put his robbery targets to sleep.
- Stole a mansion.
- Based crime sprees on the letters of his name, a hand of cards, superstitions, songs, noises, historical blunders.
- A backward crime spree.
- Forced Batman and Robin into giant death traps based on gambling games.
- Sent Batman formal invitations and rebus puzzles to his schemes.
- Turned himself invisible.
- Established a syndicate of Jokers in every state.
- Dressed in a different costume for each crime.
- Hired gag writers for new material.
- Took inspiration from Batman and got his own prank-filled Utility Belt.
- Kidnapped Robin to force Batman to commit crimes.
- Launched his own newspaper for criminals.
- Attempted to make a movie about defeating Batman.
- Taunted Batman with clues to his next crimes in advance.
- Partnered with Lex Luthor to make indestructible Mechano-Men to commit robberies.
- Founded the Crime-of-the-Month Club.
- Caused a minor earthquake.

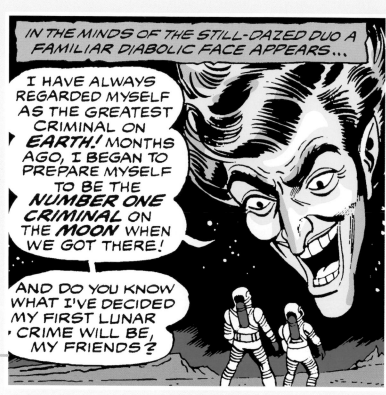

- Faked his death and pretended to be a ghost.
- Established a crime contest for the False Face Society.
- Used a giant vacuum cleaner to suck up precious gems.
- Dressed as a silent film–era comedy star.
- Stole the original models of famous inventions.
- Faked a moon landing.
- Tricked Snapper Carr into revealing the location of the Justice League's headquarters.
- Attempted to feed Batman to a shark.
- Forced Batman and Wildcat into a fight to the death.
- Melted a millionaire's stash of platinum.
- Skyjacked a plane on behalf of a dangerous foreign power.
- Used a shrinking serum on a hostage and then ran him over with his truck.
- Attempted to trademark fish he poisoned to get a percentage of every sale.
- Tied his enemies to exploding candles atop a giant birthday cake.
- Trapped Batman in a room full of killer toys.
- Tried to construct a mountainside monument to himself . . . and blow up Batman in the process.
- Staged a coup in Guatemala.
- Became the Iranian ambassador to the UN to gain diplomatic immunity.

WHEN CLARK KENT MET . . .

Growing up in Smallville, Clark Kent encountered numerous people he'd meet again as Superman.

ARTHUR CURRY: Aquaboy was nearly killed fighting corrupt sailors aboard a leaking oil tanker. Superboy cleaned all the crude oil off him, saving his life. Together, they went back out to protect the ocean from further pollution.

BARBARA GORDON: Superboy rescued a drowning girl at Camp Smallville—a young Barbara Gordon, who was eager to grow up to be a Super Hero. She debuted at camp as Mighty Girl, years before she became Batgirl.

J'ONN J'ONZZ: Future Justice League teammate Martian Manhunter witnessed Clark's rocket ship fall to Earth and decided to keep tabs on the child. The summer Clark was eight years old, J'onn adopted the persona of Josh Johnstone, a migrant worker who helped on the Kent family farm, to meet the boy.

HAL JORDAN: On a flight to Coast City for a Kent family gathering, Clark was seated next to Hal Jordan, years before he became Green Lantern. Hal taught Clark to surf, and later—as Superboy—Clark rescued Hal when he was kidnapped by a group of smugglers.

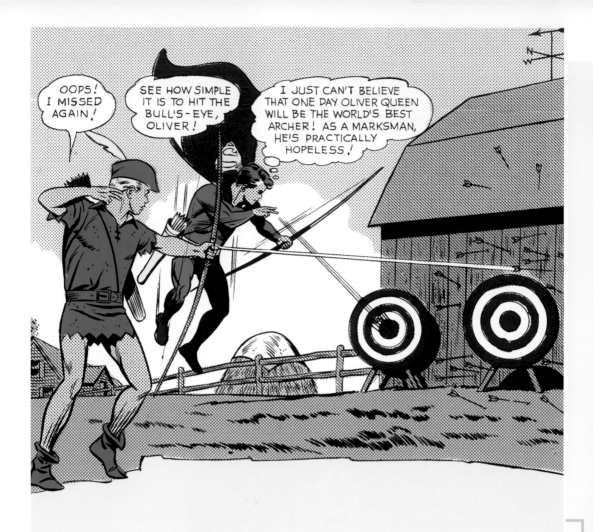

LOIS LANE: Both Lois and Clark won a trip to Metropolis as an award from the *Daily Planet* for best high school newspaper reporters. They competed to get the best headline for the day, which Lois won for a story about Superboy. Clark treated her to ice cream as a reward.

JIMMY OLSEN: Professor Mark Olsen went missing, but Superboy assured Jimmy, his toddler son, that he'd find him. Superboy succeeded in getting the professor back for Jimmy's birthday, making a pal for life in the process.

OLIVER QUEEN: Before Oliver Queen was Green Arrow, he was just a kid in a Robin Hood costume who had recently moved to Smallville. Oliver wasn't very good with a bow and arrow, but Superboy urged him to keep practicing.

PERRY WHITE: Before Perry White was Clark Kent's editor at the *Daily Planet*, he struggled to make it as a reporter. With the help of Superboy, Perry got a scoop on the criminal known as the Ringmaster and earned a staff position at the *Daily Planet*.

THE GREAT TEAMS OF WORLD WAR II

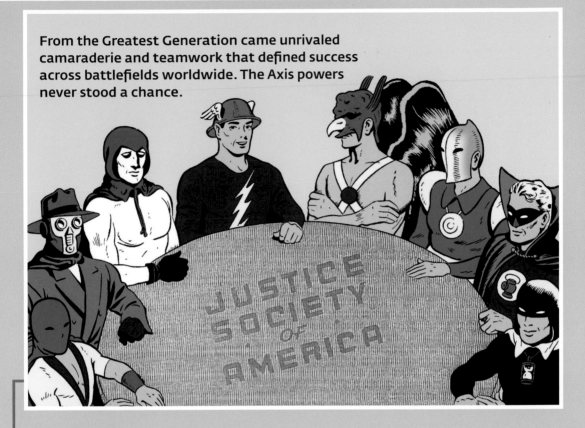

From the Greatest Generation came unrivaled camaraderie and teamwork that defined success across battlefields worldwide. The Axis powers never stood a chance.

SUPER HERO TEAMS

THE ALL-STAR SQUADRON: Following the attack on Pearl Harbor, President Roosevelt asked all Super Heroes to band together in a single organization that answered directly to him and the war department.

THE FREEDOM FIGHTERS: A group of heroes led by Uncle Sam who traveled to Earth-X, a world without Super Heroes where the Nazis were winning the war, in hopes of turning the tide.

THE JUSTICE SOCIETY OF AMERICA: The oldest and longest-lasting group of Super Heroes formed in 1940 on behalf of President Roosevelt after saving him from an attack by Hitler and the Valkyries.

SEVEN SOLDIERS OF VICTORY: Formed in 1941 to fight the criminal mastermind known the Hand, the team remained active until they were scattered throughout time after a battle with the Nebula Man.

THE SQUADRON OF JUSTICE: A group composed of heroes from Fawcett City.

YOUNG ALL-STARS: The youth auxiliary of the All-Star Squadron, made up of teenage heroes who faced threats on US soil.

YOUNG ALLIES: Teen heroes from Allied countries who worked with the Young All-Stars.

MILITARY GROUPS

THE BLACKHAWKS: The elite international squadron of volunteer fighter pilots, led by Major Janos "Blackhawk" Prohaska.

THE CREATURE COMMANDOS: A team of monsters produced by Project M, whose hideous appearances were meant to inflict psychological terror on their foes.

THE EASY COMPANY: Led by Sgt. Rock, this famed fighting unit landed on the beaches of Normandy on D-Day and went on to participate in most battles in the European theater of World War II.

THE FLYING BOOTS: A trio of trapeze artist brothers who found themselves fighting in the South Pacific, including on the extraordinary Dinosaur Island.

FORCE 3: A trio of guerrilla fighters from the United States, Greece, and Poland.

GHOST PATROL: Three members of the French Foreign Legion who continued to fight the Nazis even after their deaths.

THE HAUNTED TANK UNIT: A cavalry of tanks commanded by Sergeant Jeb Stuart, including one possessed by the ghost of Stuart's ancestor.

HUNTER'S HELLCATS: Lieutenant Ben Hunter's team, gathered from the army prison stockade, became a first-rate commando team under his guidance.

THE LOSERS: A series of military career failures thrust these soldiers together, but what they accomplished as a group proved they were anything but losers.

RED, WHITE, AND BLUE: A marine, an army soldier, and a navy sailor who conducted covert intelligence operations together.

SUICIDE SQUADRON: A ragtag and expendable unit sent on dangerous missions where casualties were high and morale was low.

KID HEROES

THE BOY COMMANDOS: Orphans serving as mascots for the army until they proved their worth in battle.

THE BLUE BOYS: Led by Little Boy Blue, this group of youngsters combated the crime wave that seized Big City.

THE NEWSBOY LEGION: A gang who got by on their wits and knuckles in the Suicide Slum neighborhood in Metropolis.

GREEN LANTERN CONSTRUCTS

Fueled by willpower, the power rings of the Green Lantern Corps formed hard light constructs of anything their wearers imagined. Blunt objects like fists were common, but creativity truly shined.

BRAIN WIPING: The biosentient mathematical formula Dkrtzy Rrr—undetectable to anyone but the Guardians of the Universe—controversially invaded the brains of its foes and wiped them clean.

COAST CITY: After his hometown's destruction, Hal Jordan tried to bring it all back, down to the tiniest detail.

DISGUISES: Simon Baz and Jessica Cruz were just your ordinary, everyday sanitation workers; just ignore the green glow.

DOLPHIN: It was no seahorse, but Kyle Rayner helped Aquaman travel in style.

BOTTLED UP: After stopping a drunk driver, Hal left him in a bottle for the police.

KRYPTONIAN TELE-DISRUPTOR: Leave it to John Stewart to reconstruct a lost Kryptonian device for blocking teleportation just by glancing at the blueprints.

MARINE UNIT: John was never outnumbered with a backup marine unit by his side.

MONSTER HAL: Doped by drug dealers, the best Hal could muster was a truly horrific version of himself.

RECLINER: Guy Gardner wasn't very formal when addressing the Guardians.

SOUND WAVES: Blind Green Lantern Rot Lop Fan used an F-sharp bell construct to produce sound waves.

SUPER-MEDICINE: While suffering from intense pain, Hal mustered the willpower to produce a painkiller.

TURKISH TO ENGLISH DICTIONARY

TURKISH-TO-ENGLISH DICTIONARY: The ring had a built-in translator for any language, but Kyle still conjured up a dictionary.

WHATEVER THIS IS: This unclassifiable monstrosity could only come from the mind of Guy.

GUARDIANS OF THE UNIVERSE

Most of the Guardians evolved beyond the need for names, but a few maintained identities.

APPA ALI APSA: Also known as the Old Timer, he spent time on Earth to get better accustomed to mortals.

BASILUS, BROOME BON BARRIS, PAZU PINDER POL, AND VALOREX: Original members of the Guardians.

DAWLAKISPOKPOK: Turned his back on his brethren in favor of a family.

DENNAP: One of the reborn, second generation of Guardians.

GANTHET: The sole survivor after the Parallax-infected Hal Jordan destroyed the Corps.

HERUPA HANDO HU: One of the original Guardians, instrumental in creating the Manhunters.

KONTROSS: Ganthet's predecessor as the Guardians' representative in the Quintessence.

KRONA: The mad Guardian driven insane by his quest for knowledge.

LIANNA: A Guardian raised on Zamaron, tall in stature, unlike her siblings.

PALE BISHOP: A former Guardian who established the Pale Vicars of the Paling, as anti-emotion order of monks.

RAMI: Creator of the power rings.

SAYD: Cofounder of the Blue Lantern Corps with Ganthet.

SCAR: A Guardian badly burned by the Anti-Monitor.

TEMPLAR GUARDIANS: A subgroup of the Guardians who guarded against the First Lantern's escape. Unlike their predecessors, all had names:

GURION
KADA SAL
NATOS
PAALKO
QUAROS
REEGAL
YEKOP
ZALLA

BURNED BY THE HELLBLAZER

Whether you loved John Constantine or crossed him, you risked ill fortune just by being in his orbit. Somehow John would find a way to do you wrong, such as the following greatest hits of damnation.

STANLEY MANOR: Incinerated from the inside out after John transferred the curse Stanley had used on him.

SIR PETER MARSTON: Ate himself after John allowed him to be possessed by the demon Calibraxis.

CHERYL MASTERS (JOHN'S SISTER): Murdered by demonic offspring John sired with Rosacarnis.

NICK NECRO: Left to die and then had his trench coat stolen by John.

NEO-NAZIS: Brutally murdered by a golem made from one of their victims.

OLIVER (LAST NAME UNKNOWN): After getting mixed up with John, he was forced to sacrifice his soul to the demon Blythe in exchange for freeing his daughters.

PRISON INMATES: Stirred into a riot so John could acquire cigarettes.

RITCHIE SIMPSON: John unplugged the computer containing his consciousness, rather than telling Ritchie that his body died.

THE SOUL OF JOHN CONSTANTINE: The worst bits of John's soul were cut away, transferred to another, and surrendered to the First of the Fallen in exchange for freeing the damned children of hell.

ANGIE SPATCHCOCK: Injected with John's demon blood (to save her life, but still).

SWAMP THING AND ABIGAIL ARCANE: The conception of their child was interrupted by John popping back into his body, which Swamp Thing had been using.

THE TATE CLUB: The two-hundredth-anniversary party of the magic group was ruined when John revealed how each member was going to die.

JOSH WRIGHT: Drugged with acid and sealed in a morgue with the corpse of the woman he killed.

GIOVANNI ZATARA: Died in a botched séance John orchestrated.

BLATHOXI: Financially ruined after John collapsed the UK soul exchange market.

TRISH CHANDLER: Nearly killed by John to stop a demon that had possessed her.

CHANTINELLE: Seduced by John so he could regain the demon blood he lost.

PHOEBE CLIFTON-AVERY: Given wine laced with a love potion she wisely didn't drink, but then was murdered by a demon that John had drugged with the same potion.

THOMAS CONSTANTINE (JOHN'S FATHER): His soul was irreversibly bound to a decaying cat.

RICHARD ELDRIDGE, MICHELLE HANSON, LOFTY, MUPPET, STRAFF, AND DANI WRIGHT: Unknowingly served the boiled head of Bran the Blessed—the Holy Grail—for dinner to keep it out of the wrong hands.

DICKIE FERMIN: Devoured by a wild boar John alerted to his presence.

THE FIRST OF THE FALLEN: Tricked into drinking holy water, which caused his innards to explode. Later forced into curing John's cancer along with the Second and Third of the Fallen to avoid a war over John's soul.

GABRIEL THE ARCHANGEL: Kicked out of heaven, John proceeded to cut off his wings with a chainsaw.

GREG: Dani Wright's ex was cursed with a menstrual cycle and breasts for hitting Dani.

KAREN GREY: Deceived into passing her own soul onto hell.

GOLDEN BOY: John's unborn twin was strangled in the womb.

THE KING OF THE VAMPIRES: Dragged into the sunlight, bursting into flames.

GARY LESTER: Used as bait to trap a demon.

ASTRA LOGUE: Consigned to hell after a failed exorcism.

ONE-OF-A-KIND TRANSPORTATION

Non-metahuman heroes and villains still had to get around, opting for modes of transportation that were practical, stylish, and very much on-brand.

AIRCRAFT

AERIE ONE: The Birds of Prey's plane.

ARROWPLANE: Green Arrow's plane.

THE BUG: Blue Beetle's aircraft, usually carrying Justice Leaguers in tow.

INVISIBLE JET: Wonder Woman's jet.

THE JOKERGYRO: The Joker's custom copter.

JUSTICE LEAGUE CRUISER: A shuttle for nonflying teammates.

THE LIVING ROOM: Air transportation for Aquaman's team, the Others.

THE PEQUOD: An aircraft used by Nightwing's team of Outsiders.

SHEBA: The Suicide Squad's helicopter.

SKY CYCLE: Smaller aircraft for nonflying members of the New Teen Titans.

STEEL EAGLE: The Justice Society of America's jet.

SS-1: The Suicide Squad's plane.

THE T-JET: The New Teen Titans' jet.

TITANS COPTER: The original Teen Titans' transportation.

BATMAN'S AIRCRAFT

THE BAT-ROCKET
THE BAT-COPTER
THE BATGYRO
THE BATPLANE (AKA THE BATWING)
THE WHIRLY-BAT

AUTOMOBILES

THE ARROWCAR: Green Arrow
THE BATMOBILE: Batman
THE BAT-VAN: Batman
THE CATMOBILE: Catwoman and Catman
THE DEVILMOBILE: Blue Devil
THE FIDDLE CAR: The Fiddler
THE JOKERMOBILE: The Joker
THE MOTHMOBILE: Killer Moth
REDBIRD: Robin

TRAINS

THE BAT-TRAIN: A traveling Batcave used for a countrywide Anti-Crime Week, organized by police commissioners in various cities.

SPECIALTY TRANSPORTATION

Some vehicles truly defied classification—one-of-a-kind modes of transportation that were unforgettable.

THE DOLL PLANE: Doll Man's airplane was easy to miss since it was scaled for his tiny size.

DRAGONWING: An alien spacecraft piloted and bonded to the Great Ten hero the Immortal Man in Darkness, who is slowly killed by his connection to the ship.

THE FLYING SUNDIAL: A hovercraft shaped like a sundial that was operated by Chronos.

GIANT SEAHORSE: Aquaman's loyal, giant seahorse Storm carried him far and wide.

GOITRUDE: This early-twentieth-century taxi belonging to Green Lantern sidekick Doiby Dickles was converted for space travel.

GYROSUB: Spysmasher's transport functioned as a car, a plane, a boat, and a submarine.

THE JOKER'S SKY SLED: Shaped like The Joker's head, this flying craft shot fireballs out of its mouth.

THE MIGHTY MOLE: An experimental tunneling vehicle used by Cave Carson on his underground adventures.

THE MOUNTAIN OF JUDGMENT: A gargantuan converted missile carrier that served as a mobile home for the Hairies.

THE ROCKET DISC: Doc Magnus's thought-controlled aircraft for the Metal Men.

SPACEHOG: Lobo's customized SpazFrag666 went from zero to sixty instantaneously and ran on unleaded.

STAR-ROCKET RACER: A flying car belonging to the Star-Spangled Kid and his successor Stargirl, typically driven by partner Stripesy.

THE SUPER-CYCLE: A three-wheel, all-terrain vehicle from New Genesis, used by Young Justice, which displayed a degree of sentience in addition to flight and teleporting capabilities.

SUPERMOBILE: Constructed of the metal Supermanium, this vehicle emulated many of Superman's powers.

THE WHIZ WAGON: A spacious flying car from New Genesis that seated five or more, perfect for the Forever People and the Newsboy Legion.

MOTORCYCLE RIDERS

Heroes who customized bikes to get around.

BATGIRL
BATMAN
BLACK CANARY
HUNTRESS

NIGHTWING
ROBIN
VIGILANTE
WILDCAT

WONDER WOMAN'S INVISIBLE JET BLUEPRINTS

VERTICAL
STABILIZER

FUSELAGE

RUDDER

COCKPIT

AILERON

NOSE

WINGS

HEADS-UP!

A who's who of the *DC Book of Lists* cover

1. Raven
2. Vixen
3. The Flash (Jay Garrick)
4. Bizarro, Jr.
5. The Joker
6. Green Lantern (Guy Gardner)
7. Star Boy
8. Green Lantern (John Stewart)
9. Donna Troy
10. Dr. Mist
11. Doctor Sivana
12. Mar Novu
13. Nix Uotan
14. Starwoman
15. Doctor Manhattan
16. Starman (Farris Knight)
17. Bernadeth
18. Mr. Freeze
19. Sarge Steel
20. Gangbuster
21. The Atom (Ray Palmer)
22. Shazam!
23. Kobra
24. The Creeper
25. Robin (Jason Todd)
26. Doctor Fate (Kent Nelson)
27. Solomon Grundy
28. Red Tornado
29. The Spectre
30. Batgirl
31. Speedy
32. Vril Dox II
33. Dark Ranger
34. Deathwing
35. Green Lantern (Hal Jordan)
36. Lagoon Boy
37. Plastic Man
38. Silver Banshee
39. Tattooed Man
40. Jesse Quick
41. Cheetah
42. Martian Manhunter
43. Doctor Mid-Nite
44. Harley Quinn
45. The Flash (Danica Williams)
46. Catwoman
47. Two-Face
48. Big Bear
49. Batwing
50. Wonder Girl
51. Tomorrow Woman
52. Starman (Jack Knight)
53. Robin (Damian Wayne)

54. Darkseid
55. Gorilla Grodd
56. The Emerald Eye
57. Green Arrow
58. Thanatos
59. Hourman (Matthew Tyler)
60. Talon
61. Mister Miracle
62. Batman
63. Sandman
64. El Gaucho
65. Jimmy Olsen
66. Tommy Tomorrow
67. Dubbilex
68. The Human Target
69. Green Lantern (Charlie Vicker)
70. Superman
71. Brainiac
72. Guardian
73. Lex Luthor
74. Felix Faust
75. Manhunter (Mark Shaw)
76. The Penguin
77. Green Lantern (Kyle Rayner)
78. The Flash (Barry Allen)
79. Lucifer Morningstar
80. Alfred Pennyworth
81. Iron
82. Doctor Fate of the 33rd Century
83. Amanda Waller
84. Manhunter (Paul Kirk)
85. Cyborg Superman
86. John Constantine
87. Manhunter (android)
88. Green Lantern (Simon Baz)
89. Manhunter (Chase Lawler)
90. Lois Lane
91. The Atom (Al Pratt)
92. Marcus Driver
93. Professor Zoom
94. The Question
95. Accomplished Perfect Physician
96. Lightning Lad
97. Hassan
98. Lyrissa Mallor
99. Captain Cold
100. Wonder Woman
101. Dream
102. Mister Mxyzptlk
103. Donna Troy
104. Manhunter (Dan Richards)
105. Hawkgirl
106. Black Canary

107. Hourman (Rex Tyler)
108. Booster Gold
109. Dan Turpin
110. Weaponer of Qward
111. James Gordon
112. The Knight
113. Cosmic Boy
114. Blue Beetle
115. Metron
116. Green Lantern (Kai-Ro)
117. Ravager
118. Kid Flash
119. Superboy-Prime
120. Cyborg
121. Validus
122. Frankenstein
123. Firestorm
124. Deadshot
125. Hawkman
126. Impulse
127. Jonah Hex
128. Manhunter (Kirk DePaul)
129. Animal Man
130. Manhunter (Kate Spencer)
131. Aqualad
132. Congo Bill
133. The Riddler
134. Mera
135. Black Adam
136. Superboy
137. Sandy the Golden Boy
138. Nightrunner
139. Starfire
140. Black Manta
141. Black Orchid

THE DC BOOK OF LISTS

A MULTIVERSE OF LEGACIES, HISTORIES, AND HIERARCHIES

RANDALL LOTOWYCZ

ART CREDITS

This book features illustration across the years of DC history by the following artists. Running Press has made every effort to identify and acknowledge the artists whose work appears in these pages.

Daniel Acuña, Arthur Adams, Neal Adams, Dan Adkins, Tony Akins, Jeff Albrecht, Gary Amaro, Murphy Anderson, Mirka Andolfo, Ross Andru, Jim Aparo, Bernard Baily, Darryl Banks, Carlo Barberi, Eddy Barrows, Chris Batista, Ed Benes, Joe Bennett, Lee Bermejo, Jordi Bernet, Jerry Bingham, Simon Bisley, Stephen Bissette, Fernando Blanco, Bret Blevins, Brian Bolland, Brett Booth, Tim Bradstreet, Brett Breeding, Norm Breyfogle, M.D. Bright, June Brigman, Pat Broderick, Bob Brown, Jimmy Broxton, Martinez Bueno, Rick Burchett, Chris Burnham, Jack Burnley, Sal Buscema, Mitch Byrd, John Byrne, Stephen Byrne, John Calnan, Jamal Campbell, Greg Capullo, Nick Cardy, Fred Carrillo, Joe Certa, Ernie Chan, Howard Chaykin, Jim Cheung, Cliff Chiang, Brian Ching, Ian Churchill, Yildiray Cinar, Matthew Clark, Gene Colan, Mike Collins, Amanda Conner, Darwyn Cooke, Paul Cooper, Pete Costanza, Denys Cowan, Federico Cueva, Paris Cullins, Fernando Dagnino, Andrew Dalhouse, Tony Daniel, Alan Davis, Shawn Davis, John Dell, Mike Deodato, Jr., Nick Derington, Tony DeZuniga, Dick Dillin, Steve Ditko, Rachel Dodson, Terry Dodson, Mike Dringenberg, Bob Dvorak, Dale Eaglesham, Scot Eaton, Alvaro Eduardo, Martin Egeland, Lee Elias, Gabe Eltaeb, Steve Epting, Steve Erwin, Mike Esposito, Glenn Fabry, Mark Farmer, Raul Fernandez, Eber Ferreira, Juan Ferreyra, Michel Fiffe, David Finch, Travel Foreman, John Forte, Gary Frank, Ron Frenz, Kerry Gammill, José Luis García-López, Pat Garrahy, Mitch Gerads, Vince Giarrano, Dave Gibbons, Joe Giella, Keith Giffen, Craig Gilmore, Dick Giordano, Jonathan Glapion, Patrick Gleason, Scott Godlewski, Al Gordon, Timothy Green II, Sid Greene, Mike Grell, Tom Grindberg, Tom Grummett, Butch Guice, Yvel Guichet, Andres Guinaldo, Paul Gulacy, Craig Hamilton, Tim Hamilton, Cully Hamner, Scott Hanna, Ed Hannigan, Chad Hardin, Mike Harris, Tony Harris, Doug Hazlewood, Don Heck, Clayton Henry, Phil Hester, E. E. Hibbard, Greg Hildebrandt, Tim Hildebrandt, Bryan Hitch, Rick Hoberg, James A. Hodgkins, Dave Hoover, Corin Howell, Adam Hughes, Victor Ibanez, Jamal Igle, Carmine Infantino, Frazer Irving, Geof Isherwood, Jack Jadson, Mikel Janin, Phil Jimenez, Jorge Jiménez, Staz Johnson, JG Jones, Joëlle Jones, Kelley Jones,

Ruy José, Dan Jurgens, Bob Kane, Gil Kane, Karl Kesel, Sam Kieth, Jack Kirby,
Leonard Kirk, Barry Kitson, George Klein, Scott Kolins, Don Kramer, Andy Kubert,
Joe Kubert, Andy Kuhn, Greg LaRocque, Stanley 'Artgerm' Lau, Jim Lee, Bob LeRose,
Bob Lewis, Steve Lieber, Steve Lightle, Ron Lim, David Lopez, Aaron Lopresti,
Adriano Lucas, Jorge Lucas, Emanuela Lupacchino, Andy MacDonald,
Mike Machlan, Kevin Maguire, Doug Mahnke, Francis Manapul, Tom Mandrake,
Lou Manna, Guillem March, Pablo Marcos, Esteban Maroto, Cynthia Martin,
Gary Martin, Shawn Martinbrough, Alitha Martinez, Ray McCarthy, John McCrea,
Scott McDaniel, Todd McFarlane, Ed McGuinness, Mike McKone, Shane McManus,
Linda Medley, Adriana Melo, Miguel Mendonça, Jesús Merino, Mort Meskin,
Jonboy Meyers, Grant Miehm, Danny Miki, Frank Miller, Inaki Miranda, Lee Modor,
Christopher Moeller, Sheldon Moldoff, Jim Mooney, Travis Moore, Mark Morales,
Rags Morales, Moritat, Ibrahim Moustafa, Diogenes Neves, Graham Nolan,
Irv Novick, Kevin Nowlan, Michael Avon Oeming, Patrick Olliffe, Jerry Ordway,
Joe Orlando, Mark Pacella, Carlos Pacheo, Agustin Padilla, Carlo Pagulayan,
Mark Pajarillo, Eduardo Pansica, George Papp, Yanick Paquette, Fernando Pasarin,
Chuck Patton, Jason Pearson, Paul Pelletier, George Pérez, Joe Philips, Al Plastino,
Francis Portela, Howard Porter, Eric Powell, Joe Prado, Bruno Premiani, Steve Pugh,
Frank Quitely, Jheremy Raapack, James Raiz, Humberto Ramos, Khary Randolph,
Arthur Ranson, Norm Rapmund, Ivan Reis, Doug Rice, Cliff Richards, David Roach,
Marshall Rogers, William Rosado, Alex Ross, Dave Ross, Luke Ross, Stephane Roux,
Joe Rubinstein, Paul Ryan, Stephen Sadowski, Jesús Saíz, Daniel Sampere,
Alex Sanchez, Rafa Sandoval, Amilton Santos, Marco Santucci, Marguerite Sauvage,
Ira Schnapp, Lew Sayre Schwartz, Nicola Scott, Steve Scott, Trevor Scott, Bart Sears,
Mike Sekowsky, Val Semeiks, Miguel Sepulveda, Paulo Sequeira, Liam Sharp,
Kevin Sharpe, Howard Sherman, Jon Sibal, Walt Simonson, Howard Simpson,
Tod Smith, Peter Snejbjerg, Joe Stanton, Arne Starr, Joe Staton, Cameron Stewart,
Karl Story, Rob Stull, Goran Sudžuka, Curt Swan, Romeo Tanghal, Jordi Tarragona,
Rick Taylor, Ty Templeton, Greg Theakston, John Timms, Marcus To, Andie Tong,
Rick Veitch, Mike Vosburg, Ron Wagner, Lee Weeks, Kevin West, Anthony Williams,
Freddie E. Williams II, J.H. Williams III, Bill Willingham, Ron Wimberly,
Phil Winslade, Chuck Winter, Chuck Wojtkiewicz, Bill Wray, Bernie Wrightson,
Annie Wu, Xermanico, Patrick Zircher, Michael Zulli

ACKNOWLEDGMENTS

I have so many people to thank for the very existence of this book. I'm indebted to Steve Korté for recommending me. Everyone at Running Press wowed me with their efforts: my extraordinary editor, Cindy Sipala, for this insane opportunity and humoring me throughout; SMOG Design, Inc. for making sense of the words and images with their design work; Fred Francis for his herculean task of guiding the book through production; Ada Zhang, Frances Soo Ping Chow, Katie Manning, Kristin Kiser, Amy Cianfrone, Kara Thornton, Alina O'Donnell, and everyone else at Running Press who had a hand in this undertaking. It's always a pleasure working with the fine folks at Warner Bros. and DC, whose knowledge and dedication is unrivaled, including Benjamin Harper, Mike Pallotta, Benjamin Le Clear, Paul Reese, Hank Manfra, Steve Sonn, Matt McNutt, Joseph Daley, and Leah Tuttle.

I owe a huge debt to all the creators whose work I feature. I couldn't have done what I did without their writing and art. Special shout-outs to Dan Jurgens, whose work got me hooked on comics in the first place. Ron Marz, Jimmy Palmiotti, Brian Michael Bendis, and Cecil Castellucci all provided small bits of inspiration at various points in writing this book, so I want to thank them as well. And, of course, I bow down at the altar of Jack Kirby. Thank you, king!

Finally, I want to recognize and thank my family, Jackie and Peter Wolff. I don't know where I'd be without them.

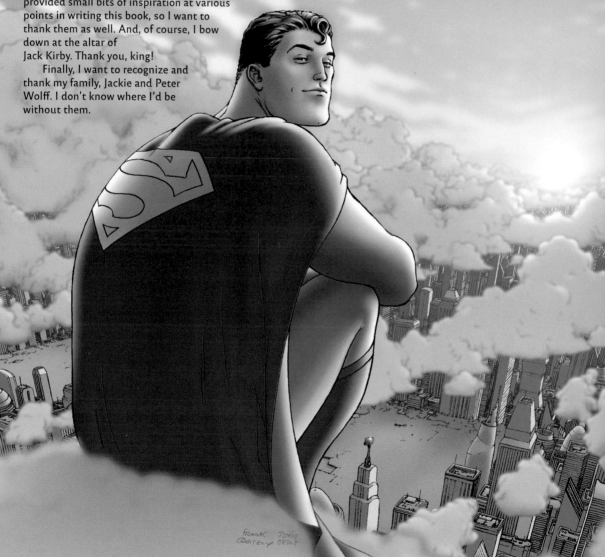

ABOUT THE AUTHOR

RANDALL LOTOWYCZ lives with his family in Brooklyn. During the day, you can find him in the West Village, where he works as a marketing and sales director for a book publisher. He is also the *Wall Street Journal* best-selling author of the *DC Comics Super Heroes and Villains Fandex* and *Superhero Playbook*. Learn more about him at www.RandallJL.com.

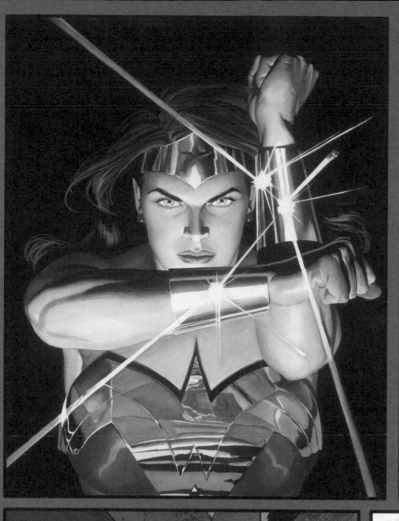